THE ART TEACHER'S HANDBOOK

Second Edition

Robert Clement

Stanley Thornes (Publishers) Ltd

Originally published in 1986 by Hutchinson Education (as ISBN 009-164181-0) Reprinted in 1986, 1987, 1988, 1989, 1990

Reprinted 1990 by Stanley Thornes (Publishers) Ltd (as ISBN 07487-0356-X)

This edition first published in 1993 by:
Stanley Thornes (Publishers) Ltd
Old Station Drive
Leckhampton
CHELTENHAM GL53 0DN
England

A catalogue record for this book is available from the British Library.

ISBN 07487-1455-3

Typeset by Tech-Set, Gateshead, Tyne and Wear
Printed and bound in Great Britain by Butler & Tanner, Frome, Somerset.

CONTENTS

ACKNOWLEDGEMENTS

I would like to thank John Morton for his expertise in preparing the new photographs for this second edition of *The Art Teacher's Handbook*.

In addition to all those teachers who have contributed so much to this publication through their work in schools, I would like to thank the following colleagues who in their different ways have made a very special contribution to my work – through their support, through their thinking and through so many intriguing and friendly debates about education in art and design:

Maurice Barrett, Norman Binch, John Broomhead, Philip Creek, Keith Gentle, David Hinchcliffe, Arthur Hughes, Dan Jelly, Howard Jones, Terry Jones, Alison Kelly, Chris Killock, Annette Mason, Shirley Page, Ray Petty, Derek Pope, Tony Preston, Peter Riches, Jim Short, John Steers, Helen Stokes, Vincent Stokes, Liz Tarr, Rod Taylor, Neil White, Robin Wiggins and Robert Witkin.

I am grateful to the following teachers and colleagues who have allowed me to use documentation or description of their own work in schools within this book:

John Broomhead, Rob Chapman, Michael Clarke, Jean Coombe, Derek Doran, Nick Dormand, Richard Dunn, Janet Griffith, Nick Hall, Peter Hall, Mark Horsfield, Marjorie Howard, Garry Hutton, Alison Kelly, Chris Killock, Tony Preston, Margaret Reilly, Peter Riches, Jackie Ross, Penny Snow, Helen Stokes, Vincent Stokes, Rosaleen Wain.

I am also grateful to the staff of the following schools in Devon who have allowed me to use the work of their pupils in this book:

Ashburton Primary School, Audley Park School (Torquay), Axe Valley School, Bridgetown C. of E. Primary School (Totnes), Chumleigh Community College, Churston Grammar School, Clyst Vale College, Coombeshead School (Newton Abbot), Cuthbert Mayne R.C. School (Torquay), Dawlish School, Eggbuckland Community College (Plymouth), Estover Community College (Plymouth), Exwick Middle School (Exeter), Great Torrington School, Heathcoat Middle School (Tiverton), Heavitree Middle School (Exeter), Hele School (Plympton), Honiton Community College, Ilfracombe Community College, Ivybridge Community College, John Kitto Community College (Plymouth), Kind Edward VIth College (Totnes), Kingsbridge School, Manor Primary School (Ivybridge), Notre Dame R.C. Comprehensive School (Plymouth), Okehampton College, Park School (Barnstaple), Pilton School (Barnstaple), Plymouth High School for Girls, Plymstock School, Priory High School (Exeter), Queen Elizabeth School (Crediton), St Luke's High School (Exeter), St Margaret's C. of E. Primary School (Torquay), South Molton Community College, Stokenham Primary School, Tavistock College, Teign School (Kingsteignton), Teignmouth Community College, Thornbury Primary School (Plymouth), Tiverton School, Uffculme Community College, Westlands School (Torquay), Westcroft Junior School (Bideford), Woodfield Primary School (Plymouth), Woodford Junior School (Plympton).

The authors and publishers would like to thank the copyright holders below for their kind permission to reproduce the following textual material and illustrations:

Art Institute of Chicago for *Into the world there came a soul called Ida*, by Ivan Albright, page 167; Ashmolean Museum, Oxford, pages 97–8; Birmingham City

Museum and Art Gallery, pages 137–8; Solomon R. Guggenheim Museum, New York, pages 135–6; The Controller of Her Majesty's Stationery Office for the Programmes of Study for Art in the National Curriculum, pages 25–32; Julia McKenzie for *Vase of Tulips*, page 175; National Gallery, London, for *Hilaire Germain-Edgar* by Degas, page 175; Tate Gallery, London, for *Carnival* by Max Beckmann, page 150; United Feature Syndicate, Inc., for permission to reproduce the *Peanuts* cartoon, page 267.

The author and publishers extend their apologies to anyone whose rights have been overlooked, and will be happy to correct any errors or omissions in future editions.

INTRODUCTION

This Second Edition of *The Art Teacher's Handbook* has been made necessary because of the considerable changes that have taken place in education and in the practice of teaching art and design since its first publication in 1986. The most important change has been the introduction of the National Curriculum, which has had a significant impact upon the way that subjects are taught in our schools and on working relationships between them.

The National Curriculum in art will be introduced into schools at the beginning of the academic year 1992–3 and it is hoped that this new edition of *The Art Teacher's Handbook* will provide teachers of art and design with useful support in putting the new curriculum in place. In addition, this new edition takes account of other developments that have taken place within the teaching of art in recent years through the introduction of GCSE examinations, the advent of technology and computer-aided design and the significant developments that have taken place in the teaching of critical and contextual studies.

This book is based upon my work with teachers as Art and Design Adviser to Devon between 1970 and 1992. In that time I have had the privilege of working with many committed and distinguished teachers in both primary and secondary schools, and their work and thinking has had a significant influence upon my own work as an art educator.

I have tried in this book to make a bridge between the considerable body of research that has taken place into the theory of art education over the past twenty years and the day-to-day practice of teaching art in schools. I hope that my attempts to illustrate general principles and to match these with teachers' descriptions of their own practice will help other teachers to measure their practice more effectively.

All the material in this book is drawn from in-service courses and conferences, from working parties of teachers and from my own observation of teachers working in schools in Devon.

I would like to acknowledge the very considerable debt that I owe to the late Joslyn Owen, Chief Education Officer to Devon from 1974 to 1989, both for his support and encouragement and for his challenging ability to reduce an ill-founded theory to tatters!

Robert Clement
August 1992

1 A FRAMEWORK FOR THE SYLLABUS

Art for whose sake?

Over the past three decades there has been continuous, and sometimes acrimonious, debate about the purpose and function of the teaching of art and design in our schools. At the two extremes, opposing views have held that art in schools should principally be the vehicle through which children can express their ideas, feelings and emotions and, on the other hand, that art education is about providing children with the basic and necessary skills to enable them to make images and artefacts.

If you discuss the relevance of art teaching with different groups of people within education – or with anyone outside it – you find a perplexing variety of responses. In many schools there is a considerable gap between what the art teacher aims to do – what he/she sees as his or her function within the school – and what the teacher appears to be teaching to other people, not least to the children within their care. Teachers of all subjects grumble about the way that external sources counteract the influences they try to bring to bear within the classroom; the art teacher has also to contend with the whole range of misconceptions about what art is about and what art is not about and should be.

Children's own attitudes towards art, and their understanding of its relevance to them, are only partly influenced by the teaching they receive in schools.

Consider this range of views from a group of 15-year-olds who, a decade ago, had just chosen to take art for the then 'O' level examination. Their attitudes were clearly as influenced by external sources as by the teaching they had received within their own school.

Art gives me a rest from the normal school routine.

Another aim of art which is most important is to get the standard of our painting raised high enough for us to pass our 'O' level examination.

You can only teach people a certain amount of art – it is mostly talent.

If a subject had to be dropped in school I think it should be art, because it has no value except to those whose job is on the artistic side.

I chose art because I like it and I don't want to take geography.

I think that art is valuable because it provides an outlet for self-expression amidst the turmoil of other subjects.

The value of art in school is that it makes us use imagination and it makes a person use his senses, especially sight – it is a sort of poetry for the eyes.

I like things neat and interesting. Sometimes I like to break away from this, to feel free, to go mad. This I can express in art. Art is a way of freeing your emotions in a safe way. Art is an outlet.

This range of descriptions by children of how they viewed their art education matches the curious variety of functions attributed to art in our schools. Traditionally, art departments in secondary schools are saddled with a confusing proliferation of functions, many of them unrealistic and few of them having much to do with children's learning. They are more likely to do with producing certain kinds of images and artefacts, passing on culture, developing good taste, providing a useful therapy for backward children, or a little relaxation from real academic work for the brighter children.

Many art teachers still tend to rely too much

upon the products of their work with children as the main justification for the place of art within their school. Although the quality of the children's work is a strong indicator to the strength and purpose of a department, that in itself may not be sufficient. As art educators, we may too easily assume that art making is self-justifying, because we ourselves have spent so much of our lives making art and teaching others to do the same. Many laymen, and many of our colleagues within schools, simply do not share the same faith and need evidence other than the work itself to give support to our convictions.

Within schools, art has to be justified through a description of its value to the learning and development of children. In order to make this justification, you will need to know something of the nature of art as a medium for learning.

Good art education in schools operates within two modes: 'productive' and 'critical'. 'Critical' is used here in the positive sense of appraising and evaluating. The production of images and artefacts is greatly enhanced by informed and relevant experience in the critical role. Although the making of images and artefacts and the critical appraisal of the work of artists and designers is central to a sound education in art, the competencies which good art teaching seeks to develop in children are much more varied and broader in character. Art education in schools also has to take a major responsibility for important aspects of children's development, which is of intellectual, personal and social significance.

Within the schools, the arts do *not* exist simply to provide an affective balance to what is assumed to be a predominantly cognitive curriculum.

It is the case that each of the major cultural forms we call the arts, the sciences, the social studies and the humanities are symbolic systems that humans use in order to know. They are all cognitive. Symbolic systems are the means through which consciousness is articulated and they are also the means through which what has become conscious can be publicly shared.

Eliot Eisner in 'The Impoverished Mind'

Feeling is, of course, important within artistic

activity, and art teachers need to help their pupils to refine and sensitize their feelings, but the prior concern within art education has to be with those feelings aroused through aesthetic qualities within the environment and by and through artefacts – with feelings and personal responses related to objective experiences and which are capable of expression through visual means.

The aims of art education

Art education within secondary schools can have a bewildering variety of aims and objectives. They need to be clearly and simply defined, so that they serve as a statement of intent for the work of an art department and provide the logic for the deailed syllabus structure they should support.

Basic aims

There are four general categories of aims, and although there may be overlap between them, there is sufficient differentiation to make them useful as a way of both defining and balancing the work of an art department.

Aesthetic aims are helping children to understand and use the language of aesthetics – and to comprehend the nature and function of art forms within the context of their own work, within an historical context and within the context of their own environment and culture.

Perceptual aims are providing children with the particular perceptual skills needed to comprehend and respond to art and design forms and to the visual environment.

Technical aims are teaching the necessary skills involved in the use and manipulation of materials.

Personal and social aims are improving the quality of children's learning – their abilities to think, perceive, make decisions, work through problems etc., and heightening and improving the children's personal perception of the world and their reactions and responses to it.

Aesthetic and perceptual aims are most important in that they describe those qualities that make art, as a way of learning, unique within the

curriculum. Personal and social aims are most important where they are operational – to do with improving and sharpening children's learning. They give weight to the argument that art plays a constructive part in the general education of children. In association with perceptual aims, they play a large part in determining the pattern of work in the first three years of secondary schooling, where it needs to be argued and proved that art provides a useful vehicle for learning and that there are exclusive ways of operating within art that are beneficial to all children, whatever their skills or potential as artists.

Specific aims

The specific aims for art education, which take account of the variety of purposes indicated above, have been identified most recently by the Art Working Group. This Working Group was commissioned to prepare the groundwork for the National Curriculum in Art, and its recommendations published in *Art for Ages 5 to 14*. They are described as follows:

- to enable pupils to become visually literate: to use and understand art as a form of visual and tactile communication and to have confidence and competence in reading and evaluating visual images and artefacts.

- to develop particular creative and technical skills so that ideas can be realised and artefacts produced.

- to develop pupils' aesthetic sensibilities and enable them to make informed judgements about art.

- to develop pupils' design capability.

- to develop pupils' capacity for imaginative and original thought and experimentation.

- to develop pupils' capacity to learn about and observe the world in which they live.

- to develop pupils' ability to articulate and communicate ideas, opinions and feelings about their own work and that of others.

- to develop pupils' ability to value the contribution made by artists, craftsworkers and designers and to respond thoughtfully, critically and imaginatively to ideas, images and objects of many kinds and from many cultures.

Example 1 shows how one group of teachers, in the introduction to their syllabus, have considered carefully both the rationale for the work in their department and the way that the aims of the department might be defined by using the categories described above.

A framework for art education

Like all forms of human expression, art (the making of images) is evidence of response to different kinds of experience. Both the experience received and the response that follows can be either objective or subjective.

This simple model provides a useful framework for art teachers to use as a monitor of the range of experience they provide for their pupils.

Whatever starting point you use in your work with children, the experience they have and the responses they make will be determined by the context within which you place the event. In Chapter 5 detailed examples are given of the way that children's experience of something as familiar as a house is determined by both the questions

asked of the children about the house and the context within which they are asked to view and respond to it. Whether they describe the house, analyse it, tell stories about it or conjecture about it will depend upon how you focus their view of that familiar form.

Similarly, the children's perception of themselves through the making of a self-portrait will be determined by the context within which the task is placed, by whether you ask them to describe themselves in as much detail as possible, or to measure themselves very carefully, or to record subtle colour changes in the face, or to make comparisons between themselves looking happy and sad, or to conjecture through the drawing about how they might look in twenty years' time etc.

This is why it is of little use trying to structure an art syllabus on the basis of content or subject matter. You need to consider carefully what kind of *response* is required of the children to each and every task you set them.

Example 2 illustrates how the head teacher of a primary school has used this method, of balancing tasks that will generate different kinds of response, as the basis for planning art and design projects in her own school. The first part provides the matrix for the planning, and the second an example of the use of this matrix for planning work in art that is related to a fiction-based project with children in Years 5 and 6.

In your work with children in secondary schools, it is important that you also maintain a balance of work that allows children access to, and experience in, the different modes of working available through the making of images and artefacts. Just as the good teacher of English ensures that children are required to write transactionally, descriptively and expressively in their English lessons, the teacher of art needs to ensure a similar balance within the making of art.

Alternative structures or **domains** *for art education*

Over the past decade or so, there has been serious debate about the way suitable frameworks can be developed for defining a well-balanced programme of work in art and design in schools through considering those key elements or *domains* that might determine an appropriate pattern of work for use in schools. The framework outlined in the previous section grew out of work undertaken within the Schools Council Art Committee in the 1970's where there was concern to provide a useful model for planning work in art for use in primary schools. This framework was published by the Schools Council in 1978 in *Art 7 to 11* (ed. Clement, R. T.).

In the United States of America, the work of Eliot Eisner (*Educating Artistic Vision*, Macmillan), in which he began to explore the structure of alternative domains for art education, was very influential upon the work of art educators in this country who, like Brian Allison (in 'Identifying the Core in Art and Design', *Journal of Art and Design Education*, Vol. 1, No. 1, 1982), also began to seek ways to both define and describe a coherent pattern for the teaching of art.

One of the most influential frameworks or models for teaching art and design in our schools was provided by Maurice Barrett in *Art education: A strategy for course design* (Heinemann), in which he proposed a model based upon those three elements within art which are an essential part of any visual enquiry:

1 The personal or conceptual element creates curiosity and interest in children, places the work within a meaningful context for them and generates feeling responses to the ideas and problems presented by the theme.
2 The technical element is concerned with the organisation and use of materials and processes – with the development of skills appropriate to the problem.
3 The visual element embraces perception and understanding of those visual elements that reveal the appearance of the world: colour, tone, surface, line, space, movement etc. It also includes understanding of the different forms of visual response appropriate to the theme or problem.

Any one of these three elements can become the dominant one or the starting point for a

particular project – but all three elements need to play their part within the work.

The value of this model is that it enables the art teacher to consider and monitor the balance of experiences presented within a particular project or across the whole art syllabus. Although, in art, there are a multitude of common experiences and disciplines that children should experience and learn, the overriding aim should always be to provide them with those looking, thinking and making skills which will enable them to respond with confidence to their individual and personal view of themselves and their world.

It is particularly crucial to get the right balance between experiences which allow for objective and expressive responses. It is all too easy for a programme of work to become dominated by one of Barrett's three elements, for example to be overweighted with the teaching of techniques at the expense of personal involvement and visual enquiry.

A balanced syllabus and one that provides children with those skills needed to support their thinking and imagining is more likely to be achieved if it is constructed with such models in mind.

Similarly, when you are planning a long art project within a programme of work, you need to consider how the different functions and elements within art balance within that project, and how these different ways of working and responding can build one upon the other. The development of structures and sequences in art education is dealt with in more detail in the next chapter.

Example 3 describes an art project designed for use with children in Year 7 and within which the teacher has used Barrett's model to construct a teaching programme in which there is a careful balance between the use of those looking, thinking and making skills that are equally important in your work with children.

In the later 1980's, another influential model based upon defining a structure of domains within art education grew out of the work of what was then the Art Committee of the Schools Examinations Council. This work was done in association with developing grade criteria for assessment within the new GCSE Examinations in Art and Design. The working group identified three key aspects of the subject, which also form a coherent framework for its assessment:

the Conceptual Domain.

the Productive Domain.

the Contextual and Critical Domain.

These are described in Example 4, 'The domains for work in art and design'.

This model was particularly influential upon the work and thinking of the Art Working Group which was commissioned in 1990 to prepare a report to the Secretary of State for Education upon the introduction of the National Curriculum in Art, and to propose a working structure for its Attainment Targets and Programme of Study. These proposals are described in detail in the following chapter.

How effectively you may use art as a vehicle for learning within your own school, and the credibility that your subject will have to the children you teach, will rest upon how effectively you use models like those described here to support and enrich your teaching within the framework of the National Curriculum in Art.

In the past one hundred years the place of art within the school curriculum has been justified by such diverse claims as the need to train the hand and eye of the artisan worker and because it serves as a vehicle for the spontaneous creative outpourings of the naturally imaginative child!

I would suggest that its real claim to a secure place within the school curriculum is more to do with the way that through the making of images children are able to engage with the real world about them and within them. In the world of school, which is dominated by the requirement to collect and store second-hand information, the making of images and artefacts allows children the means to make concrete their observations and resonses to a complex world, and through this to know better both the world and themselves.

EXAMPLE 1

EXAMPLE 1

An introduction to the art and design syllabus – philosophy and aims, Ivybridge School

Richard Dack *Head of Art and Design Department*

The overall philosophy

The position of art within the educative process is important, but no longer unique. The multiplicity of art activities combine on both conceptual and practical levels to fulfil the complex role of providing a vehicle for the expression of human ideas, awarenesses, values and responses. Additionally, the need of the individual to effect changes upon his environment requires an ability to observe, analyse, process and create effective regimes that will benefit that environment with informed opinion, judgement and change.

The heightening of perception and the realisation of the visual world in each individual, his or her ability to assess that world, and his or her role within it, are aspects which can be geared to the needs of the child and are implicit in the subject. The basic innate need of the species to *make*, involves the ability to *question*, and access to situations of experiment and learning by *doing* becomes of paramount importance. The facility for the child to develop from within, as well as the guiding of the individual from without, is essential when providing a balanced diet of activities within the curriculum. Great sensitivity is required in order to recognise the needs and levels of the child. To disregard the sensibilities of the individual may create not only a stifling of the expressive instincts of the child, but also a shallow and diminished grasp of those underlying factors that constitute his or her reality.

The Department has a common policy regarding creative, expressive and critical education. We regard ourselves as facilitators as well as educators, and we attempt to provide stimuli, environment and technical expertise conducive to the multifaceted nature of art/design education.

At a time when it appears that many departments have begun to recognise, respect and utilise aspects and practices hitherto seen as the province of art educators, the role of the department is seen as increasingly important in drawing together some of the conceptual areas, in order to avoid possible confusion arising from the multi-approach systems currently employed. We also endeavour to provide aspects of qualitative education seen to be sometimes absent in other areas of the curriculum.

It is important to identify the basic aims of the department in simple terms in order to develop and maintain cross-curricular understanding, and it is the responsibility of all within the department to communicate the essential elements of educational, personal and social development that we feel to be inherent in our role.

The functions That art education can have many aims and objectives within the school is obvious, but in order to clarify those deemed to be most important we need to identify the main areas:

(a) *Aesthetic aims* – the *language* of art, its functions and nature; the relationship of art to the environment, history and culture of the child.

(b) *Perceptual/Cognitive* – the understanding of the visual world, to instill and develop the process of visual discrimination with its associated and contributory skills.

(c) *Technical/Operational* – the acquisition of necessary intellectual, manipulatory and technical skills with materials and processes relevant to the intent of the child.

(d) *Personal/Social* – the development of the awareness of the child of his/her identity; the heightening of the child's personal perception of the world; the development of skills and awarenesses in problem-solving; the enhancement and improvement of the quality of the learning experience, helping thought and decision-making.

Sub-aims Students should:

1 be perceptually aware and visually discriminative.

2 be able to realise the relationship of materials to the form of design, expression and communication.

3 be able to appraise and critically analyse art forms, experiences, phenomena, and their visual world and environs.

4 be able to place an idea or thought into translatable, tangible terms – to communicate.

5 be familiar with those skills and techniques which form part of the criteria for evaluation.

6 develop a vehicle with which to advance a personal form of expression.

7 acquire the necessary manipulative and technical skills to enable practical and intellectual development to occur.

8 realise the historical and cultural context of what is encountered, and the contributive role of the Arts.

EXAMPLE 2

EXAMPLE 2

Planning matrix for work in art and design with children in Years 5 and 6. Extracts from the guidelines for art, Stuart Road Primary School, Plymouth

Alison Kelly *Head Teacher*

1 The planning matrix.

2 Outline planning for a term's programme of work in art and design with children in Years 5 and 6. The work in art is designed to support a cross-curricular fiction-based project generated through the study of *The Wind in the Willows* by Kenneth Graham.

The function of art

Description
Describing the appearance of things – for the pleasure of knowing or for collecting information.

Requires careful looking and suitable materials for interpretation.

Provide a focus by:
 Mark making
 Looking
 Discussion

Analysis
Isolation of certain elements or visual forms. Helps children make sense of busy, complex environment.

Exploration of tone, pattern, surfaces, etc.

Prepares for development in craft.

Communication
Involves all kinds of visual forms – literal, objective, symbols, diagrams and abstract.

Visual story-telling and explaining.

Problem-solving
Thinking and making. Planning. Enquiring. Drawing to solve problems using diagrams, drawings and words.

Expression
In association with story-telling conveys information, expresses personal feeling, qualities and ideas.

Involves the development of a language of images.

Studies of the riverbank — Upper Juniors

	Drawing	Painting	Textiles	Ceramics/3D
Description	In the field - drawing (pencil & colour work) observing general environmental as well as detailed elements. Careful drawings of collected items/case specimens to support other work.	Look carefully at the way in which other artists have painted flowers/plants/wild fowl etc. Make careful watercolour paintings of case specimens to work thro looking.	Using frayed fabrics, overlaid scrim etc. create a riverside environment that would make people want to touch it. Alternatively work on a painted background (fabric) which could be stitched on →	
Analysis	Explore the way in which different leaf shapes/colours can be worked together. Investigate the way plants entwine - how we can show a complicated group of plants some behind others.	Begin to explore elements of sketches - experiment with enlarging, reducing - play with photocopied images (Twisted tangles of roots e.g.) Colours & pattern of river pebbles underwater.	applied fabrics. Mount on card which has been painted to continue the scene. (see work of V. Warren) Use a combination of fabric & thread techniques to interpret a wild wood scene from studies.	Using analytical drawings of leaves/plants to create a plaque of entwined foliage.
Communication	Using the characters in the Wind in the Willows design a wardrobe of clothes which reflects the animals characters. (Toad wouldn't be a gardener!) Design a boat for gnomes. (Another cypher & alphabets.)			Make a 3D ceramic map of imaginary country based on stories read.
Expression	Using description of gnomes disguise as friend & draw them as one!	Using a limited ink palette use preliminary drawings to develop more frightening tree shapes for the wild wood. Interpret quotes from Little Grey Men (see drawing & painting)	Create a fabric 'habitat' for the creature invented → to live in.	From description in the book & other personal ideas make a model of Toadhall. After looking at freshwater insects/invertebrates designs make an unusual creature.
Resources	Drawing media - to include pens & ink. First hand experience imperative! Support with good case specimens, reference, collected objects.	Don't forget work of art - particularly to support painting style & storytelling	Keep materials simple. Possibly introduce spray backgrounds & painted grounds. Experiment with dyes.	Artefacts, objects, photographs, maps - ancient & modern. Wind in the Willows - Little Grey Men.

EXAMPLE 3

EXAMPLE 3

'New and worn' – a Year 7 project, Dawlish School

Jean Coombe *Head of Expressive Arts Department*

An art project for 11/12-year-olds in which careful thought is given to the balance between looking, thinking and making skills.

This project is built upon a balance of the three elements that constitute the nature of the art process – the conceptual, the operational and the synthetic. It takes into account the developing characteristics of the pupils involved and contains a sequence of appropriate activities which are rooted in real and direct experience, and which lead to imaginative and expressive response. The use of 'visual source material' is an important feature of the project, as is 'looking and talking' (as a defining,clarifying, reinforcing and questioning etc. agent).

The broad aims of the project are:

1 to give pupils the opportunity to confront their environment through observation, articulation, manipulation, analysis etc., and in so doing build a deeper understanding of it and a firmer relationship with it;

2 to encourage personal statements about the environment, and in so doing liberate and give worth to the feeling response and uniqueness of the individual pupil, so that his/her understanding of himself/herself as a person of worth in that environment is underlined.

'New and worn' Session 1

1 Class discussion based upon the 'worn' parts of various objects – saddle, pipe, spoon, nail, boot. Objects handled freely, spontaneous comments encouraged. A lot of very close investigation – using lenses to magnify and isolate. Various questions inserted to direct the looking and generate specific channels of thought:

 Why do objects change?

 Do they change in the same way?

 Do they change at the same speed?

Specific references to the objects being handled.

Fig. 1.1 Photographs used in the initial display to stimulate observation and discussion about the difference between things that are new and those that are worn or decayed.

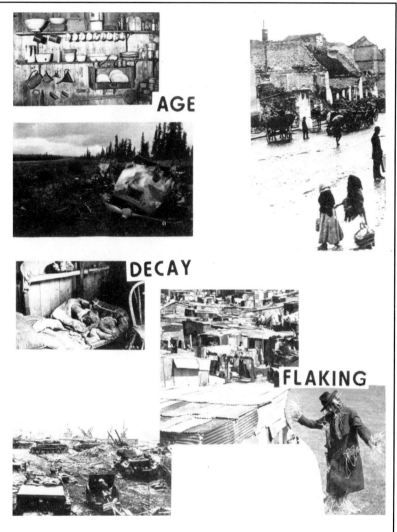

2 Drawing activity based upon selected worn object – part or all of it – lenses and viewfinders used to isolate, magnify and to underline the scrutiny required.

3 Session ended with reference to a large board of photographs and words – all related to aspects of worn objects. Emphasis made through matching word (tattered/ torn/crumbling/gnarled etc.) and image. Discussion. Homework set – collection of photographs and objects.

Session 2
1 Investigation through looking and class discussion of homework photographs added to the board with words, objects added to the collection.

EXAMPLE 3

Fig. 1.2 Nail.

Fig. 1.3 Bicycle pedal.

Fig. 1.4 Horse shoe.

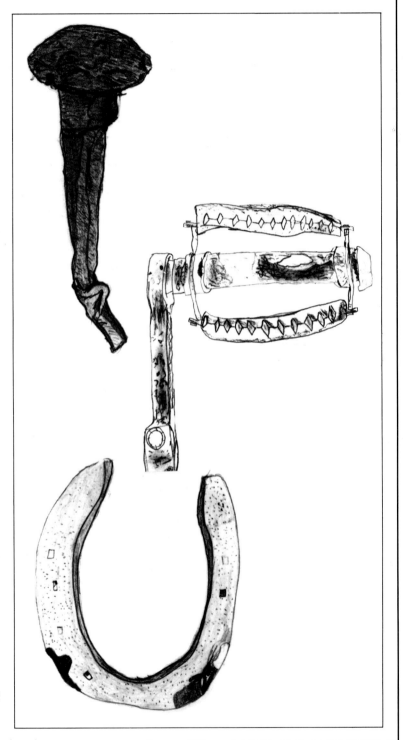

Detailed studies in pencil of eroded objects collected by the children. The children were asked to make drawings which described carefully just how and where each of the objects had been most eroded by time or weather.

2 Drawing activity of the previous session continued. Some children now wanting to start again – this time using their own object.

3 Class discussion based upon drawings made and upon old buildings known to the children. Homework set as the previous week, with photographs of old ruined buildings added.

Session 3

1 Discussion of collected homework, with focus particularly upon the photographs of buildings. Reference to a display of photographs showing buildings ruined by various forces.

2 Children asked to select a building photograph from the display (mounted on card), or to use their own, to scrutinise/ investigate it – using lenses and viewfinders – to isolate the most interesting part and to draw it. Homework collections continued.

Sessions 4 and 5

Continued drawings with much emphasis upon looking and accuracy. The viewfinders became keyholes or binoculars or windows, through which the observer kept a close watch – becoming an investigator . . . with an eye for detail! Homework – rubbings of various surfaces.

Sessions 6 and 7

Discussion of homework. Locations and quality of marks and patterns. Paint mixing exercise – focus upon secondary and tertiary mixtures, upon different textural qualities and upon old, decaying, worn colours.

Sessions 8, 9 and 10

Paintings – children required to make a painting of an old or crumbling building seen or remembered or invented. Emphasis upon creating an 'atmosphere' of decay.

EXAMPLE 3

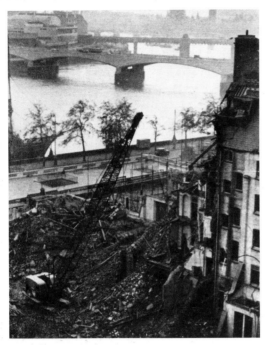

Fig. 1.5 Using view finders to make detailed studies from photographs of derelict and ruined buildings. The children were asked to imagine that they were sheltering from a raid or natural disaster and were recording what they could see from their hiding place.

Fig. 1.6 Group colour studies of 'old' colours – working from objects and resources collected by the children.

Fig. 1.7 (top)

Fig. 1.8 (bottom)

*Paintings of decaying and
ruined buildings – based
both upon observation and
recollection of
environments known to
the children.*

EXAMPLE 4

EXAMPLE 4

The domains for work in art and design

The Secondary Examinations Council

Draft grade criteria for the assessment of work in Art and Design for GCSE.

**Domain A:
The Conceptual Domain**

This domain is concerned with the formation and development of concepts and ideas in art and design. Such development can be systematic or intuitive, but will always involve a creative and imaginative response to an idea, theme, subject or task. This will include the ability to develop imaginative work as well as working from direct experience. The formation and development of ideas and concepts may be shown through the production of supporting studies or be made explicit in a realised piece of work. This domain relates to candidates demonstrating the ability to:

> observe, select, interpret and record personal responses to first hand experience.
> select and use reference and resource materials as a means of forming concepts and developing ideas.

**Domain B:
The Productive Domain**

This domain is concerned with the ability to select, control and use the formal elements (e.g. form, tone, line, colour) of art and design in the realisation of ideas, feelings and intentions. The handling of such elements should be seen in relation to the candidate's functional or expressive objectives. It is important to emphasise that it is acceptable for candidates either to specialise in or to provide evidence of activities in a range of media, techniques and processes. This domain requires candidates to demonstrate the ability to:

> select, use and compose the formal elements of art and design in the systematic, intuitive or expressive ordering of ideas, feelings and intentions.

**Domain C:
The Contextual and
Critical Domain**

This domain is concerned with those aspects of art and design which enable candidates to express ideas and insights which reflect a developing awareness of their own work and that of

others. Candidates should show evidence of their knowledge and understanding of the differing contexts in which work may be produced (e.g. historical, social, cultural, technological) and a developing ability to make informed critical judgements. Candidates can provide evidence of their engagements in these aspects in a variety of ways: through their own practical work as well as by using other visual, written and oral forms of response. Candidates will need to develop an appropriate vocabulary to enable them to participate in these activities. This domain relates to candidates demonstrating the ability to:

Provide evidence of their knowledge of contexts and evidence of understanding through analysis and interpretation. Candidates also provide evidence of their ability to make critical judgements about their own work and that of others.

2 THE NATIONAL CURRICULUM IN ART

The National Curriculum

The National Curriculum was established in principle, and almost completed, by the Conservative Government of 1987–92. The Final Orders for Art, Music and Physical Education were placed before parliament just before its dissolution in March 1992! The roots of the National Curriculum lay within a speech made by a Labour Prime Minister, James Callaghan, at Ruskin College Oxford in 1976. That speech led to a long-running debate about the state of education in schools in England and Wales and a growing public awareness and concern about the very significant differences in achievement and opportunity that children were granted from school to school.

Whatever the debate about the changes that have been imposed upon the management and curriculum of schools over the past decade, there has been consistent support across all shades of public opinion in support of a National Curriculum that might go some way towards ensuring a degree of continuity, consistency and progression in the education of children as they progress from teacher to teacher and from school to school.

The National Curriculum has been established principally to ensure progression and continuity in the teaching of the basic subjects to children from the ages of 5 to 16, and to reduce the amount of clutter, overlap and repetition that has characterised much teaching in schools. It has not been unknown for children to 'do' the Romans and to make a 'colour wheel' several times between the ages of 5 and 12 and for the content of much of their teaching to be determined by a teacher's whim rather than by the children's needs.

It has been very evident, not least within the teaching of art and design, that the quality and content of subject teaching has varied considerably from school to school. Many children have been fortunate if the teaching they have received from year to year in art and design has built upon and extended what has gone before.

The development of the National Curriculum has had, of course, that significant and additional political agenda that is concerned with the relationship between the quality of a country's educational provision and its economic performance.

These factors have all contributed to the structure of the National Curriculum and to the way that it has been shaped and put in place in schools.

National Curriculum structure

The advent of the National Curriculum has accelerated the development of a common core curriculum for all schools, where all children receive much the same pattern of subject teaching in Key Stages 1 and 2 (years 1 to 6) and Key Stage 3 (years 7 to 9). The initial intention that there should be a common curriculum in Key Stage 4 (years 10 and 11) has been somewhat diluted by pressure of time and continuing political debate about subject values.

All children are now taught the three *Core* subjects of English, Mathematics and Science, and six of the seven *Foundation* subjects throughout Key Stages 1, 2 and 3 (a Modern Foreign Language is introduced in Key Stage 3). They have to maintain work in Key Stage 4 in the three Core subjects to GCSE accreditation, and in the extended core of Technology, a Modern Foreign Language and Physical Education. In Key Stage 4 they have to work in the Humanitites in either History or Geography or in a combination of these disciplines.

Art and Music are now optional in Key Stage 4, although a considerable proportion of schools do require all children to choose to work in one of the 'aesthetic' subjects. The pattern of option and course choices is discussed further in the following chapter 'Structure and sequence'.

During the establishment of the National Curriculum, there was a major public debate about the presence of the arts in the curriculum and about their curriculum relationship. This was generated mainly through concern amongst drama educators, because Drama and Dance were subsumed within the programmes of study for English and Physical Education respectively. There was an attempt to have the separate disciplines of Art, Music, Drama and Dance subsumed within the general title of 'Expressive Arts' and for them to be regarded as a holistic group of subjects that could be taught in partnership. There was, however, no great enthusiasm for this view amongst art and music educators and, eventually, a recognition that whatever their common purpose in celebrating and communicating ideas and meaning publicly, the disciplines were so distinct as to have to be taught as discrete areas of experience.

There has been some considerable debate amongst art educators about the effect of National Curriculum implementation upon the nature and status of art teaching in schools.

The requirement that art should be taught consistently and systematically in Key Stages 1, 2 and 3 has been widely welcomed as this will eventually ensure that all children will receive a nine-year programme of art teaching between the ages of 5 and 14. It will obviously take time and some considerable in-service support to primary schools to put these programmes effectively in place but, by the turn of the century, they should have generated a significant improvement in the overall quality of experience that children receive in their art education in these nine years.

Many art educators were disappointed that the original intention to have art as part of the common core of work for all children throughout their schooling was eventually abandoned, as it became increasingly obvious that it was not possible to maintain the teaching of all the National Curriculum subjects at a level of credibility in Key Stage 4 in the time available in the normal school day.

Others have taken the view that they would rather maintain rigorous courses in Key Stage 4 for those children committed to, and motivated by, art and design, rather than to have to teach all children a more diluted programme of studies.

There has also been some persistent questioning about whether the nature and purpose of art and design teaching would have to change radically by being required to conform to that subject structure determined by National Curriculum principles.

National Curriculum subject structure

All the subjects in the National Curriculum have been structured to the same pattern. The Subject Working Groups commissioned to undertake the initial enquiry, to determine the subject content and to present their reports to the Secretary of State for Education, were required to work to a common brief and to identify and detail the following aspects of each subject:

Attainment Targets for each subject which are determined by the nature of the subject and provide a framework within which it should be taught.

Programmes of study which detail that which should be taught in order that the Attainment Targets can be met.

End of Key Stage statements which describe what children should be able to achieve within the subject discipline by the end of Key Stage (at ages 7, 11, 14 and 16).

Level statements which provide descriptive criteria for measuring children's achievements in each Attainment Target and on a reporting scale of 1 to 10.

It can be readily assumed from the above description that the design of the National Curriculum is assessment-led, and that its principal purpose is to provide a framework for assessing and reporting upon children's progress in each of the subject discipline.

Within this framework, each of the subject Working Groups prepared its Interim and Final reports with proposals for the shape and structure of the subject and its teaching. These were subject to a pattern of national consultation and this in turn had a bearing upon what was determined by the Secretary of State to be the Final Orders for the subject and which then became, in effect, the National Curriculum for that subject to be taught in every school.

The Art Working Group

The Art Working Group, which was chaired by Professor Colin Renfrew, one of this country's most distinguished archaeologists and Master of Jesus College, Cambridge, began its work in September 1990. The Final Report, *Art for Ages 5 to 14* was published in August 1991, and after the period of consultation and somewhat acrimonious debate with the then Secretary of State for Education, the Final Orders were published to schools in June 1992.

The Art Working Group, like all other subject working groups, contained some experienced educators in the subject field, balanced by others experienced in education and those with interest in art and design through their professional life and work including, for example, two critics, one artist and an industrialist.

In the initial stages of its work, it reviewed the current state of play in the teaching of art and design in primary and secondary schools, visited schools and colleges and took evidence and advice from those concerned with teaching art and design at all levels in education.

Through its membership, the Working Group also reviewed the current literature concerned with the theory and practice of art and design education in order to identify such frameworks that could serve to determine the structure of the attainment targets for art. It also identified a number of key issues that had to be addressed in order to put in place an art and design curriculum that both mirrored good practice and was accessible to, and could be delivered by, the majority of schools.

Progression

What kind of progression children make in their work in art and design is determined by the way that the content of teaching they receive is matched to their developing perceptions of the world and the way that they record them.

Good progression from Key Stage 1 to Key Stage 2 depends upon teachers' understanding of the transition that children make from recording their experiences symbolically in their drawing and painting towards wanting and needing to record their experiences descriptively. This progression is discussed in more detail in the following chapter. Where this progression is not properly understood in the teaching of art in primary schools it will result in children being set inappropriate tasks in Key Stage 2, a decline in confidence in their making of images and artefacts, and the consequence that in many schools children are painting and drawing better at the age of seven than they are at the age of ten!

In the National Curriculum proposals this imbalance is addressed by requiring that children should be taught to make use of experiences from observation, from memory and from the imagination from the beginning of their schooling, and through detailing those elements of visual language that need to be addressed and taught in order to give them that experience and confidence to make images and artefacts in response to different kinds of experience.

In time, and as the National Curriculum is put in place, this will result in children having a more consistent pattern of experiences in their art education in Key Stages 1 and 2, and this will enable teachers in secondary schools to be more

ambitious and demanding in the tasks they set at the beginning of Key Stage 3.

Having such a varied background of experiences in art and design, many teachers working with children in years 7 and 8 tend at present to pitch their expectations too low and to set them such undemanding and remedial tasks as making routine colour wheels!

When you are working with children in years 7 and 8 you should begin your planning for Key Stage 3 projects by looking at the Programmes of Study for Key Stage 2 and making sure that the work at least matches the National Curriculum expectations for work at this stage.

In the past, and in too many schools, the pattern of work in Key Stage 3 has been determined too much by a lack of knowledge about what has gone before, and by the assumption that what takes place in years 7, 8 and 9 is merely preparation for the more serious business of the GCSE courses in Key Stage 4. The National Curriculum does establish expectations and patterns of work for Key Stage 2 that should enable better progression to take place from primary to secondary schools. It should also ensure that work in Key Stage 3 is ambitious and demanding enough to make the experience worthwhile in its own right, irrespective of whether the children choose to continue their studies in art and design.

The balance between making and understanding

The Final Report from the Art Working Group generated considerable discussion about the balance between teaching children to make art and helping them to understand the purpose of their making.

It was generally perceived that the making of images and artefacts was a significantly dominant factor in the work of the majority of primary and secondary schools. In many primary schools, making was undertaken without much preliminary investigation and drawing. In many secondary schools there were few opportunities for children to review or reflect upon their work in Key Stage 3, although recent developments in GCSE courses have given this aspect of pupils' work a higher profile in Key Stage 4.

Through the examination of good practice in both primary and secondary schools, it was evident that there is a strong correlation between good investigation and good making, and that quality making is achieved through understanding formulated from the rigorous investigation of different experiences. Where children are encouraged to explore a variety of natural, made and environmental resources, then they are able to acquire that knowledge and understanding about their experiences that enables them to translate these effectively into making images and artefacts in different media. This principle led to the initial proposals for a separate Attainment Target to be called 'Investigating' and for the presence of two key strands concerned with investigating in the Final Orders.

The use of investigation and resources is discussed in detail in Chapter 4 'Teaching Strategies and Resources'.

There was a similar recognition that children's understanding of what they have made and its purpose is enhanced through their being given opportunities to review their work, and that it is particularly important for the habit of review to be encouraged early in their schooling. In Key Stages 1 and 2, children's work is all too often accepted enthusiastically and uncritically by the teacher, whatever their response to the task, and this can all too easily lead to their devaluing their own achievements in art and design. Similarly in Key Stage 3, pressures of time may inhibit teachers from giving space for discussion and review of what has been achieved in any session.

The National Curriculum does emphasise the importance of giving children time to reflect upon their intentions and achievements in making their work, in the knowledge that this will contribute significantly to their understanding of the scope, purpose and possibilities of their making and will affect the quality of future work.

Making art in context

In framing the National Curriculum in Art, account has been taken of important developments over the past decade in the use of critical and contextual studies in support of children's making of art in schools. These have been generated through Rod Taylor's work at the Drumcroon Centre in Wigan and through the recent 'Critical and Contextual Studies' research project sponsored by the Arts and Crafts Councils. These developments have gone some way towards establishing the value to teachers of using the work of artists, craftsworkers and designers in support of their teaching and towards helping children to understand the possibilities in making images and artefacts.

It is now much more common practice for teachers in both primary and secondary schools to recognise the practical value to children of using the work of other artists as reference and resource material for their own work. As in their language work, where they will recognise the possibilities of language through reading the work of other story-tellers and poets, children can be both stimulated and challenged through familiarity with the work of other artists and designers. They can learn much about the technical possibilities of painting through studying the work of other painters, and can better understand the expressive possibilities of imagery through seeing how different artists respond to and interpret familiar subject matter and themes.

In the National Curriculum these aspects of art teaching have been incorporated in the key strand that requires children to be familiar enough with other artists' systems and methods to use them to inform their own work.

A newer dimension for many teachers will be the requirement that children should be given some understanding of the social, cultural and historical context within which art is made. They can then appreciate that art is made and used for different purposes and within different contexts, and that these in turn will be influenced by the time, place and culture within which the work was made.

This was certainly the most controversial of the proposals in the Final Report from the Art Working Group, and one which generated considerable concern amongst teachers, both because of its resourcing implications and because it was implicitly requiring children to have more knowledge about the life and work of artists whose work they might use. There were also those who argued that this knowledge of the context of art was essential to childrens' understanding of the work they were referring to and using, and would help them to understand the full significance of art and design as a major social and cultural activity within all civilisations.

This argument was further exaccerbated by the changes imposed upon both the Art and Music Working Groups' proposals by the National Curriculum Council in the Draft Final Orders. These stipulated that there should be an additional key strand in the Attainment Targets for Art and Music concerned specifically with historical knowledge about the work of artists and musicians, with an emphasis upon the study of particular periods and movements within the European cultural tradition. This proposal triggered off a long and acrimonious public debate between art and music educators, the National Curriculum Council and the Secretary of State for Education. Although the NCC proposals were softened and made more general in the Final Orders, there still remains that unnecessary and additional strand of enquiry to satisfy the conservative view that, in the teaching of art and design, knowledge about art of the past is more important than its making in the present!

The Attainment Targets for art in the National Curriculum

In *Art for Ages 5 to 14*, the Art Working Group recommended a model of three Attainment Targets for the National Curriculum in Art that mirrored closely the three domain structure proposed by the Art Committee of the Schools Examinations Council in the late 1980's and which is detailed in Example 4 in the previous chapter.

Their reasoning was described as follows:

'Through Attainment Target 1 (Understanding) pupils will begin to appreciate the methods and approaches of artists, craftsworkers and designers and use them to inform and enrich their own work. They will recognise that there are different kinds of art made for different purposes. They will compare and contrast work undertaken in different cultures and contexts and evaluate how these influence meaning and interpretation.

Through Attainment Target 2 (Making) pupils will develop the practical skills and knowledge which will enable them to express ideas, feelings and meanings. They will acquire skills by working with a range of materials, tools and techniques and the visual language of art, craft and design. They will work individually and collaboratively, on a small and large scale and in various dimensions. They will talk about their work and review and modify it in the light of discussion.

Through Attainment Target 3 (Investigating) pupils will learn to be visually perceptive and to visualise ideas. They will observe, record and form ideas for their own work from direct experience of the natural and made environment, as well as from memory and imagination. They will also be able to use a wide range of reference materials to clarify and develop ideas for their work'.

The Working Group also proposed that there should be two key strands to each Attainment Target. These would form the basis for the design of the Programmes of Study and the End of Key Stage Statements.

The Key Strands are described as follows:

Investigating

Observe and record, make connections and form ideas by working from direct experience, memory and imagination to develop visual perception.

Visualise ideas by collecting and using a wide range of reference materials.

Making

Develop skills and express ideas, feelings and meanings by working with materials, tools, techniques and the visual language of art, craft and design.

Review and modify own work in relation to intentions.

Understanding

Respond practically and imaginatively to the work of artists, craftsworkers and designers.

Explore art, craft and design in a wide historical and cultural context.

In the process of consultation that took place following publication of the Final Report, this attainment target model was approved by the vast majority of those responding to the proposals from the Art Working Group. It did not, however, satisfy the Secretary of State for Education, who was seeking to reduce the number of Attainment Targets in the National Curriculum subjects in response to public concern about the weight of testing at the end of each key stage. The National Curriculum Council was instructed to reduce the number of Attainment Targets for both Art and Music from three to two. This was achieved by placing the proposed Attainment Targets and four key strands for Investigating and Making together to make Attainment Target 1: Investigating and making, and by adding the additional 'Knowledge' strand to those existing for 'Understanding' to make a new Attainment Target 2: Knowledge and understanding.

In the Final orders for Art the Attainment Targets are described as follows:

Attainment Target 1: Investigating and making
The development of visual perception and the skills associated with investigating and making in art, craft and design.

Attainment Target 2: Knowledge and understanding
The development of visual literacy, and knowledge and understanding of art, craft and design including the history of art, our diverse artistic heritage and a variety of other artistic traditions, together with the ability to make practical connections between this and the pupil's own work.

The Attainment Targets are now weighted two to one in favour of Attainment Target 1. These changes imposed upon the Art Working Group's proposals have resulted in the conversion of three simple Attainment Targets into two more complex ones and this, together with the imposition of a key strand devoted to the history of art, have made

the Attainment Targets for art more complex than was either necessary or desired by the majority of art and design educators.

Ironically, and in a fit of Celtic independence, the Secretary of State for Wales decided to retain the original proposals from both the Art and Music Working Groups, and we now have National Curricula in Art for England and Wales that have different Attainment Targets, although the Programmes of Study are broadly similar.

The diagram below shows the relationship between the English and the Welsh versions.

Differences between Attainment Targets for England and Wales

England

AT1 Investigating and making

AT2 Knowledge and understanding

Wales

AT1 Understanding

AT2 Making

AT3 Investigating

The Programmes of Study for Art in England and Wales are virtually identical other than for the additional 'Knowledge' strand in AT2 Knowledge and Understanding (England). The different Attainment Target structures mean that the programmes of study are differently ordered and numbered. Their relationship is shown below.

England		Wales	
AT1	Investigating and making	AT2	Investigating
1a		3a	
1b		3b	
		AT2	Making
1c		2a	
		2b	
1d		2c	
AT2	Knowledge and understanding	AT1	Understanding
2a			
2b		1b	
2c		1a	

The Programmes of Study

The Programmes of Study for Art outline what should be taught to enable the Attainment Targets to be met at the end of each Key Stage. In the Final Orders for Art, they are set out to show how they relate to the four key strands in AT1 and the three key strands in AT2. Each of the seven strands of work has an End of Key Stage Statement which summarises what children should be able to achieve in their work in art. The Programmes of Study for that strand of work describe what needs to be taught within that Key Stage. For example, the Programmes of Study for the two 'Investigating' strands of AT1 in Key Stage 2 are set out as follows:

End of Key Stage Statements

By the end of Key Stage 2, pupils should be able to:

(a) communicate ideas and feelings in visual form based on what they observe, remember and imagine.

(b) develop an idea or theme for their work, drawing on visual and other sources, and discuss their methods.

Programme of Study

Pupils should:

(i) select and record images from first hand observation.

(ii) respond to memory and imagination using a range of media.

(iii) use a sketch book to record observations and ideas.

(iv) experiment with ideas suggested by different source materials and explain how they have used them to develop their work.

These Statements of Attainment and their associated Programmes of Study describe what an eleven-year-old should have achieved and should have been taught by the end of Key Stage 2 in order to be able to 'investigate' effectively.

Since the majority of children transfer from primary to secondary schools at the age of eleven, the End of Key Stage Statements for Key Stage 2 will serve as a good common starting point for teachers of art and design in secondary schools to

begin planning their work for Key Stage 3, and could be a useful framework for planning work in Year 7.

The End of Key Stage Statements for Key Stages 2 and 3 are set out below to illustrate what kind of progression might be achieved in the teaching of art in the first three years of secondary schooling.

The full Programmes of Study for Art in the National Curriculum are included as an Appendix at the end of this Chapter.

End of Key Stage Statements

AT1 Investigating and making

Key Stage 2	Key Stage 3
(a) Communicate ideas and feelings in visual form based on what they observe, remember and imagine.	Use expressive and technical skills to analyse and present in visual form what they observe, remember and imagine.
(b) Use a range of items they have collected and organised as a basis for their work and talk about what they have done.	Develop and sustain a chosen idea or theme in their work, investigating and explaining their use of a range of visual and other sources.
(c) Work practically and imaginatively with a variety of materials, exploring the elements of art and design.	Apply a broad understanding of the elements of art and the characteristics of materials, tools and techniques to implement their ideas.
(d) Implement simple change in their work in the light of progress made.	Modify their work as it progresses, reviewing its development and explain the reasons for change.

AT2 Knowledge and understanding

Key Stage 2	Key Stage 3
(a) Recognise different kinds of art and their purposes.	Identify the conventions used by artists and assess critically their effects.
(b) Begin to identify the characteristics of art in a variety of genres from different periods, cultures and traditions showing some knowledge of the related historical background.	Demonstrate a knowledge and understanding of the principle features and our artistic heritage and appreciate a variety of other artistic traditions.
(c) Make imaginative use in their own work of a developing knowledge of the work of other artists.	Apply imaginatively the methods and approaches of other artists in the presentation of their own ideas and feelings.

The Programmes of Study should serve as a framework for planning the scope of your work with children. The general requirements are unlikely to inhibit the character and diversity of work that is such a distinguishing feature of the overall pattern of art and design teaching in this country.

In each Key Stage, children should be taught to work in painting and drawing, in both two and three-dimensional design and on a variety of scales. They will need to be taught to understand and appreciate the work of other artists, craftsworkers and designers working in a variety of times and cultures. These general requirements allow considerable diversity in the range of practice from school to school, and allow teachers to continue to base their work on the personal disciplines that motivate good teaching.

The Attainment Targets and Programmes of Study, by their very nature will need to be used holistically. It is almost impossible to separate the Programmes of Study and to teach them in isolation, since the teaching of every familiar activity in art and design involves different combinations of Programmes of Study. Work may well be rooted in one of the two Attainment Targets, but almost any activity can begin within one or the other. The making of a self-portrait, for example, can begin in AT1 through direct observation of the self in a mirror, or in AT2 through discussion about and consideration of the way that self-portraits have been made by other artists.

Even in such a routine activity as teaching Year 7 children basic colour perception and making you could well be involving them in the following

kinds of work and Programmes of Study from Key Stage 3 during the course of a half-term project:

AT1 (i)	observing and recording colour from first-hand experience.
AT1 (iii)	collecting and organising colour resources.
AT1 (v)	experimenting with different pigments and grounds.
AT1 (vi)	using colour to create different kinds of effects.
AT1 (ix)	researching the sources for the names of colours.
AT2 (ii)	assessing different artist's use of colour.
AT2 (v)	studying and using other artists colour methods and systems.

Putting the National Curriculum in place

It will take some considerable time to put the National Curriculum in Art in place. Those five-year-old children who start their schooling in September 1992 will be the first to undertake the full nine years of the Programmes of Study in Art, and will not complete the programme until the year 2001. Those secondary school children who start Year 7 in September 1992 will not take the new GCSE examinations that develop from the National Curriculum programmes in art until 1997!

Initially it will make sense for those teachers working with children in primary schools in Key Stage 2 (ages 7 to 11) to make sure that they have

in place the Programmes of Study for Key Stage 1, and for teachers in secondary schools to look to Key Stage 2 as the basis for developing their work with children in Key Stage 3.

As in all new curriculum developments, like the introduction of GCSE in 1986, it will be necessary to begin by placing existing practice alongside the requirements of the new art curriculum to see what you already have in place. The seven key strands of work that determine the End of Key Stage Statements and the Programmes of Study will serve as an essential monitor for existing practice. By comparing these with the balance and range of work in your own school or department you can quickly and easily identify where you are satisfying national curriculum requirements and where you will need to make changes and introduce new developments.

You will need to keep a checklist of the different kinds of activities and processes required by the National Curriculum in order to be able to review and monitor the presence and balance of these within the school year and across the key stage. Example 1 'Checklist of art and design activities and processes' provides one model for undertaking this kind of review.

In planning art and design projects, you will now need to keep a record of the Attainment Targets and Programmes of Study being addressed within each project (as in the colour-making example above), to ensure that the Attainment Targets are being addressed in balance within the year and across the Key Stage.

You will also need to put in place a pattern of assessment and appraisal of children's work which relates to the Attainment Targets for Art and which will be determined by the End of Key Stage Statements for each of the seven key strands of activity. The practice and procedures for assessment are dealt with in some detail in Chapter 10 'Record keeping and assessment'.

EXAMPLE 1

EXAMPLE 1

A checklist of art and design activities and processes

Shirley Page and Philip Creek *Advisory Teachers for Art, Devon*

A checklist designed for use on in-service courses to familiarise teachers with the main activities and processes in art that are required within the National Curriculum.

Attainment Target 1: Investigating and making

Investigating Draw from direct experience of the natural and made world.

Draw from memory and imagination.

Select and use reference and resource materials.

Making Use a range of materials, tools and techniques in painting and in 2- and 3-dimensional design.

Explore and use a range of visual elements:
colour
line and tone
pattern and surface
shape and form

Reviewing Talk about own work and that of others. Use an art vocabulary.

Attainment Target 2: Knowledge and understanding

Use other artists' systems and methods to inform their own work.

Know about different kinds of work and how and why it is made.

Understand and appreciate work from different times, places and cultures.

APPENDIX: The Programmes of Study for Key Stages 2 and 3

Key Stage 2

Attainment Target 1: Investigating and making

The development of visual perception and the skills associated with investigating and making in art, craft and design.

Programme of study (relating to Attainment Target 1).

End of Key Stage Statements

By the end of Key Stage 2, pupils should be able to:

a) communicate ideas and feelings in visual form based on what they observe, remember and imagine.

b) develop an idea or theme for their work, drawing on visual and other sources, and discuss their methods.

c) experiment with and apply their knowledge of the elements of art, choosing appropriate media.

d) modify their work in the light of its development and their original intentions.

Programme of Study

Pupils should:

i) select and record images and ideas from first-hand observation.

ii) respond to memory and imagination using a range of media.

iii) Use a sketch-book to record observations and ideas.

iv) experiment with ideas suggested by different source materials and explain how they have used them to develop their work.

v) apply their knowledge and experience of different materials, tools and techniques, using them experimentally and expressively.

vi) experiment with different qualities of line and tone in making images.

vii) apply the principles of colour mixing in making various kinds of images.

viii) experiment with pattern and texture in designing and making images and artefacts.

ix) experiment with ways of representing shape, form and space.

x) plan and make three-dimensional structures using various materials and for a variety of purposes.

xi) adapt or modify their work in order to realise their ideas and explain and justify the changes they have made.

xii) use a developing specialist vocabulary to describe their work and what it means.

Attainment Target 2: Knowledge and understanding

The development of visual literacy and knowledge and understanding of art, craft and design including the history of art, our diverse artistic heritage and a variety of other artistic traditions, together with the ability to make practical connections between this and pupils' own work.

Programme of study (relating to Attainment Target 2).

End of Key Stage Statements

By the end of Key Stage 2, pupils should be able to:

a) identify different kinds of art and their purposes.

b) begin to identify the characteristics of art in a variety of genres from different periods, cultures and traditions, showing some knowledge of the related historical background.

c) make imaginative use in their own work of a developing knowledge of the work of other artists.

Programme of Study

Pupils should:

i) compare the different purposes of familiar visual forms and discuss their findings with their teachers and peers.

ii) understand and use subject-specific terms such as landscape, still-life, mural.

iii) look at and discuss art from early, Renaissance and later periods in order to start to understand the way in which art has developed and the contribution of influential artists or groups of artists to that development.

iv) identify and compare some of the methods and materials that artists use.

v) experiment with some of the methods and approaches used by other artists, and use these imaginatively to inform their own work.

Key Stage 3

Attainment Target 1: Investigating and making

The development of visual perception and the skills associated with investigating and making in art, craft and design.

Programme of study (relating to Attainment Target 1).

End of Key Stage Statements

By the end of Key Stage 3, pupils should be able to:

a) use expressive and technical skills to analyse and present in visual form what they observe, remember and imagine.

Programme of Study

Pupils should:

i) develop skills for analysing and recording from observation, memory and imagination, using a variety of media.

ii) keep a sketch-book to collect and record information and ideas for independent work.

b) develop and sustain a chosen idea or theme in their work, investigating and explaining their use of a range of visual and other sources.

iii) select and organise a range of source material to stimulate and develop ideas or themes.

iv) discuss the impact of source material on the development of their work.

c) apply a broad understanding of the elements of art and the characteristics of materials, tools and techniques to implement their ideas.

v) use a wide range of media and techniques to realise their ideas, express feelings and communicate meaning.

vi) select from the range of visual elements and interpret their use in making images and artefacts.

vii) explore and experiment with materials, images and ideas for three-dimensional work, and realise their intentions.

d) modify their work as it progresses, reviewing its development and meaning and explain the reasons for change.

viii) modify and refine their work as the result of continuing and informed discussion.

ix) discuss their work using a specialist vocabulary.

x) plan and make further developments in response to their own and others' evaluations.

Attainment Target 2: Knowledge and understanding

The development of visual literacy and knowledge and understanding of art, craft and design including the history of art, our diverse artistic heritage and a variety of other artistic traditions, together with the ability to make practical connections between this and pupils' own work.

Programme of study (relating to Attainment Target 2).

End of Key Stage Statements

By the end of Key Stage 3, pupils should be able to:

a) identify the conventions used by artists and assess critically their effect.

Programme of Study

Pupils should:

i) explore the diverse ways that artists working in different cultures produce images, symbols and objects, recognising the main codes and conventions used to convey meaning.

b) demonstrate a knowledge and understanding of the principal features of our artistic heritage and appreciate a variety of other artistic traditions.

ii) express opinions about and justify preferences for different kinds of art, taking account of different viewpoints.

iii) develop an understanding of art taken from the following periods: Classical and Medieval, Renaissance, post-Renaissance, nineteenth century and twentieth century.

iv) analyse the work of influential artists who exemplify (iii) above and assess the contributions they have made.

c) apply imaginatively the methods and approaches of other artists in the presentation of their own ideas and feelings.

v) use a knowledge of the methods and approaches used by artists and an understanding of the reasons for the artists' choice to enrich their own work.

3 STRUCTURE AND SEQUENCE

Influences upon the structure of art education in schools

Now that the National Curriculum for Art is in place, it will provide an established framework within which you and your colleagues will have to determine the pattern of art and design teaching in your school over the next decade. As with the introduction of GCSE in 1986, when for the first time there were established common criteria for the teaching of art within examination courses, with the introduction of the National Curriculum you will have to review your current practice in the light of the new requirements. You will have to consider how you can best use the National Curriculum model within your own Department, and what kind of structure and sequence of work will have to be put in place to make it effective.

In addition, there are a number of other factors that will influence the pattern and structure of your work:

1 The changing needs of the children themselves taking account of their perceptual development and of the shifts and changes that take place in their making and use of images;

2 The organisation of the school, both in the detail of its timetabling and in the overall development from a general education for all children towards a core programme plus options;

3 In the organisation of the art department, the deployment and use of teachers with different skills and interests and the way that this will influence both the sequence and pattern of work the children experience.

We shall look at each of these in turn.

The needs of children

In their years of schooling, between the ages of five and sixteen, children go through three different stages in their perception and understanding of the world. These transitions have a profound influence upon their visual perception of the world and need to be understood in order that teachers can properly match their work to the needs of the children.

Although we are mainly concerned here with the teaching of children in middle and secondary schools, it is useful for the specialist teachers of art to have some knowledge of the route by which the children have passed to them. This is particularly crucial to the planning of work for children in their first year in secondary schooling.

Until the age of six or seven, children are not able to analyse their response to the environment. Their drawing has little reference to formal or traditional forms of visual expression, nor are they confused by the differences between the images they make and those that they see about them. They happily kaleidoscope time, space and scale in one drawing, and it is this very quality that gives the work of young children the vitality and quality of expression that begins to wane as they begin to develop the ability to handle the formal tools of communication. As soon as they are able to convey their thoughts, ideas and feelings through the written and spoken word, the emotive drive to communicate through visual means begins to wind down, simply because it can be satisfied in other ways. At the same time, children begin to develop the ability to see and respond to the world independently of their feelings. They become more objective, more aware of existing visual forms and images and the apparent authority of

those forms, and more aware of the complexity of the visual environment and the problem of interpreting the 'real' world. They become more conscious of the differences between the images they make and those that surround them.

The point at which children recognise that the drawings and images they make have public consequences is a crucial one. It is the point at which children begin to compare and relate their drawings both to the real world and to all those other images of the real world that surround them in pictures and photographs, and in film and television.

Between the ages of nine and thirteen, children's image-making is dominated by their need to use drawing, painting and three-dimensional modelling as the means to comprehend better how the world works, how it is put together, what it looks like, how different things compare etc. Through their work in art they can seek better understanding and control of those complex factors that make up the natural and man-made world.

It is here that the teacher needs to begin to support the children's desire to make 'real' images in very positive ways and to provide the source materials, resources, help in looking and focusing that will encourage children to begin to investigate and to communicate through their drawings, as well as to use them as vehicles for personal and imaginative response.

Many secondary school art departments receive children from a large number of primary schools, with considerable variation between schools in the quality of experience and the children have been given in this use of visual enquiry to investigate the real world. In many primary schools, and especially those where the work in art is closely linked to work in environmental studies and science, the children may have been given a rich experience in the use of drawing and painting as a means of investigating the real world. In others, the children's work in art may have been almost totally divorced from investigation of the real world and to have consisted of a mixed diet of copying and painting 'imaginative' pictures.

Teachers in secondary schools should have some knowledge and understanding of the work in art in their serving primary schools, otherwise they may not be able to gauge properly the general level of experience the children may bring with them to the secondary school. It does not make any kind of sense for the programme of work in an art department in a secondary school to be based upon the assumption that the children's art education begins here! When at the age of eleven children arrive in their secondary schools, they have already been painting, drawing and making artefacts for the best part of six years. That experience, of whatever kind, has to be built upon and used, otherwise the notion of sequence is totally denied and programmes of work in the first year of secondary schooling may considerably underestimate the qualities and understanding that many children may have already achieved through their work in art in the primary schools.

It will take some time for the National Curriculum to have an impact upon the structure and content of the teaching of Art in Key Stage 2 in primary schools, but its introduction should result in a more consistent practice between schools. It will also establish clear expectations of what should be taught to children in their art lessons in Key Stage 2, and therefore give you a clearer picture of the base from which you should be working with children when they come to you in Year 7.

As children approach adolescence, the function of art education becomes more complex. The young adults become increasingly sensitive to their own personal relationships with other people, and to their own social environment. In their early teens, children go through a period of change and adjustment accompanied by all those uncertainties and doubts which can profoundly affect their response to, and use of, images. Frequently, they are no longer satisfied with the making of images that simply describe their experience. They become aware for the first time that an image can express things that have meaning over and above simple description – that real images can have ambiguity of meaning and an emotional context that has personal significance.

This requires the art teachers working with

13/14-year-olds in the secondary school to make adjustments in their teaching. Art teachers frequently refer to the difficulties of teaching Year 9 pupils in secondary schools and may assume that the problem is only one of social and personal adjustment post-puberty. Just as the good primary school teacher will take account of the 8-year-old's desire to describe the real world, and will adjust the balance of work accordingly away from story telling and towards description, the specialist art teacher in the secondary school needs to re-think the context of the art curriculum in this second stage of transition.

'Please, Miss, I can't draw' is a familiar 8-year-old cry. It doesn't mean that 8-year-olds can't draw; it simply means that the teacher is setting them drawing tasks impossible for 8-year-olds. 8-year-olds are demonstrably very good at drawing simple and interesting things of which they have real and direct experience. When 13/14-year-olds express an equivalent uncertainty – perhaps rather more subtly than the above cry – it is some indication that you may need to re-think the context of some of your work with them.

At the root of the adolescents' uncertainty is a concern to use their imagery to say things that have more personal meaning. This need can be met through some adjustment in the content of your work with them and with more focus upon the various ways that the experiences and skills developed in the first two years in secondary school can be used to support this desire to make images and artefacts that have personal meaning. The various means by which expressive work can be strengthened and supported are dealt with in succeeding chapters.

The influence of the organisation of the school

The way in which art can be taught to children, and its pattern and sequence, are significantly influenced by the way that schools are organised. The majority of children in this country transfer from primary to secondary school at the age of eleven. In making that transfer they move from one very different kind of school to another.

In their last year in the primary school they will spend at least 75 per cent of their time with one teacher; in their first year in the secondary school they will be taught by at least ten different teachers, and in some schools that operate rotational systems within departments or faculties they may be taught by as many as twenty different teachers in one year. In the majority of primary schools the use of time is fluid; in secondary schools time is tabled in units ranging from 30 minutes to one hour. In primary schools the single teacher of each class allows for much closer links to be established between different areas of the curriculum; in secondary schools these links are much more tenuous, even when art is timetabled in association with other subjects in aesthetic or practical groupings.

As a result, children have to make a considerable adjustment to the way that they learn through art or any other subject. In many primary schools, and especially in those where visual enquiry is a major element of the children's work in environmental studies and science, the children will actually spend a great deal more of their time in drawing, painting and model-making than they can do in the secondary school, where the allocation of time is likely to be between 60 and 90 minutes in each week.

A blindingly obvious question is, 'How do you as an art teacher take account of this in thinking about the work of Year 7?'

It is important to know something about the normal pattern of work in art and craft in primary schools, in order that your own syllabus or programme of work begins to make some kind of sense in sequence to what has gone before. Ideally this should be done by visiting at least some of your serving primary schools, to familiarise yourself with the experience the children may bring with them to the secondary school.

The introduction of the National Curriculum with its emphasis upon continuity from key stage to key stage, does bring with it useful opportunities for consultation with colleagues in primary schools about how such progression can be established. Many heads of art departments have

already begun such liason through a variety of means:

by visiting and teaching groups of children in local primary schools.

by involving their department in those 'experience' days when Year 6 children from local primary schools spend time at the end of the summer term in their 'new' school and having experience of working in different departments.

by arranging for the exchange of exhibitions of work between their own school and local primary schools.

by providing in-service support to teachers in local primary schools (see Chapter 8, Example 1).

Key Stage 3: Years 7, 8 and 9

In the majority of schools, art is timetabled as a separate subject throughout the first three years of secondary schooling (Years 7, 8 and 9) for an average of 70 minutes per week. In many schools, art is block timetabled in faculty groupings with either technological subjects or other arts (these arrangements are discussed further in Chapters 8 and 9). The use of block timetabling can be supportive to art and design where it allows time to be used more flexibly or allows art to be taught to smaller classes or tutor-based groups. It may be a disadvantage where it results in setting up a carousel or rotational system of teaching the subjects block timetabled together, with consequent effect upon their continuity.

In Years 10 and 11 art becomes an optional subject. It remains a popular option, with between 40 and 45 per cent of children choosing to continue with their work in art, which the majority of those going on to take external examinations. However, this means that for the majority of children in secondary schools, the work of the first three years is the sum total of their art education. We cannot therefore assume that these three years mainly serve in the purpose of preliminary training for the more serious work of Years 10 and 11. The case for art in the first three years has to rest firmly upon its value to all children.

Within the context of this general three-year course for all children, you have to decide on the skills of looking, perceiving, making and understanding that are necessary to all children within art and how these complement, strengthen and extend their learning.

A general course in art does not necessarily mean a generalised pattern of activities continuing for three years. The experiences and skills essential to the 11-year-old who has just come up from primary school are very different to those of the awkward adolescent of fourteen. The work of the first three years should consist of a continuous experience in art, where regular and weekly sessions are used to match the developing skills and changing perceptions of children from the ages of eleven to fourteen. This general course has to be telescoped into 40 sessions a year and about 50 hours of teaching. It has to be taught in week by week units and within larger units of terms and half terms. This requires both an efficient use of time and a real regard for maintaining continuity from week to week, from term to term and from year to year.

Example 1, 'The organisation of work in Years 7 and 8' is an extract from an Art Department Handbook in which careful thought is given to the transition from primary to secondary school, to continuity of work in the first two years of secondary schooling, and to the pattern of work that best supports these changes.

The Attainment Targets and the Programmes of Study for Art in Key Stage 3, as described in the previous chapter, provide a framework for your work with children in these first three years. You will have to use this framework to determine the content of your work: what needs to be taught; how much of that all too limited time should be spent on each aspect of the work; how you maintain a balance between the key strands of investigating, making and understanding; and in what order and sequence the experience should be provided.

In their planning of these three-year general courses, many art teachers find it useful to use flow charts and diagrams as a means of identifying

and giving structure to the pattern of work from year to year. The head of department has to find the right balance between providing enough structure to ensure a comparable experience for all children and allowing individual teachers some room for manoeuvre and the opportunity to make particular use of their own individual skills and interests.

It seems sensible to insist that children should all follow a similar programme of work for at least the first two years. Even with the most generous timetabling, the children will only have about 100 hours of working time in the studios over these two years, and this time will have to be well used to ensure that the children acquire the basic skills of drawing and painting, some experience in at least two craft areas and sufficient time for a good supporting programme of discussion and appraisal.

There is a strong case for allowing some variations in Year 9, on two grounds. The first has has already been referred to in noting the changes that take place in children's perceptions of themselves and others as they pass through puberty, and their consequent need to use their image-making more individually and personally. That need can be catered for within the general programme of work, through the gradual introduction of longer working projects within which considerable personal interpretation is both encouraged and allowed.

The need for a more individual programme of work in Year 9 also stems from the fact that for the majority of children this is their final year of work in the art department. They do need therefore to have had some opportunity to pursue in greater depth ideas and areas of work that are particularly satisfying to them. The motivation for this may be triggered off by particular ideas, or by certain materials for which they have a particular affinity. Where the work of the first two years is carefully monitored and properly assessed, it should be possible for the art staff to help children identify which aspects of work in the department they could best focus upon during the third year. Where are they most confident, which materials do they most enjoy using, with which resource materials

do they find the most affinity, and to what kinds of content do they best relate?

The three-year general course will be fully successful only where it provides both a satisfying and useful experience for all children, and a good grounding for those who wish to pursue further their studies in art.

Example 2, 'Teaching processes in art and design', shows how in one school the pattern of work is determined both by the need to give children experience of working through different kinds of processes and by making good use of the balance of teaching skills within the department. In each year, the children work in different areas such as sculpture, painting, textiles and graphics, and in each area there is focus upon such different working methods and processes as designing, researching, analysing and responding expressively. This ensures that the children receive a good balance of experience in Key Stage 3 whichever combination of teachers they work with across these first three years.

Key Stage 4: Years 10 and 11

The place of specialised courses in art and design in Years 10 and 11, leading to external examinations at 16 plus, remains secure. The introduction of GCSE in the late 1980s has had a major impact upon the pattern of work in art in Years 10 and 11 over the past few years. Quite apart from introducing common criteria for work in art and design which have to be observed by all the Examination Boards, it has also led to the introduction of more rigorous courses in art and design, as demonstrated in Example 4 in the previous chapter. The new criteria for GCSE courses has established content where much more weight is given to a quality of investigation and research that generates the good making of images and artefacts. More emphasis is placed upon related work in critical studies, through which children can become more informed about their own work through the study of the work of other artists, craftsworkers and designers. Because there is a parallel between these developments in the new GCSE examinations

and the structure of the new National Curriculum in Art, most competent teachers of art and design should find little difficulty in making that transition from existing courses to the new programmes of study for art in Key Stage 4.

Art and design continues to be one of the most popular option subjects at 14 plus with an average of 40 per cent of all children choosing to pursue their studies in art and design in Key Stage 4. Much of its strength rests within the character of the subject, in that it is one of the few curriculum areas that allow children the opportunity for reflection upon their experiences and because it offers equal opportunities of achievement to children of very differing abilities.

Art does not exclude children who have worthy things to offer but who cannot surmount the often narrow and artificial barriers erected against them in other subjects. Although art teachers are often irritable about the fact that they have to cope with more than their fair share of what their colleagues may define as unmotivated and less able pupils, they can take some comfort from the fact that this is as much a reflection upon the inadequacies of other subject teachers to cope with the normal range of children as it is a description of art as being a dumping ground for the less able. There is no doubt that many art teachers are able to achieve high levels of motivation and response from children who have been conspicuously rejected by other subject teachers. This says a great deal for the value of art education in schools.

What access children have to art and design courses in Key Stage 4 depends upon the option system in operation in your school. Over the past decade there has been a significant movement towards establishing a core or 'entitlement' curriculum for all children, initially through developments within the Technical and Vocational Education Initiatives programme and more recently because the National Curriculum itself has necessarily imposed upon schools a common core programme of studies for all.

Art departments appear to fare better where the art staff have given careful thought to the range of courses that they might offer to children in Years 10 and 11, and have begun to recognise that the description of 'art' as one generalised kind of activity is not enough to meet the varied needs of 15/16-year-olds.

In Key Stage 4 all children now have to take the core subjects of English, Mathematics and Science to GCSE level. They have to continue with work in Technology and Modern Languages, and though not necessarily to the level of GCSE accreditation, in practice the majority of children will probably do so. In most schools, it is now common practice for all children to also work in one of the Humanities in Key Stage 4 and to have a choice either within the Arts or within that group of subjects related to Technology, including art and design. In addition to this core of around 80 per cent of curriculum time, there may be a further choice of one or two subjects in an extended core which allows the choice of a second language or humanities subject, further choices within the Arts and Technology, or the opportunity to work in some of those subjects that are not within the National Curriculum.

In the average-sized school, this means that children can choose to work in art and design in the option bands related to the Arts and Technology and there may be a second choice of option in the extended core.

The advent of GCSE, with its pattern of endorsed (specialised) and unendorsed (general) courses in art and design, has in recent years accelerated the move towards offering a choice of art and design courses in Key Stage 4. Smaller schools may offer a general course covering a range of art and design disciplines, and perhaps one endorsed course in painting and drawing or one of the design disciplines, depending upon the expertise within the department. Some large departments will offer a general course plus other courses where there are opportunities to specialise in Fine Art, Textiles, Graphic Design, Three-dimensional Design or Photography. It is generally true that option levels for art and design tend to be higher in those departments offering a wide range of courses in Key Stage 4.

Where either the size of the department or the

option system do not allow you to offer a variety of courses within your art department, it is possible to go some way towards this where Year 10 and 11 groups are block timetabled together. When two or three Year 10 groups are working at the same time within the department, it makes obvious sense to try to match the different skills and interests of the different art teachers to the needs and interests of the children. In some departments, this is achieved by providing a common programme of work for the first two terms of Year 10, and by then grouping the children according to their interests with the art teacher who can best match these. Where the programme of work in Years 7, 8 and 9 has been designed to give the children comparable experiences, so that they enter Year 10 on a roughly equal footing, it is not difficult to plan a common programme of projects for them and to use that experience to assess the kind of course that would then be best for them to follow.

In one school this is managed through the block timetabling of three art groups together. During the first term and a half of Year 10, all the children work through the same series of four or five project themes, spending an equal amount of time in the painting, graphics and ceramics studios. In consultation with the staff, they then decide which of the three courses available in the three studios they will follow. An important element in the success of this programme is in the design of the projects they follow, the rigorous application of deadlines for completion of work and the group presentation and assessment of the children's work at the end of each project.

Where your department has the advantage of block timetabling, there are a variety of ways in which the early work in Year 10 can be used diagnostically to ensure that children are helped in sorting out the pattern of work that is most appropriate for them.

The organisation of children's learning in secondary schools by subject divisions does inevitably lead to argument between teachers, and sometimes conflict, as to how best to share out the precious little time that is available. This is fairly straightforward in the first three years, where there is a general consensus that all children should have much the same spread of experience across a range of subjects. It becomes more complex at the upper end of the school, where subject choice is influenced partly by ability within the subject, partly by the children's liking for the subject and significantly by the children's (and their parents') thinking about future education and work intentions. When at option time art comes onto the open market, the success of a department may depend upon how well its work is understood by colleagues, children and their parents. The more your colleagues and the parents know about the value of art – both its general value to the development and under-standing of children and the specific values of the skills and insights it offers – the more likely you are to recruit a genuine cross-section of children to work in the department. Although many of these values are self-evident in the children's work, they can be reinforced through the way the children's work is presented and explained, through exhibitions, through the way in which courses are described and explained in the school's handbook and within option systems etc.

In many schools the move towards a common core curriculum, and with it an entitlement to take both aesthetic and technical subjects through to the end of compulsory schooling, has resulted in a strengthening of the place of art and design in Key Stage 4. This is particularly true in schools where art departments have had the range of expertise to offer courses that span the aesthetic/technical divide within both these areas of entitlement.

Many art and design departments have made good use of the opportunities to contribute to the technological and vocational initiatives (TVEI) in schools that have been presented in recent years. Good use has been made of TVEI funding through the development of City and Guilds courses, courses for the Certificate of Pre-Vocational Education and, more recently, the introduction into schools of B.TEC First Certificates as preparation for entering into Further Education. Much of this work, where art departments have taught design-

based modules in a variety of design-based disciplines, will serve as useful experience for the development of combined art and technology courses that are likely to emerge in future years as alternative courses in Key Stage 4.

Where schools have an aesthetic entitlement, with all children required to work in one of the arts disciplines in Key Stage 4, and where there has been the choice of working in such disciplines as art and design, textiles, music, drama, dance or media studies, this has generally led to an increase in the number of children opting to work in art and design.

At the other extreme, and in response to those pressures on time created by the National Curriculum requirements, some schools have established modular courses in the arts in Key Stage 4. These require children to continue working across a range of arts subjects, but with such a poor allocation of time that children have received only a minimum amount of experience in each, and consequently given little opportunity to develop work in the arts of any real quality.

It is necessary for art to remain within a core of aesthetic studies for all children until their leaving school. It is equally necessary that children are given opportunities for work in such depth, within their chosen expressive subject, that they have sufficient time and opportunity to acquire the skills and ways of working that enable them to use their art with confidence and meaning.

The relationship between art and design and the other aesthetic and technological subjects is explored further in Chapter 8, 'Craft, design and technology' and in Chapter 9, 'Art and other subjects'.

Effective use of staff

There has been a general increase in the size of art departments over the past two decades corresponding to the increasing size of schools. Most art departments will now have at least three members of staff, many will be much bigger. Where art departments are grouped in faculties with other subjects, the art staff may well be operating within a unit of up to twenty teachers. This has led to an increasing prevalence in the appointment of specialists within art departments – to teach ceramics, graphic design, textiles etc. The average department today probably consists of three art teachers, at least two of whom will have the responsibility for dealing with one aspect of the department's work. These factors do mean that careful attention has to be given to the way that art teachers with different skills and interests are used within a department, and to ensure that between them they provide a programme of work that makes for some kind of sense and balance for the children.

The National Curriculum now requires that in each Key Stage children should have a basic grounding in drawing and painting, opportunities to work in both two- and three-dimensional design, and a coherent, supporting programme of work in critical studies. It is not always enough to assume that a simple rotation of the children between different teachers provides a satisfactory solution to the problem of offering a balanced programme of work, and one that also ensures some sequence of experience from one activity to another. The models of art experience described in Chapter 1 suggest that a balanced programme of work is more determined by the different modes of enquiry that are possible and essential within art and craft, rather than by the classification of art experience through a division into skills and materials. It is obvious enough that almost any of the materials through which we work with children will allow for a variety of ways of experiencing and responding. The art teacher who works with children mainly through the medium of clay is providing one kind of experience where the making is determined by the acquisition of certain skills, and quite another where clay is regarded as being an ideal medium in which to draw three-dimensionally.

Example 2 illustrates one way of achieving a balance of experiences for children as they pass from one teacher to another.

Where children within an art department are being taught by different teachers during the

school year, the question of sequence is equally important to that of balance. Especially bearing in mind the limited amount of time that children have in their general programme of art and craft teaching, it is more than essential to ensure that as they pass from teacher to teacher, or from year to year, they are given experience and skills that build one upon the other and which avoid repetition. This places a very real responsibility upon the head of department to ensure that the departmental syllabus serves more purpose than simply providing general guidelines which individual teachers are then allowed to 'interpret' in their own way. This can all too easily lead to needless repetition of skills teaching, exploration of concepts and even of content.

Teachers in different circumstances use various ploys to ensure some balance and continuity within the work of their department or school. In many primary schools, where the curriculum leader for art has to provide both a framework within which non-specialist colleagues can work and detailed guidance as to the delivery of the art teaching in Key Stages 1 and 2, it is common practice for the staff to use an agreed planning matrix as was illustrated in Example 2 in Chapter 1.

Example 3, 'Suggested planning sheet for art and craft', is similar to that in use in many primary schools. Teachers outline their proposals for work in art at the beginning of each term so that the curriculum leader can see what is happening across the school and can then consult with colleagues about its detail and delivery. It is now much more common practice for heads of art departments in secondary schools to use similar devices to monitor work across a department, and to ensure that there is both good balance within the work of a year group and continuity as the children move from teacher to teacher or from year to year.

Example 4, 'Planning sheet for coursework units', is used in one department both to forecast units of work with different groups of children in order to monitor the work across the department, and to give children themselves a clear picture of the expectations of them in each unit of work.

This use by teachers of a variety of teaching ploys in support of their work, combined with giving children access to a range of different kinds of source material, is an important element in providing a balanced programme of work within a department. The use of different teaching strategies and resources within art teaching is examined in greater detail in the next chapter.

EXAMPLE 1

EXAMPLE 1

The organisation of work in Years 7 and 8, Ivybridge School

Richard Dunn *Head of Art and Design Department*

Extracts from the Art and Design Department Handbook which illustrate how the transition from primary to secondary school and the balance of work in Years 7 and 8 are managed.

**Organisation –
Lower School**

The transfer from the junior school to the larger secondary sector is a big, and sometimes rather intimidating step for the incoming pupil. This period of acclimatisation influences both the organisation and the content of the Year 7 course. The emotional, physical and intellectual changes that occur within the first three years at secondary school can be enormous. Physical changes and the individual's role in his micro-society, his taste, manipulatory powers and aspirations can create a greater difference between Years 8 and 9 than occurs between Years 7 and 8. Taking these basic factors into account, the courses are organised as follows.

Years 7 and 8 are considered as very closely related units and, in order to establish appropriate corporate atmospheres and to assist relationships in stable units, each group has one art tutor for the whole year. When the group moves from 7 to 8 the tutor changes but the group remains the same. Each group therefore changes area with the teacher during its year-long course, rather than moving on a 'circus' at smaller timed intervals. The gradual introduction of increasingly complex concepts and experiences is seen as a continuum which accelerates as the child gets older, the main aims in these initial stages are:

(a) to acclimatise the child to his/her surroundings.
(b) to introduce a basic visual language.
(c) to encourage inventive thinking.
(d) to develop confidence in self and in alternative means of communication.
(e) to develop some skills in the use of a variety of materials and sequences.
(f) to experience working as a member of a team/group towards a common end.
(g) to begin to organise a personal method of analysing and solving visual problems.

Year 7

In Year 7 the child is subjected to not only a new, large environment, but also a new social role, new subject definitions, greater specialisation and, in effect, a different way of life to that previously experienced at junior school.

The initial bewilderment which can be caused in the individual in this foreign environment is something which, although perhaps quickly surmounted, can shape his subsequent approach and attitudes to his schooling.

The role of art in the junior school is sometimes more general than in the secondary sector. It can be seen as an intrinsic part of the cross-curricular project work that the junior sector does so well. It is taken as a useful part of life in an essentially visual culture and, as a result of its curricular universality, it is understood by the majority of children. In the secondary school it becomes an independent subject with its own separate time allowance. It can become merely illustrative and consequently frustrating to many of those children who feel that their imaging skills are below that of their peers, and a resultant disassociation can begin.

The Year 7 course contains considerable use of group investigation and discussion, and the 'universality' is drawn to the attention of all. The environment is used as a common point for experience and analysis, and structured investigations involving the introduction of various concepts are followed. By experiencing and observing certain phenomena we hope to enlarge and develop the process of analysis and eventual synthesis of observation, investigation, and conceptual realisation of each child. We also promote and encourage the need in individuals to explore, make comparisons, and manipulate materials, using the medium as a vehicle for individual expression, and enhancing the process of analysis as a means of establishing an understanding of the environment.

By the end of Year 7 it is expected that each pupil should be able to:

1 control a variety of basic mark-making and modelling materials.

2 draw with care and achieve a recognisable image.

3 explain aspects of his/her drawn images verbally.

4 be capable of working in a group or on his/her own, and when in the former, to be able to discuss relevant material appropriately and sensibly.

5 respect his/her own work and that of others.

EXAMPLE 1

6 respect the equipment and facilities of the department.

7 maintain a period of concentrated exploration appropriate to working within the area.

Year 8

Areas of experience, observation and expression still continue to be the core of the course. Line, tone, colour, texture, shape and form are still identified visually and conceptually with the work continuing to be project-based. The groupwork emphasis is gradually reduced with pupils encouraged to assert their own realisations and imagery. Emphasis continues to be placed on direct experience – constantly remembering that imagination is always based on what is known. Observation forms the core of the projected work with initial emphasis being placed upon the natural world and the man-made environment.

Projects are based on the ability to research and analyse information, and are encouraged to develop in, and through, diverse means of presentation. Set pieces may involve all pupils in similar research at the outset, but will also have a choice facility inbuilt in order that the pupil may choose in which order to tackle the investigation, and which subject choice to make.

As in Year 7, opportunities are constantly available for pupils to embark upon highly personalised, expressive work. Constant re-evaluation of the world, of experiences and phenomena is encouraged by staff through discussion as well as through the nature of the projects applied. The hoped-for sequence is usually: observation – investigation – analysis – re-examination – exploration/experiment – synthesis – representation – communication – evaluation.

By the end of Year 8 it is expected that each pupil will:

1 demonstrate an increased technical level of achievement.

2 demonstrate increased confidence in handling materials and processes.

3 demonstrate increased breadth of material awareness.

4 be able to sustain a course of study for increased periods of time.

5 demonstrate increasing levels of exploratory powers

6 be able to deal with increasingly complex concepts, and be able to identify appropriate methods to deal with them.

7 have increased ability to communicate verbally as well as visually when discussing his/her work.

EXAMPLE 2

The teaching processes in art and design, Lipson School, Plymouth

Christopher Killock *Head of Art and Design Department*

Extracts from the Art Department handbook:

Planning matrix for the balance of units of work in Key Stage 3.

Planning for Year 9 unit of work in sculpture, and teaching through the expressive process.

Syllabus framework In order to make these general aims central to our work as teachers, we have identified the teaching processes we think are most important and have incorporated them in our syllabus framework:

(a) *The design process* – observation, analysis, evaluation, proposed solution, testing and revision, i.e. problem solving.

(b) *Thematic enquiry* – through group or individual project work. Emphasis on personal organisation and research.

(c) *Concentrated visual research and analysis* – for a functional or expressive purpose.

(d) *Expressive response* – to a concept or experience. Unrestricted exploration and development.

Structured discussion and appraisal will form part of each process.

In the first four years each module will be linked to one of these four teaching processes. It is not intended that any process is linked specifically to one specialist area and it is important that the processes are seen as universal in their application. By the time pupils enter Year 11 they should have the experience and confidence to develop their own working methods.

EXAMPLE 2

Here is a chart showing the modules each child will be taught during Years 7 to 9 at Lipson School.

Module	1	2	3	4
Year 7	Sculpture	Pattern	Texture	Painting
Year 8	Painting (1)	Sculpture	Textiles	Painting (2)
Year 9	Sculpture	Textiles	Graphics	Painting

Year 9 **Sculpture**

Process: Expressive response

Aims: To combine a variety of clay building techniques, in particular clay modelling, with slab construction. If time allows, to introduce direct plaster application to armatures. To encourage a bold and direct response to these materials. To emphasise the importance of drawing in 3-D work. To link all this with an imaginative stimulus.

Description: Various drawing methods developed into three-dimensional work of two types: free construction and clay modelling.

Stages:

(1) Introduce the idea of movement – in the body, in machines, in animals. Historical place of speed in art. Movement in art, e.g. *The Rout of San Romano*, *Nude Descending a Staircase*, Futurists, Constructivism. Movement as dance, pose, balance. Expressive power of movement.

(2) Producing movement with a scrap lump of clay – producing shapes which seem to imply movement.

(3) Life drawing and quick poses to capture movement: (a) five-minute silhouettes; (b) five-minute straight-line 'slash' drawings; developed – using tone to reinforce movement.

(4) Using scrap wood and wire, cut into fine strips developing the slash drawings in 3-D. Using plaster or Polyfilla to serve the same function as tone in the drawings.

(5) Modelling of a body in clay. A figure jumping a wall, through a window, over a hurdle, etc.

Skills to be Assessed:

(1) *Observation skills* – various types of life drawing. Skills of recall – a particular pose as significant.

(2) *Technical skills* – construction and modelling skills. Handling drawing loosely, yet with purpose.

(3) *Critical skills* – understanding the wide range of the project. Seeing the point of the 'slash' drawings as a way of analysing movement. Understanding the use of works of art.

(4) *Design skills* – being aware of the development of an idea through various stages.

(5) *Skills in communicating ideas and emotions* – ability to see the potential of materials. Ability to emphasise movement through selection.

(6) *Social skills* – ability to work at a quick pace. Ability to join in structured discussion.

EXAMPLE 3

EXAMPLE 3

Suggested planning sheet for art and craft, Glen Park
Primary School, Plympton

Helen Stokes

Planning sheet used in a primary school to enable the
curriculum leader to monitor work being undertaken by
teachers with different class groups in Key Stages 1 and 2.

Example of planning for a Year 3 project on the theme of
'Gardens'.

Suggested planning sheet for art/craft

AGE RANGE:	THEME:		Materials to be used	Group size	Check List
RESOURCES/DISPLAY	DRAWING:				
	(INVESTIGATIONS RELATED TO ABOVE)	PAINTING			
		2D DESIGN			
		3D DESIGN			
		CLAYWORK			

ADDITIONAL COMMENTS/ASSESSMENT

EXAMPLE 3

Example of a planning sheet for a first year junior project (Year 3)

AGE RANGE: 7-8 years	THEME: "Flowers in the Garden" part of a study of the school grounds	Materials to be used	Group size	Check List
RESOURCES/DISPLAY Collection of pictures/photos/paintings of garden plant/famous gardens	DRAWING: Close observations of plants from different view points. Use of magnifying glasses. Discussion about plant structure, size, colour, shape, petal arrangement	Crayons pencils charcoal, pastel variety of paper	6-8 at one time	✓
Purchase of bedding plants/hanging baskets	(INVESTIGATIONS RELATED TO ABOVE) Designing own hanging basket / PAINTING Matching/mixing shades of green large paintings of plants Use of different types of strokes	Poster paint powder paint Variety of brushes & papers	"	✓
Collection of display of flower pictures by famous artists, eg Van Gogh sunflowers	Collect fabrics, materials with appropriate colours. Plan design / 2D DESIGN Create imagery flowers A second design/drawing to predict how the flower may appear in the near future	Fabric/thread papers/beads seeds, glue	"	✓
Study layout of school garden	Discuss view of garden from above. Look at colours, size, shapes, shade texture. Use of viewfinder / 3D DESIGN Plans of garden using junk materials/building bricks Create a sculpture for the garden from natural wood	Junk materials Old branches	"	✓
Study plants in school garden; "plants which weren't planted by us"	Observation drawings of one plant with a wild flower / CLAYWORK Tile work based on wild flowers; emphasis on delicate lines, texture of leaves	Wood Clay; rollers/sticks/oddments	"	✓

ADDITIONAL COMMENTS/ASSESSMENT
This topic continued for a term so that an important aspect became "change within our garden" and lots of drawings were done to illustrate these which involved study of colour changes/size changes etc. - a rich source of interest

EXAMPLE 4

Planning sheet for coursework units, Combe Dean School, Plymstock

Peter Hall *Head of Art and Design Department*

Planning sheet for coursework units, used to monitor work in the department and to provide children with working briefs for the unit of work.

Example of planning for Year 7 project on the theme of 'Imagination and Fantasy'.

EXAMPLE 4

COOMBE DEAN ART COURSEWORK UNIT YEAR

NAME	Tutor

Date Set	Deadline

COURSEWORK UNIT

(Please write in these sections your intentions.)

ORGANISATION
Research and record

Development of ideas

Materials

COOMBE DEAN ART DEPARTMENT

Year 7 **Tutor Group** **Name**

UNIT OF WORK IMAGINATION AND FANTASY

RESPONDING - the imagination is as important to you as your ability to paint, draw, design and make objects. You will look at the work of artists who have used their strong imagination in their paintings: the Surrealists (Dali, Cocteau, Ernst, De Chirico), Magritte, Escher, Dadd, Breughel. What do you think of such paintings? Does it remind you of dreams and nightmares? Which of these paintings is closest to your own dreams? Which artist appeals to you most of all?
Notice that some artists can make an everyday situation seem strange by adding something unexpected. Which artists are particularly good at this?

GENERATING IDEAS - begin to collect at home photographs that show good use of imagination or fantasy. Also select photos of people involved in a variety of activities. Make notes of adverts on TV that make clever use of imagination. Can you think of a good story that you have read that makes use of fantasy? Make brief notes about the story.
Help us to collect a number of still-life objects that are connected by a theme. e.g. fruit, vegetables, cylindrical objects, round objects, objects of the same colour (red, blue, yellow etc.), stones and rocks, scrap wood, sand and seaweed/sea flotsam.
Pick out photographs of rooms. What could you add to this room to change the atmosphere? Try something unexpected like: a mirror that doesn't reflect or that turns to water; a door that leads to outer space; a wall that melts; a floor that is soft and rubbery; an apple that fills the room. Do not use ideas that are too jokey or silly, try to be subtle and clever.

MAKING - bring in to lessons all your studies, drawings, notes and your chosen still-life objects.
You will make a number of studies of the still-life using a variety of materials. Concentrate on shape, tone, texture and form. Having completed these drawings you will add one extra object that will deliberately change the scale of of the still-life e.g. a small toy soldier, a tiny doll, action-man, dolls' house furniture, toy trucks and cars, any small-sized model etc.
Place your "new'' object in with your still-life. Make a close-up view of the "new" object in its surroundings, so that, for example, parts of oranges become like huge, textured rocks OR round objects become small planets or moons. Notice what happens to scale and proportion.
Produce a painting based upon your research. Put together ideas from homework studies together with your classroom work. Look through your collection of photos and notes. Above all, use your imagination.

EXAMPLE 4

EVALUATING

Look back on the unit of work you have just completed and write your response to the following questions:

1) What kind of art work have you been looking at? What were the main things that you noticed about their work? Name some of the artists that you came across during this unit of work?

2) What are your opinions about the art work that you have been looking at? Did you like or dislike their work? Give an explanation.

3) In what century and decade were these art works produced?

4) Can you explain how looking at artists' work has helped you with this unit of work?

5) What do you think of your own response to this unit of work? Have you been successful in some areas? If so explain why and where? What do you think you could have done to achieve a higher mark?

6) Look at the list of words below. What new words, connected with this unit of work, have you learnt? Underline your "new" words.

ABSTRACTION (taking out small area), ANALYSE (to look closely at and study), COLOUR, FORM (a solid shape), COMPOSITION (the art of arranging objects, areas and people in a painting), HIGHLIGHTS, INVESTIGATION (to search and inquire), LINE, OBSERVATION (the act of seeing and noting), PATTERN, PERSPECTIVE, PLANE (surface on which object sits), REALISATION (to make real, to bring into being), RESEARCH (careful search of a topic), SHAPE (an objects' outline), SCALE & PROPORTION (the relation between the size of one object and another), SPACE (the gap between one object and another), TEXTURE (the feel or touch of a surface), TONE (tint or shade of a colour).

4 TEACHING STRATEGIES AND RESOURCES

Strategies and resources

As an art teacher, like any other teacher, you have available to you a variety of systems and resources that you can use in support of your work. The interplay between teaching systems and support material plays a very important part in determining both the quality of experience you provide for your children and the nature of their response.

Reference has already been made to the need to provide for children a rich variety of visual and personal experience in support of their programme of work in art. The art teacher who fills his room with interesting collections of natural and man-made things, good photographs and reproductions of works of art, and who directs the children's attention towards the environment that surrounds the school, is more than half way towards ensuring that the children have sufficient to feed the mind's eye.

Such basic visual provision as this can be made even more effective when the visual experiences are well matched to the variety of strategies that you can use to focus children's attention and to generate the quality of discourse and enquiry that is the hallmark of the really effective teacher.

Here is a list of the various teaching systems and resources that, when used in different combinations, will provide you with a variety of strategies in support of your work.

The use and allocation of time is an important supporting element to all these systems.

Systems	Resources
Telling them (exposition)	Images
Questioning	Natural things
(teacher-based)	Man-made things
Discussion	The environment
(teacher/child)	Places
Interaction (between	Events
children)	People
Enquiry (child-based)	The school
Tasks	Children
Writing – copying	Words
note-taking	Sounds
information	Music
collecting	Prose
Resource collecting	Poetry
Worksheets	Children's work
Questionnaires	Works of art
Doodling	Artists
Mark-making	Exhibitions
Image-collecting	etc.
Image-making	
etc.	

Talk and interaction

By far the most important system any teacher can use is that of generating enquiry through talk, whether through exposition, questioning, discussion or interaction. There is no doubt that there is a strong correlation between the quality of children's work in art and the amount and quality of discourse that both precedes and supports the work. There is very clear evidence for this, especially in the work that is done in many primary schools, where good class teachers who have had very little experience or training in art are able to generate work of considerable quality simply through their ability to focus children's observation and perception through good talk in support of their looking.

The use of good talk, discussion, questioning and interaction are essential for the key strand of Investigating in Attainment Target 1 of the National Curriculum in Art. Children's perceptions of their

world and of the possibilities of responding to it through making images and artefacts are considerably enhanced through the enquiry that good talk can generate.

The pressure of time upon the typical secondary school curriculum, and especially the division into 35- or 40-minute modules, does discourage some art teachers from making sufficient use of talk and appraisal in support of their work – a feeling perhaps that the children aren't working unless they are drawing or painting or making something! I have witnessed many art lessons where the teacher has used only a brief exposition to start the lesson and has relied entirely on individual tuition to maintain the children's enquiry. Other than when working with small groups of well motivated and older children, this is a very limited system of teaching and one that is ill suited to motivating and directing a group of 30 children, who may be with you for only an hour or so.

Instruction or exposition or 'telling them' has its place, especially in relation to demonstrating basic techniques or skills, or in simply setting out the map of the lesson. It always needs to be reinforced through questioning to make sure that what has been stated has been understood by the majority of the children in the group.

The use of questioning in association with looking is one of the most important and basic methods of teaching available to the art teacher. Children see as much through talk as they do through direct observation, and especially in a society where they spend a great deal of time viewing or scanning television (a very passive form of looking). A good teacher can help children to see more perceptively through good questioning and talk, and through this means can give them new perceptions of even the most mundane and familiar things.

The use of talk, and especially questioning in support of drawing, is dealt with in some detail in Chapter 5 'Teaching Drawing'. It makes sense to use questionnaires in association with looking, especially where the children are to work from their own individual source material and where you wish to retain the information over a period of

time for them to return to as work develops. Good questionnaires can be found in the Examples at the end of Chapter 5.

Questioning and questionnaires may be used for sharp focus upon particular detail of content. They can also be used more open-endedly to encourage surmise or speculation, as in the questionnaire which accompanies Example 1 at the end of this chapter. This project plan is usefully divided into three sections: teacher activity, pupil activity and resources/materials. Note the variety of teaching ploys and methods used in this project, which include exposition, questioning, filling in questionnaires, class discussion, group discussion, group collecting, interaction and role play, working in small groups, in pairs and individually.

This deliberate use of sub-groups and pairs of children is a most useful way to avoid questioning and discussion becoming too much dominated by the teacher or, as frequently happens, by the few most articulate children in the group. Also, children will respond much more confidently to an open class discussion when they have had the opportunity to share their observations and views within a smaller group first. This is particularly true of any attempt to generate appraisal by the children of their own work or of the work of others, where they are frequently inhibited by being asked to make general comment to the whole class.

It makes similar sense to use a variety of group sizes within the class for any work that is essential, and preliminary work to the making of individual images. The work can be in the form of note-taking, collecting information, collecting resources making experiments etc. as in any of the following:

writing down words which describe the object to be drawn;
comparing orally two or three very similar things;
collecting useful visual information or reference material from books or magazines;
making and mixing particular colours;
experimenting with materials to discover a range of tone, surface or pattern; observing visual phenomena; etc.

Figures 4.1 and 4.2 are written notes and technical experiments made by children in Year 7 in response to a questionnaire about the colours and textures they observed in houses near the school. In making and sharing these notes of their observations and experiments the children were becoming more perceptive, collectively, about familiar things in their environment.

Sharing this kind of work in groups makes better use of the time available than to require each individual child to repeat the same programme of work. Children can learn a great deal from each other, and their understanding of concepts is certainly strengthened when they work together in this way. Children will, for example, learn a great deal more about colour if they explore certain qualities of mixing and matching in small groups, rather than if they are each expected to make their own individual colour wheel or chart. Children also learn a great deal about visual phenomena through observing and talking about them, as well as by recording them in drawing and painting. When, for example, you embark upon a project dealing with one of those basic and essential concepts to do with colour, or perception of light, or the exploration of surface, it will help key the children into the concept if they are first asked to investigate the phenomenon through a combination of observation, talk and interaction.

Section 2 of Example 2 describes some initial

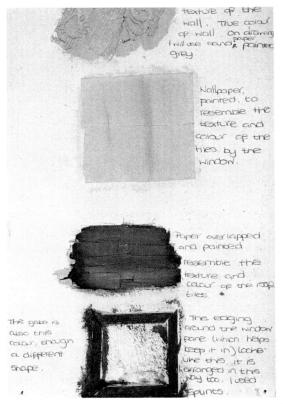
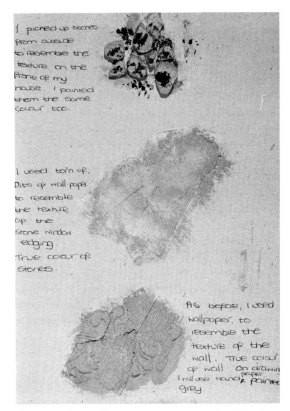

Figs 4.1 and 4.2 Collecting information; mixed media (16 × 14 cm). 11-year-olds, Eggbuckland School, Plymouth.
Collecting information about materials, colours and surfaces in buildings in the local environment as part of a combined art, design and technology project. Children were asked to research the range of colours and surfaces used to decorate buildings in the area.

activities that might usefully precede the more traditional means of observing and recording aspects of light and dark. This project, which can be used as the basis for anything up to a term's programme of work, has been designed to make full use of the variety of strategies and resources that can best strengthen and support children's understanding and use of the phenomenon of light.

Workcards and project sheets

Workcards and project sheets may be used for a variety of purposes in support of your work with children. They are useful where you need to provide children with technical information in support of a project or where you want to reinforce the teaching of different kinds of processes, as in drawing.

Example 3 is a worksheet used to reinforce a homework project and to remind children of some of the basic principles of making drawings from direct observation. Example 4 is of a drawing worksheet used to help and encourage children to examine in detail a drawing made by Samuel Palmer and to study the different ways in which he uses ink with both pen and brush in his work.

Worksheets are almost essential whenever you embark upon work where the children are likely to be widely scattered outside the studio. In these circumstances, it is very difficult to provide that individual tutorial support that is possible within the art room, and the children do need that detailed reminder of what they are seeking in the environment to encourage them in their studies. A simple instruction sheet can be used to help and remind children of the task in hand.

When you are taking children to visit museums and galleries to see exhibitions as part of their work in critical studies, it is essential to use well-designed worksheets in order to help them to focus upon particular works of art and related tasks within what may well be a complex exhibition. Examples of these are given in Chapter 7 'Understanding and using works of art and design'.

Worksheets may also be used to set the children fairly basic tasks as in Examples 5 and 6. These graphic design and communication worksheets work well because they set the children a manageable task through providing sufficient information and enough clues for them to pursue their work without constant support.

Worksheets can also be used to cope with the different speeds at which children work within the art room. In almost any project that you undertake with your children, you will find a proportion of the class finishing their task competently and well in advance of many of their fellow pupils. It is much more constructive to give those children who finish first additional tasks to work upon – such as those outlined in these worksheets – rather than to rush the slower workers towards an unsatisfactory conclusion, or to make them leave their work unfinished in order to keep pace with the others. The child who goes through a whole term without being given time to finish the bulk of his work is bound to feel frustration and dissatisfaction at his efforts.

Worksheets or project sheets can be more complex. They may be used to establish the pattern of work for a group and to make clear your expectations of the children in their work over a period of time. When starting a new project, it is always good practice to explain to the group the nature and scope of work to be undertaken, so that the children can understand the purpose of their preliminary investigations and drawings and what further work these will lead to. It can be frustrating for children if they do not know what their preliminary work is about or where a particular exercise may be leading!

Example 7 is a project sheet for Year 8. This is used in a department where every coursework unit is presented in this way so that the children have a clear view of the purpose of their work over the next few weeks.

Example 8 is a more complex project brief presented to students in Year 10, which sets out the purpose of their work, explains its theme, describes its possible outcomes and lists the research tasks and homeworks that will need to be undertaken in support of the work.

Homework

In Example 8, there is specific reference to the way in which homework can be used very positively to support the research that students in Year 10 are making in their exploration of the theme of 'Memories'. It is very important to make constructive use of homework time in your work with children. It is a requirement of the National Curriculum in Art that all children should keep and maintain notebooks and sketchbooks in support of their work and much of this enquiry can be undertaken through good use of homework time.

The advantages of using homework constructively are described in the Departmental Handbook for the Art and Design Department at Lipson School in Plymouth as follows:

Homework is important for these main reasons:

1 It can reinforce and extend class projects.
2 It is an opportunity for the child to work at home unaided.
3 Much of the work is based upon the child's home, and as such helps to develop fuller awareness and understanding of his/her immediate environment.
4 It helps develop patterns for the future with regard to effort and attitude to self-disciplined work and research.
5 It introduces the child to research and the ability to find and develop ideas by using resources other than the Art Room.
6 It is extra time above lessons to develop his/her abilities.

Bearing in mind the pressures upon time in most secondary schools, the structured use of homework simply to extend the amount of time that children have to practice the basic skills of looking and drawing can be most valuable. In Years 7 and 8, the emphasis is likely to be upon using the home and the local environment as source material and to encourage children to select and draw from that environment. Figures 4.3 to 4.5 are of homework drawings made by children in Year 7, of themselves, their feet and the view from a window at home.

The development of work in critical studies, and the requirement in Attainment Target 2 that children should acquire understanding and knowledge about the work of other artists and designers, will mean that homework time will need to be increasingly used for reading and research in this field. Example 9 is part of a project brief used with children in Year 7. It describes the three homework tasks set to children following their viewing of a slide/tape presentation about the work of Vincent Van Gogh.

In Years 9, 10 and 11, as teaching projects become more demanding of preliminary research and investigation, it would be logical to use homework increasingly as research time and for the pursuit and development of ideas.

Time, scale and tasks

The structuring and use of time is an important element in the teaching of art. Even allowing for the fact that children do work at very different speeds, there are occasions when you need to set specific time allocations for different kinds of work. This is particularly true of all that work that may be described as preliminary investigation. Examples 1 and 2 both illustrate the way that a particular lesson may be subdivided with time allocated to such different activities as class discussion, group discussion, note-taking, material exploration, observation of source material, interaction, making images etc.

Children respond well to being given clear guidance as to how much time they have for a particular task, and they enjoy the challenge, for example, of making six different kinds of drawing in one hour, or – in small groups – seeing how many colours they can make with three different colours in the space of fifteen minutes.

Almost anything you choose to ask the children to draw or paint is worthy of some kind of preliminary investigation. Even a pencil drawing of a simple object is best preceded by, say, five minutes of work in pairs to find ten words to describe it, five minutes to see how many different shades you can make with the pencil, five minutes

Figs 4.3 to 4.5 *Homework drawings; pencil. 11-year-olds, Notre Dame R.C. School, Plymouth. Drawings made for homework assignments made by children in Year 7.*

Fig. 4.3 Self-portrait.

Fig. 4.4 My foot.

Fig. 4.5 View from a window at home.

to practise drawing the shape, and then half an hour to make the drawing. The more complex the task, the more detailed needs to be the preliminary investigation.

Figures 4.6 and 4.7 illustrate the work from a class of 12-year-olds working on a theme of metamorphosis. In this project the time was allocated as follows:

15 minutes to practise the range of tone possible to achieve with 2B, 3B and 4B pencils;
20 minutes' talk about their own shoes;
30 minutes of practice drawings;
5 minutes' evaluation;
90 minutes to make careful shoe drawing;
15 minutes to make a tracing from original drawing;
30 minutes' discussion about how their shoes might change . . . into what kind of landscape or buildings;
30 minutes (homework) to make preliminary studies for metamorphosis;
20 minutes' evaluation of studies;
30 minutes practising colour mixing and shading with coloured pencils;
120 minutes to make the shoe/landscape drawings.

Figures 4.8 to 4.11 illustrate work by children in Years 5 and 6 in a primary school, exploring different aspects of themselves in preparation for making a self-portrait. In this project, the time they spent on different stages in the projects was as follows:

In the morning:

1 20 minutes discussion about differences in appearances between children in the group, and the use of identity kits in detective work to piece together the appearance of people.
2 10 minutes practice with pencils to revise use of different weights of line in a drawing.
3 30 minutes working in pairs and using mirrors to compare and make drawings of differences between each others' features such as eyebrows, eyes, noses, mouths, etc.

Fig. 4.6　Shoe drawings; pencil (24 × 20 cm).

Fig. 4.7　Metamorphosis of shoes into landscape; coloured pencils (34 × 27 cm). *These objective drawings of their own shoes were used by these children as the basis for a project on metamorphosis, where they were asked to change their shoe into a landscape or building. A good example of using objective drawing as the starting point for an expressive piece of work. 12-year olds, Heathcoat Middle School, Tiverton.*

Figs 4.8 to 4.11 *'Aspects of myself'. 10 and 11-year-olds; Stokenham Primary School. Work made by children in Years 5 and 6 as part of a self-portrait project.*

Fig. 4.8
Identikit
drawing; Pencil
(9 × 20 cm).

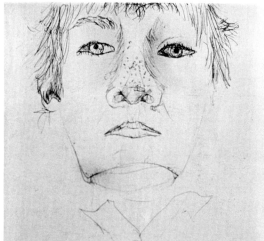

Fig. 4.9
Self-portrait in a
hand mirror;
ballpoint pen
(16 × 16 cm).

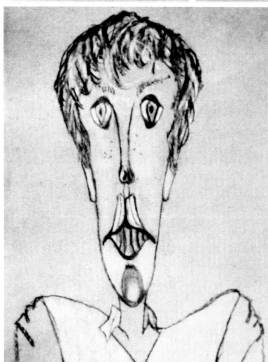

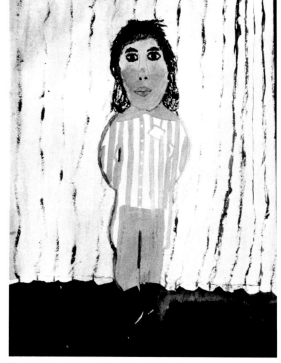

Fig. 4.10 Self-portrait in a spoon; chalk and charcoal (19 × 28 cm).

Fig. 4.11 Me at the Ice Rink; tempera (27 × 40 cm).

4 45 minutes making a drawing in ballpoint pen of themselves using a hand-mirror.

5 10 minutes discussion about how different they looked when viewing themselves reflected in a shiny spoon or hub cap.

6 10 minutes practice making tones with chalk and charcoal.

7 45 minutes making drawings of themselves reflected in a shiny surface.

8 10 minutes review of work so far.

In the afternoon:

1 30 minutes viewing and comparing six self-portraits made by other artists; establishing how, in a self-portrait, the artist both describes and comments upon his or her appearance and uses the setting and objects to help identify what kind of person they are.

2 30 minutes writing about how they might make their own self-portrait and what aspects of themselves they would emphasise.

3 60 minutes making preliminary notes and sketches for their self-portrait.

On the following day:

The whole morning to make paintings of their own self-portrait.

In addition to illustrating a good use of different strategies, ploys and resources, and emphasising the value of good investigation to making work, this description also emphasises the virtues of the flexible use of time that is possible in primary schools, where the class teacher is the sole arbiter of how time is managed to give children most benefit.

There are of course enormous advantages in trying to find within the school year such con-centrated periods of working time as described in the last project, especially with older children. In some authorities, this can be achieved through using residential centres – where a school can book in a group of children for up to a week at a time. In others, it is possible to organise local workshops for children from several schools when, especially during the latter part of the summer

term, it is possible to give children an opportunity for an intensive period of work in art without too much disruption to the normal school curriculum. Many children find the challenge of having to work in this kind of way most rewarding. The demands of having to pursue a particular idea or theme for several days does give them some notion of what it is like to study art in further or higher education, in addition to the advantage of being able to work uninterrupted by that wretched bell!

Figures 4.12 to 4.14 illustrate some of the work done by 15-year-olds in the East Devon area who attended a four-day workshop at the end of the summer term, when they spent the first two days working and making studies in various parts of the Royal Devon and Exeter Hospital before going on to develop these studies further in the studios at Exeter College of Art and Design.

When at the beginning of Year 10, children embark upon their two-year course leading towards an examination at 16-plus, it is necessary to give them some kind of preview of what the two-year course entails – how they might use their time and what alternative projects and kinds of work they need to cover. It is not enough to assume that now they have 'chosen' to do art the children are able to determine their own individual programmes of work. Although a minority may well have the ability and motivation to do this, the bulk of children still need some kind of structure to work to. Many heads of department have found it useful to provide an over-view of the two years' work by giving the children an outline or summary of those areas of work that have to be covered, what alternatives exist within the syllabus and what the deadlines are for completion of certain projects. Example 8 usefully spells out to the children in the school how they should use their homework and free study time over five terms, in order to strengthen their basic drawing skills across a range of different kinds of source material.

The variety of strategies you use in your teaching will make a considerable difference to the kind of response you receive from your children in the art room. It is all too easy for art

Fig. 4.12 Corridor with wheel chairs; mixed media (56 × 75 cm).

Fig. 4.13 Children's ward; mixed media (60 × 82 cm).

Fig. 4.14 Two wheel chairs; pencil and charcoal (56 × 72 cm).

Work by 15-year-olds resulting from the opportunity to work intensively for four days, when the first two days were spent working and making studies in the Royal Devon and Exeter Hospital, followed up by two days of studio work at Exeter College of Art and Design.

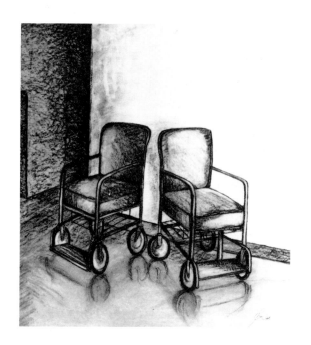

teaching, or any teaching for that matter, to become predictable. I well remember that tired old list of six 'titles' chalked on the blackboard each term by my own art teacher, and there are art rooms today where the only generator for the work is a predictable and dusty still-life group or a pile of magazines.

Good talk, genuine dialogue between teacher and child, discussion and interaction between children, real investigation – all these are hall-marks of good teaching in whatever subject. In the teaching of art they are as essential as the variety of visual resource material you will find in most art rooms.

Resources – range and access

The collection, organisation and use of resource material is an important part of your work as an art teacher. Every art teacher has to be a magpie – the kind of person who can't pass by a builder's skip without looking in to see what other people are throwing away!

Although art teachers adopt different styles in the presentation and use of their rooms – ranging from the happy cluttered junk shop to the well ordered visual laboratory – they all need to provide a battery of visual resource material of all kinds and some kind of system to ensure that children and staff are able to find and use it easily.

All art teachers need to have their own collections of resources to support their own particular way of working. These will reflect individual taste and idiosyncrasies. It is always pleasant to visit a large art department and to see a variety of visual environments within one unit. In bigger departments, it is necessary to have some kind of overall policy for the use and distribution of resource materials – both to avoid too much duplication from room to room and to ensure that reference material is easily and quickly available.

Whether you are working in a one-teacher department, co-ordinating the work of several teachers in a middle school, or running a large department in a secondary school, it is important to create a resources or reference area so that children can have easy and independent access to the variety of resource material they will need, especially when they begin to work more individually and with much more personal choice of content.

Primary source material

The importance of using direct experience as the basis for much of our work with children does make it essential to have as rich a collection of natural and man-made forms as your art room will accommodate.

Although natural and man-made forms will frequently be used independently, as useful and intriguing things in their own right and that are worthy of close study, they are most effectively used when they are grouped and organised and placed in conjunction with other reference material, to explain or to illustrate the possibilities within one particular idea or concept, for example:

colour range and relationships;
the ordering of pattern and its relationship;
metamorphosis from one form to another;
change and decay;
distortion;
light and reflections; etc.

(Figures 4.15 to 4.26 show some of the uses of combinations of natural and man-made forms together with secondary source materials to illustrate different concepts.)

For example, a display intended to give children some understanding of the basic properties of one colour could contain any or all of the following:

selection of plants;
swatches of material in different shades of green;
colour charts made up from magazine sources;
painters' and decorators' colour charts;
group of everyday green objects;
fruits and vegetables;
samples of different coloured papers;
reproductions of several paintings that have a green bias;
branches and stones covered with lichen;
etc.

65

Studies from man-made forms. Examples of children working from some of the rich variety of man-made forms that are available as source material.

Fig. 4.15 Toy tractor; ballpoint pen (17 × 10 cm). 11-year-old, Chumleigh School.

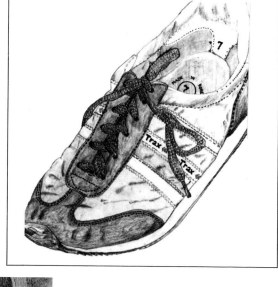

Fig. 4.16 Training shoes; coloured pencils (21 × 28 cm). 13-year-old, Hele School, Plympton.

Fig. 4.17 Teddy bear with belongings; 15-year-old, mixed media (38 × 20 cm), Chumleigh School.

Examples of children working from a variety of natural forms, where they have been particularly motivated by the challenge of recording in detail those subtleties of surface and pattern that can be found in the variety of animal and plant forms that are available for their study.

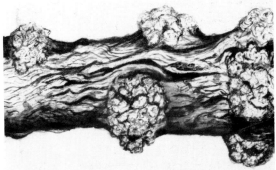

Fig. 4.18 Branch covered with lichen; water-colour and pencil (25 × 60 cm). 13-year-old, Axminster School.

Fig. 4.19 Clump of grass; 12-year-old, pencil (18 × 15 cm); Uffculme School.

Fig. 4.20 Driftwood; 12-year-old, Fibre tip pen (20 × 16 cm). Notre Dame R.C. School, Plymouth.

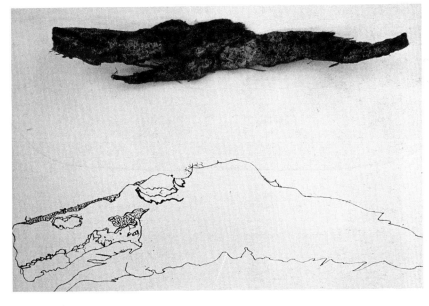

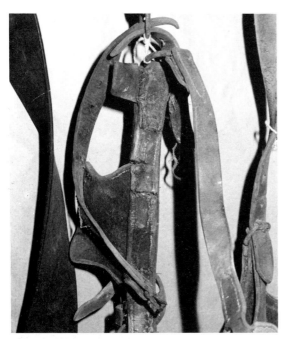

Fig. 4.21 Horse's bridle.

Thematic displays of source material, turning and spiral forms.

Fig. 4.23a Wire springs.

Fig. 4.22 Lawn mower.

Fig. 4.23b Seaweed.

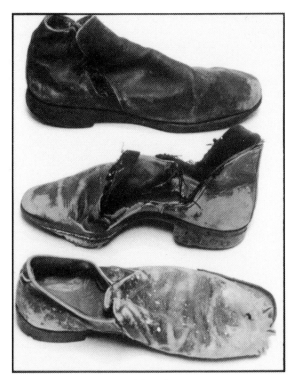

Thematic displays of source material, metamorphosis.

Fig. 4.24 Shoes and jaw bones.

Fig. 4.25 Bicycle saddle.

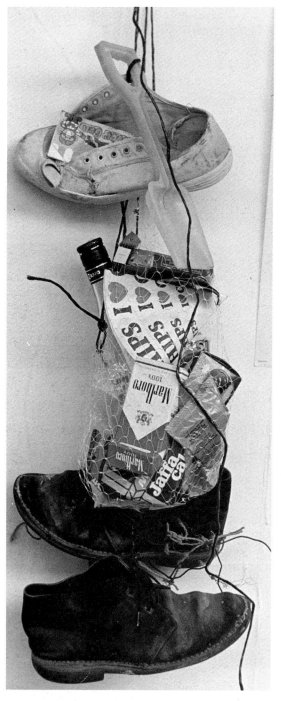

Fig. 4.26 Beachcombing; a collection of random objects found on a local beach and used to stimulate a drawing activity.

Everyday and familiar things may be used to generate more expressive work as well as the more usual objective work. Familiar things placed in unusual context – as, for example, when they appear out of scale, lit imaginatively, reflected or distorted in different kinds of surfaces or placed in an unusual juxtaposition – may all trigger off unusual or personal responses in children (Figures 4.27 to 4.29). Where, for example, your school is situated in an urban area, you can reconstruct for children in the studio different kinds of environments that will be comparatively unfamiliar to them, in much the same way that Thomas Gainsborough recreated in his studio those table-top landscapes of stones, mosses and plants he so delighted to paint. Figures 4.30 and 4.31 show a reconstruction of a beach scene in the studio using a variety of materials, and the drawings made in response.

Where you can 'acquire' redundant window dummies from fashion stores you can reconstruct in your studio all kinds of figures in different kinds of combinations and events.

The natural and man-made world come together most dynamically outside the school. Each school is contained within an environment or community that has its own particular or peculiar qualities, in which the activity of many manifests itself in different ways. Some environments are developed slowly over a long period of time, and the recording of that change can provide a valuable source for your work with children. Some, like the new shopping centre or housing estate, are virtually ready-made – but even the most boring housing estate can be studied to record the way it is used by the people who live in it. A housing estate can be visually coded to show:

what colours people paint it;
what eccentric or personal additions they add to their properties;
how they plan and use their gardens;
how different kinds of people move within it;
etc.

Much useful research into the use of the man-made environment came through the Schools

Displays of familiar things placed in unusual context in order to trigger off personal responses in children.

Fig. 4.27 (top left) Natural and man-made plants.

Fig. 4.28 (top right) Natural and man-made horns.

Fig. 4.29 Transistor and coral.

Council/Arts Council project 'Art and the built environment' and its associated publications.

The school itself can be an exciting visual source: as a three-dimensional structure housing many activities and hundreds of people, at various kinds of work, it offers rich variety; it is divided into different sections for different kinds of activities; it is built of materials which support, divide, protect, move, decorate, cover and join; it contains forms which are coloured, patterned, solid, reflecting, soft, hard, regular, irregular etc.

The school houses children who are interesting source material in themselves. Children are all different from each other, they move differently, wear different things, make noises, pull faces, interact, change shape, squash into small spaces, expand into larger ones, play games, make things, order and disorder etc.

Fig. 4.30 Reconstruction of a beach scene; a beach landscape reconstructed in the studio using a variety of natural and made forms.

Fig. 4.31 Beachscape; 16-year-old. Chalk and charcoal (60 × 38 cm). Drawing made in response to the reconstruction of the beach scene.

Figures 4.32 and 4.33 are of work undertaken with children in Year 8, where the routine exercise of figure-drawing was enlivened by placing the work in the context of disguise. Two children posed for the class over a period of time and at 15–20 minute intervals put on additional clothing such as hats, scarves, coats, etc., and the class made a record of their gradual and enveloping disguise. This use of 'dressing up' the routine model made the work more interesting and intriguing to the children.

There is so much first-hand source material available to use in art teaching, the main problem is not so much what to work from today, but how to ensure that over a period of time a reasonable balance is kept between the use of natural, man-made, environmental and personal resources.

Figs 4.32 and 4.33
Disguise; figure drawing exercise enlivened by being placed in the context of disguise. The models donned additional clothing at fifteen-minute intervals and the children were asked to make a series of drawings to show the changes in appearance.

Fig. 4.32 Children posing in disguise.

Fig. 4.33 Disguise drawing; pencil (20 × 15 cm). Uffculme School.

Examples of children's use of the environment as source material for their work – ranging from the familiar environment of the home to environments farther afield.

Fig. 4.34 My garden; lino cut (20 × 15 cm). 12-year-old, Park School, Barnstaple.

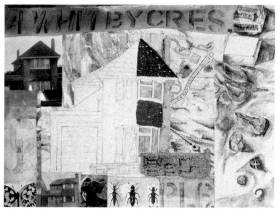

Fig. 4.35 My place; Drawing/collage recording different aspects of the child's house and the local environment. Mixed media (30 × 21 cm). 12-year-old, Eggbuckland School, Plymouth.

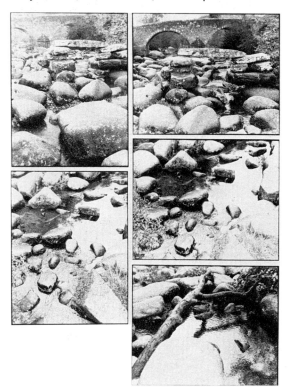

Fig. 4.36 Photographs of the river at Dartmeet. 15-year-old, Audley Park School, Torquay.

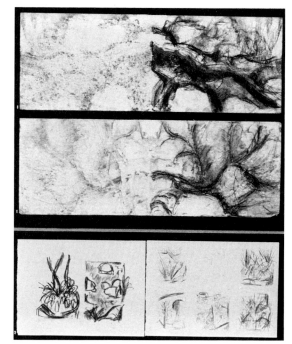

Fig. 4.37 Studies of the river at Dartmeet; pencil and charcoal. 15-year-old, Audley Park School, Torquay.

Secondary source material

In addition to real things, places, people and events, there is a vast range of secondary source material available which illustrates or reproduces evidence of the world in which we live. By far the most important of these are works of art, craft and design – both existing forms and their reproduction in photograph or on film. Because of the importance of this group, they are dealt with separately in Chapter 7, 'Understanding and using works of art and design'. There is no doubt that children learn a great deal from the study and appraisal of the work of other artists, and that this can have significant influence upon the range and quality of their studio work.

The dominant secondary source material available to us is the photograph. The considerable growth of the communications industry, and its accompanying wealth of photographic source material, has been both a boon and a problem to art teachers over the past two decades. On the bonus side has been the valuable increase in the quantity and range of reference material available through photographic material in books, magazines and colour supplements. This has made it possible for the diligent teacher to give pupils, through collecting, sorting and cataloguing photographic sources, a very comprehensive visual reference library at comparatively little cost. Where the reference material is well organised for easy reference, this can provide children with access to valuable visual information, especially in support of work which is demanding or complex in content.

The technical improvements made in colour reproduction in magazine photography has also provided both teachers and children access to a rich range of colour source material, and there have been many examples of this kind of source material being well used in the study of colour in association with painting. These are discussed further in Chapter 6, 'Painting as an extension of drawing'.

Fig. 4.39 Portrait of a friend; ink (41 × 60 cm). 17-year-old, Okehampton School.

Children using themselves as source material. Two contrasting portraits – one an introspective self portrait, the other a vigorous view of a friend.

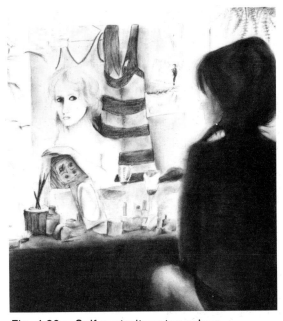

Fig. 4.38 Self portrait; water-colour (28 × 38 cm). 16-year-old, Clyst Vale College.

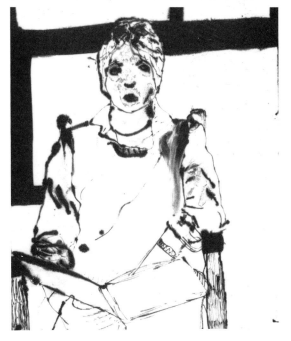

75

The use of this kind of source material has been supported and justified in the light of two significant developments in the visual arts – the 'pop art' and 'photo-realism' movements. Although the pop art movement had a viable philosophy and the result of focusing the work of artists more upon contemporary source material, its transfer into the schools has been at the rather superficial level of making fashionable the aping of images from 'popular' culture. There is a considerable difference between encouraging children to use their art to survey themselves and their own culture seriously, and simply allowing them to copy the slick images designed to sell the latest fashion or record to teenagers.

There is no doubt that photographic source material can be used constructively – to provide children with information about things they want to draw and paint for which it is almost impossible to provide them with real experience. Good photographs of such things as camels, racing cars and mountain ranges can usefully support the search for visual information.

Figs 4.40 and 4.41 *Using photographs; in these two examples, children have used personal photographs to collect and research ideas for a complex composition.*

A crucial factor here is the way in which access to photographic source material is determined by the drawing or painting problem that is presented to the children. It is a viable task to ask the children to find three photographs of very contrasting characters and to use these to create an image in which these contrasts are expressed (Figure 4.42). It makes undoubted sense to encourage the children to make their own photographic records of things they particularly want to draw or paint or model.

Figures 4.40 and 4.41 are good examples of work where children have used photography constructively and as a research tool to collect information to support the making of painting. In these examples, photography was used in conjunction with drawings and note-taking to help sort out the best way to deal with a complex composition. It may be intriguing to the children to ask them to compare the contrast between photographs of water, effects of water in reproductions of paintings and the way in which water is painted in original paintings. Many visual things we might require children to observe are so transitory – as in the movement of clouds, water or people – that photographs which 'freeze' the phenomenon can be a valuable support to their observation.

Fig. 4.40 Children at the local primary school; water colour (30 × 22 cm). 15-year-old, Dawlish School.

Fig. 4.41 The dancing class; water colour (30 × 22 cm). 16-year-old, Dawlish School.

Fig. 4.42 Three people at the bus stop; water-colour and pencil (30 × 43 cm). 15-year-old, Dawlish School.
This is a good example of the constructive use of photographic source material. In this painting, the student has taken photographs of three contrasting characters as the starting point for a composition and has tried to place them in a setting and relationship where those contrasts are expressed.

Fig. 4.43 Okehampton railway bridge; tempera colour (40 × 64 cm). 16-year-old, Okehampton School.
Photographs can be valuable source material, especially when working from the local environment. This painting is based upon photographs taken by the student himself and shows how using photography, as the initial exploration to a painting, can help the student focus upon and 'frame' part of the environment he finds particularly rewarding.

Children working directly from photographs. Although copying of this kind is useful mainly as a technical exercise in drawing, it can have additional value where the image chosen has real meaning and significance for the child who uses it.

Fig. 4.44 Tiger; tempera (30 × 42 cm). 17-year-old, Okehampton School.

Fig. 4.45 City gate; ink and wash (54 × 84 cm). 16-year-old.

Occasionally there may be photographs which are so powerful in their meaning and quality that they do genuinely stir in children a desire to express a similar meaning in their own work. We have to acknowledge the fact that certain images act as ikons for children and may genuinely motivate them to pursue an equivalent meaning in their own image-making.

The way in which you use photographic source material can have a very significant bearing upon the nature of your work with children. The question that always has to be asked is to what extent access to this kind of source material is essential to the children's image-making. Will it help them in pursuit of their own response to the task you have set them? Will such reference enlarge their perception of the images they want to make?

Photocopying and photomontage

In recent years, there has been a significant growth in the use of the photocopier in art and design departments. It is a necessary means to present children with visual information about source material and about the work of other artists and designers. Nearly all the examples used in this chapter depend heavily upon the use the photocopier to group, arrange, reduce and enlarge images.

Children can also use the photocopier as a very useful designing and sorting tool in reducing and enlarging images, through overlapping and placing images in interesting juxtaposition. It can be used to record the stages of development in a drawing or painting and to enable children to enlarge or reduce a drawing done on good quality paper and then to work on the drawing in colour and still retain the original drawing. Figures 4.46 to 4.49 are of work dependant upon this capacity.

Figs 4.46 to 4.49 *Using a photocopier; using a photocopier as an aid to drawing and painting. In these examples, the children's original drawings of churches and dragons were photocopied and enlarged onto good quality paper so that they could work on the drawings in water-colour and retain the original.*

Figs 4.46 and 4.47 Dragons; water-colour on photocopied drawing. 9-year-olds, Thornbury Primary School, Plymouth.

Figs 4.48 and 4.49 City churches in Plymouth; water-colour on photocopied drawing. Thornbury Primary School, Plymouth.

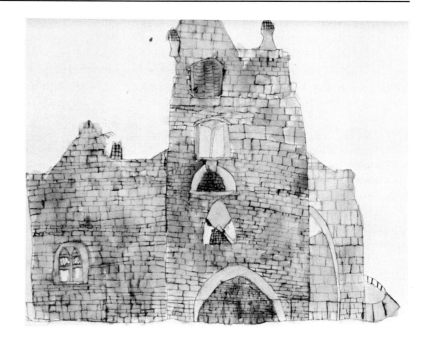

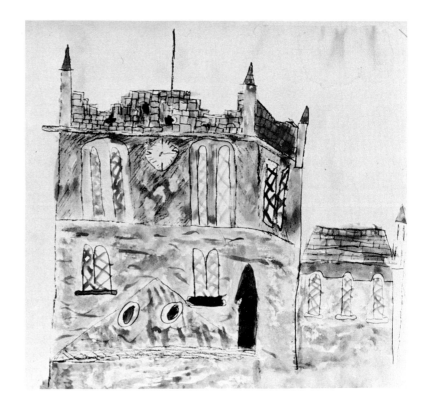

The photocopier is also a very useful support for work in photomontage in that it allows children to select, sort, reduce, enlarge and arrange images from different sources and in interesting relationships, and then to give the collection some unity through its photocopied reproduction. Figures 4.50 to 4.53 show work where children have used the photocopier to create photomontage of popular heros and heroines and to create inventive new breeds of birds by re-ordering and re-arranging the parts of existing species.

It is obviously necessary for children to have access to a wide variety of publications that illustrate the work of other artists – great masters, contemporary artists, illustrators, graphic designers and craftsmen. Such source material can be invaluable where it is used to demonstrate the variety of solutions that artists have discovered to the representation of different kinds of content. Many children find inspiration within the work of particular artists whose vision enlarges their own understanding of things they have seen and wish to represent. It is important here to encourage children to be catholic in their use of source material and to challenge those who seem to be too content to use indiscriminately the work of one particular artist or designer. The greater the

Figs 4.50 to 4.53 *Using a photocopier; using a photocopier and its enlarging and reducing capacities as an aid to making images in photomontage.*

Figs 4.50 and 4.51 Invented birds; photomontage. 12-year-olds, Eggbuckland School, Plymouth.

variety of artists' work you present to children – through photographs, publications and slides – the more likely they are to find ways of working that satisfy their own individual needs to represent the world as they see and feel it.

It is not insignificant that those art departments that most clearly develop a 'house style' – where the bulk of the children's work tends to conform to a particular kind of content or way of working – are those very departments where the only work displayed is that by the children themselves. It is all too easy for children to respond very quickly to the apparent expectations of an art teacher through observing that work which is publicly displayed for approval. The fewer alternatives they are faced with the more likely they are to assume that certain ways of working are acceptable. It is in these circumstances that 'school art' becomes the main determinant for children's image-making, at the expense of the enormous fund of source material that can be found in the work of artists, designers and craftsmen through the ages.

Other art forms

Children's work in the visual arts can be strengthened and supported through reference to and use of work in the other arts – literature, poetry, music and drama. The quality of observation that many writers and poets have brought to their perceptions of the world can frequently help children to key into the particular meaning and quality of things that they see and experience. There are many examples in this book, within the descriptions of teaching projects, where art teachers have made good use of literature, poetry and music in support of their work. The use of this kind of source material, and the working links that might be established between the arts, are discussed in more detail in Chapter 8, 'Art and other subjects'.

Figs 4.52 and 4.53 Heroes and heroines: George Michael and Kylie Minogue; photo-montage. 14-year-olds, Eggbuckland School, Plymouth.

Display and presentation of children's work and source material

It has to be taken for granted that art departments play a major part in creating some kind of visual ethos in the schools they serve. It is normally expected that the bulk of children's work displayed in public areas of the school will come from the art department. It is important to try to make more of this routine demonstration of the work of the department than standard window dressing. Obviously the children's work should be well displayed – well mounted, occasionally framed and presented – to make the most capital from this opportunity to demonstrate the work of the department.

A good public display of children's work can help to explain to your colleagues and to the children themselves that quality of looking and thinking that supports the production of the end-products. The display of children's work makes much more sense where the finished work is placed alongside the various kinds of source material that generated the work. When this is accompanied by some outline notes which explain the thinking and direction behind the work, together with examples of those preliminary studies and investigations which supported the enquiry, you are much more likely to convince your colleagues that the production of images and artefacts is the result of serious and intelligent investigation. The more you can use the advantages of being continually required to demonstrate publicly the work of your department, the more likely you are to be able to make a cast iron case for the place and importance of your subject within the school curriculum.

EXAMPLE 1

EXAMPLE 1

'Tones and tunnels' – a Year 7 project, Great Torrington
School

John Broomhead *Head of Art Department*

This project outline is usefully divided into three sections:
teacher activity, pupil activity and resources/materials. Note
the use of different teaching ploys and methods and the
accompanying questionnaire which encourages surmise and
speculation. (See pages 56–8.)

Year 7 project:
Tones and tunnels

Answer the questions below in your sketchbooks.
Use the heading 'Living caves' and do not forget the date!

1 What different types of tunnels and caves are there?
2 What are these caves and tunnels made in?
3 Make lists of both man-made and natural tunnels – what
 would be the main difference between the two?
4 What tunnels have you been in – describe your experience.
5 How would you *feel* about spending a long time living in a
 tunnel?
6 What would you do to exist – eat, keep warm etc?
7 Would the inside of a tunnel smell?
8 What noises might you hear?
9 What would the sides of a tunnel feel like if you touched
 them?
10 Would *you* feel hot or cold?
11 What creatures may live in tunnels – real or imaginary?
12 How do they move around?
13 Do they live in the roof, floor, crevices, entrance to the
 tunnel, or, deep down in its depths?
14 How do these creatures find their way around dark caves
 and tunnels?

Teacher activity	Pupil activity	Resources and materials
Section I: Tone		
Introduce Tone. Take examples of children's property (pencil case, bags, socks, books etc.) plus items from art studio. Compare and distinguish to aid understanding of differences between Tone and Colour. Touch upon 'differences' within one colour, e.g. lemon yellow, brill. yellow, orange/yellow, creamy yellow, grey/yellow.		Black and white/coloured photographs. Range of coloured objects around the room.
	Sub-groups of 4: to collect objects of same colour, but different tones. Attempt to arrange in order from light to dark.	Colour charts.
	Class discussion: children study photographs and identify areas where a wide range of tones are employed.	Good selection of photographs.
Compare black and white photographs with colour. Focus attention upon subtlety of tones to achieve detail and form in black and white examples.		
Present range of pencils. Discuss, question, 6B-6H grades, graphite/clay content, different purposes etc. Instructions to make simple tonal grid (12 squares).	Class discussion and experiment: children compare the *feel* and result of using different grades of pencil.	Sets of pencils.
	Individual: to make tonal grid ranging from white to black in 12 steps, using 6 different grades of pencil.	Squared paper.

85

EXAMPLE 1

Teacher activity	Pupil activity	Resources and materials
Section II: Caves and Tunnels		
Using tables, chairs, boxes, make simple tunnels – wide, narrow, low, high, straight, windy.	Class activity: role play, how might we move through different types of tunnels? Class discussion re feelings, posture, speed of movement etc.	Tables, chairs, tea chests.
Briefly present and discuss knowledge re caves and tunnels. Is there a difference between the two?		Photographs of tunnels and caves.
Discuss feelings, posture, claustrophobia. How do we move? Does the limited space influence how we move and the speed at which we move?	Discuss feelings evoked by Henry Moore's drawings/painting of miners and underground scenes during the War.	Henry Moore's drawings/paintings.
Alert pupils to where we may find tunnels, differences in scale, varied purpose and methods of construction.	Sub-groups: briefly list answers to questions opposite.	Questionnaires/sketchbooks.
Look and ask for children's own experiences in caves and tunnels, encourage talking to whole group.	Individual: move into questionnaires –class discussion as introduction –followed by written answers for homework.	
Section III: Looking and Drawing		
Make available a wide range of objects, natural and man-made; shells, fungi, machine parts etc. Demonstrate how these can be arranged using plasticine, house bricks, viewfinders, mag. lens to create varied viewpoints.	Working in pairs: to select and arrange objects, and find small tunnels and caves running through, suitable for observed drawing. Drawings to be made individually using pencil. No shading. Emphasise the 'entrances' to the tunnels.	Objects for drawing, mag. lens, house bricks, viewfinders, Plasticine. Sketchbooks, range of pencils.
Emphasise selection and looking before drawing begins.	Individual work: using observed drawings from previous week, make a drawing of (i) a tall thin tunnel (ii) a wide, low tunnel (iii) a long curving tunnel. Use Tone to describe depth and interior of tunnels. Find simple ways to indicate scale by adding backgrounds of buildings, mountains, insects, creatures etc.	Objects for reference. Photographs of caves, landscapes etc.

Teacher activity	Pupil activity	Resources and materials
Section IV: Cave Animals		
Present and ask for examples of animals living in caves. Identify a few. Why do these animals live in caves? Have they adapted to cope with this type of environment? If so, how have they adapted? Compare and discuss drawings.	Class discussion/question and answer.	Books, photographs.
	Make drawings of cave dwelling creatures.	Paper, pencil, coloured crayon.
Explain and demonstrate how real creatures can be changed into more exotic and mysterious creatures but still 'suitable' for cave living. Touch upon angry, friendly etc. Do not push too far with *all* children. RESPECT THEIR LEVEL OF UNDERSTANDING AND OWN IDEAS.	Invent unusual creatures but always working from the real towards the new. Write a few words about the new creature. Even give it a name.	Examples of illustrations from children's books showing strange creatures.
Section V: Relief Constructions		
Demonstrate meaning of 'relief work', how it can be achieved using card. Emphasise and place value upon 'making' skills, the importance of good craftsmanship. Relate to local potters, Dartington glass etc. How to use real objects (shells, bark, logs, lichen, cork etc.) as a basis for designing textures for cave walls. Remind pupils how to describe scale by including a 'known' subject.	Individual work but acting as a pair for mutual support: take previous drawings of caves and develop by using relief techniques as described opposite. Paint emphasising tone and texture – to provide feeling of depth. Varied brush techniques, wax crayons and pencil crayons. Develop previous ideas of cave creatures and make one using card and paint. These to be positioned within cave structure to indicate the scale/size of the cave, e.g. insect size, giant size.	Glue. Corrugated card. Emulsion paint. Powder paint/PVA medium. Wax crayons, pencil crayons. 'Cave resources', natural objects, 'animal resources'.
Outline the whole project and place value upon individual achievements.	Explain, discuss work. Display, record. Assess.	Recording and assessment sheets.

EXAMPLE 2

EXAMPLE 2

A project on light

This project was designed as part of the 'Sight Seekers' programme in which teachers from primary, middle and secondary schools worked together on the preparation of curriculum material for use with children in the 9–12 age range.

The work is generally sequential but sequence should not be pursued doggedly.

Many of the activities lead naturally into making art, others are more to do with looking, seeing and investigating materials. Some activities are complete in themselves and may not lead themselves to further expression.

Many of the resources are scrap. There must be a lot of resources – visual and material – but not so much that the child is baffled and flits from one piece of material to another. The children can supply lots of it – sweet papers, silver foil etc. – and should be encouraged to collect and discover their own.

Take trouble in collecting and setting out the stimuli and resources. Watch that the children don't just 'lick the icing off the cake'.

Preparation It is important to make some preparation for this project. All the various materials and visual resource material that you will need should be easily and readily available.

Looking and focusing aids
Slide projector or overhead projector
Coloured Cellophanes and gelatines
Torches
Candles
Mirrors
Reflecting surfaces – spoons; jam jars; shiny paper etc.
Different kinds of glasses – polaroid; coloured; coloured
 bottles; frosted; reeded
Kaleidoscope
Lenses of various kinds
Magnifying glasses
Viewfinders

Materials
White paper – cartridge; newsprint; tracing paper; tissue
Black paper
Grey paper
Magazines
Paint
Charcoal
Crayons
Pastels
Chalk
Black ink
Heelball
Shiny and reflecting materials – foil; cigarette papers; sweet
 papers; Cellophane; plastic bags; plastic sheet etc.
Scissors
Knives
Cottons
String
Cardboard
Old boxes
Various containers – yoghurt pots; cartons; tins etc.
Tubes and cylinders
Strawboard
Junk material for constructions

Visual resources
You will need to collect and display visual resources for the
children to look at and which will serve as the focus for their
looking and talking. These should include:
Photographs – different kinds of natural light; sunrise; sunset;
 dusk; brilliant sunlight; mist etc.; directional light; strong
 dark and light contrasts.
Objects with light reflecting, distorting and shiny surfaces.
Fabrics and papers with a variety of surfaces.
Papers, fabrics, tissues, plastics, through which light will pass.
(These should, if possible, be arranged against windows to
show how different materials diffuse and change light.)
 These visual resources and objects should be simply
grouped and displayed in the classroom to generate specific
kinds of looking and discussion. Some simple things are often
more effective than over elaborate and fussy displays, e.g.
Paperclips scattered on shiny paper
A pile of tins against a mirror
Xmas baubles on black plastic
Leaf skeletons against a window etc.

EXAMPLE 2

Initial activities Focusing attention upon different aspects of light

LOOKING TALKING INTERACTION

The following activities might take up one or two afternoons.
You can do any of them in any order. How many you attempt
will depend upon the response from your class and what other
kinds of talk and looking the activities encourage children to
determine for themselves. Some of these activities depend
upon certain light or weather conditions. It is best if the
children work in small groups – two or three at a time working
on different activities.

(i) Choose an object. Look at it in a box, on the windowsill,
out of doors. Describe how its appearance changes
under these different conditions.

(ii) Hold up a large leaf against the sky – hold it against the
ground.
What do you notice about the colour?

(iii) Where does the sky stop looking blue?

(iv) Make a little frame viewfinder. Look through it and
'capture' the lightest picture you can find and the darkest
picture you can find in the school playground. Notice
where they are.
Make a map or diagram to show the lightest and darkest
parts of the playground.

(v) Find a place where you can see a long way. Describe
the colour of the building nearest to you and the colour
of those farthest away. Compare the colour of the trees
nearest to you with those farthest away.

(vi) Can you half close your eyes and make things look
blurred? What do you notice? Which colours appear to
stand out most?

(vii) Look at windows of the school and of houses nearby.
Look at the windscreens of cars parked nearby.
What are they reflecting today?

(viii) Look at your face – in a shiny spoon, in a goldfish bowl,
reflected in a window. How does it change? Is it lighter,
darker, different colours?

(ix) (On a sunny day) Stand on one spot in the playground
and get your friend to draw round your shadow with a
piece of chalk. Go back to the same spot an hour later
and see if your shadow has changed. Repeat at intervals
during the day.

(x) Look at the way faces change when they are lit by a torch – from the left-hand side, from the right-hand side, from below, from above.

(xi) Look at the view through the window, through a plastic bag, through a piece of muslin, through your half open fingers, through a cardboard cylinder. Describe how it is different each time.

(xii) Place two or three familiar objects on a piece of white paper. By shining a torch on the objects from different directions, see how much you can change the shape of the shadows.

Collecting, finding and using resources

The following three activities are included to involve the children in selecting and collecting resources they might use. Each could be attempted by a small group of children – to run parallel with the looking and talking activities above. It may be necessary to plan for this to take place over a period of time to allow time for children to find and collect things. The whole class can be involved in the finding and collecting.

(i) These are all words which can be used to describe different kinds of light:

murky translucent frosted hazy shimmering dazzling smoky silhouetted glowing glaring sparkling dappled deflected gloomy flickering.

Make a collection of pictures, or sections from pictures (using viewfinders), to illustrate these different kinds of light. Make a nice arrangement of the words and pictures together.

(ii) Make a corner into a light and colour corner by placing different kinds of materials against the windows and on a table below the window and a variety of objects on the table. Choose a window which gets plenty of sun so that at different times of the day your corner will change light and colour as the sunlight changes.

(ii) Different kinds of surfaces reflect or absorb light. Make a collection of papers, materials, natural and man-made objects which are all a similar colour (red, blue or green are probably the easiest). Arrange them in an interesting way.

EXAMPLE 2

Recording light in tone and colour

Making light and dark

Divide the class into five groups. Give each group (or table) one of the following:

(i) Magazines and newspapers.
(ii) White chalk and charcoal; black, white and grey paper.
(iii) White and black crayons; black, white and grey paper.
(iv) White and black powder paint; black, white and grey paper.
(v) Black ink; white and grey paper.

Ask each group, collectively, to make as many different tones (or shades) between black and white using the materials they have on their table as they can.

Group with magazines and newspapers to find and cut out as many tones as they can.

A preliminary instruction is necessary to demonstrate how to make different tones mixing ink and water in different proportions, and to show that tones look different depending whether they are made on white, grey or black paper.

Allow 30–45 minutes for 'tone making'. Groups then to be asked to arrange all the tones they have made or found in tonal sequence from light to dark.

Detailed discussion about the different qualities of tones made with different media. Get children to identify different tones in the displays and resources in the classroom.

Shiny surface

Each child to have a shiny or reflecting surface or object:

Spoon
Tin can
Mirror
Scrap of foil
Bottle
etc.

Children to move and turn and adjust their object until they see reflected in it interesting patterns of light and dark shapes.

Children to record the pattern of light and dark using chalk, charcoal, crayons, black and white paint working on grey paper.

Some emphasis upon the way the pattern of light and dark fits onto their reflecting shape – their drawing may be spoon-shaped, or mirror-shaped, or bottle-shaped etc.

Dark and light places

Children – using viewfinders – to explore the school grounds to find their favourite 'light picture' or 'dark picture'.

Make drawings – light pictures, pencil/charcoal on white paper.
– dark pictures, chalk/charcoal on grey paper.

Those children who have chosen the same view or area to work together on a collage of their light/dark picture using newspapers, magazines, fabric scraps etc. to define main areas of the picture, then to paint and draw over as needed.

Light and dark shapes

Set up against windows or against light, groups and collections of interesting objects with subtle differences:

Row of apples
Several bottles with different shapes
Branches
Shoes
etc.

Detailed talk about the differences between the shapes – where they are fattest, thinnest, straightest, most curved, solid, fragile etc.

Children to cut and tear shapes of one group of objects in black paper placed against white or in white paper placed against black.

To look at shapes again with detailed discussion about subtleties within the silhouette – where it is darkest, lightest, most patterned, roughest, smoothest etc.

Children to draw or paint over their silhouettes to complete their pictures.

Imaginative paintings
'Me in the dark'
'My house by moonlight'
'Dazzled by snow'
'A creature seen dimly' etc.

Looking at light changing and reflecting

Colour changing

Ask children to choose one of the primary colours and then, by adding white or black, to see how many variations they can make of that colour. (It will be easier for them to work from white/colour/black.)

EXAMPLE 2

Insist that they make at least *ten* different shades.

Over a period of time, children to note and record colour changes taking place around them:

Sky
Water
Leaves
Reflections (in puddles and windows)
Things left in strong light, etc.

Colour/light diffusing

Children to observe changes in colour caused by changes in lighting and circumstances and to make appropriate studies in paintings/collage:

Pebbles in water
Houses in the rain
Fields at morning and evening
Faces by torchlight
Objects by candlelight
Familiar views through coloured spectacles, etc.

Light and colour

(i) Experiments to explain how colour may be made by placing dabs and splodges of different colours close together:

make rubbings of different surfaces using
- red crayon on yellow paper
- white crayon on green paper
- yellow crayon on blue paper etc.

Observe these from different distances to see what is the overall colour effect.

(ii) Experiment with colour dabbing using sponges or big brushes to make 'patch' colour patterns
- two colours together
- three colours together
- four colours together.

(iii) Observation of broken colour effects in:

Birds' feathers
Pebbles
Birds' eggs
Moths
Fungi
Fruits
etc.

(iv) Recording from direct observation colour patterns or tonal patterns in any of the above using as appropriate small brushes and paint, felt pens, crayons on white paper, charcoal and chalks on grey paper etc.

Children to be asked to make studies larger in scale than the objects they are observing.

(v) Observation and discussion about paintings and photographs where effects of light and atmosphere are obtained by using broken colour effects, as in paintings by Seurat, Van Gogh, Constable, Turner, Pissaro, Bonnard, Manet etc.

(vi) Children to have some direct experience of effects of broken light and colour by walking through or under trees in strong sunlight, observing light glittering on water, looking at gardens full of flowers, watching rain or snow falling, staring into fires etc.

(vii) Children to make paintings using broken patterns of colour and light on themes appropriate to time of year:

Autumn leaves falling
Bonfires burning
Mists swirling
Snow falling
Rain storms
Clouds scudding
Spring blossoming
Sun beating etc.

EXAMPLE 3

EXAMPLE 3

Homework drawing worksheet, Estover School, Plymouth

Tony Preston

Worksheet designed to support a homework task of making a drawing of a natural form at home.

Draw a detailed study of a single mushroom.

Choose the mushroom with great care – it must be visually interesting.

What qualities make it visually interesting?

Select carefully the position from which you will draw it.

Plot its position and size on the page making sure it is at least the size of the example – ideally, it should be bigger!

This drawing does not deal so much with accuracy as your ability to represent tone, texture and detail whilst capturing the unique quality of the object being studied.

EXAMPLE 4

Drawing systems worksheet

Worksheet designed to help children observe carefully the drawing methods and use of pen and ink and brush used by Samuel Palmer in *Early Morning* (1826) (Ashmolean Museum, Oxford).

Can you use these to help children study in detail the way in which a drawing has been made?

EXAMPLE 4

EXAMPLE 5

Graphic communication worksheets, Eggbuckland School, Plymouth

Peter Riches *Head of Creative Studies Department*

Two worksheets designed to encourage children to use signs and symbols to tell stories and explore different aspects of familiar things.

Picture – Story
Plan a series of simple drawings to describe the sequence of movements made in *one* of the following situations:

1 *The accident*
2 *Waking up*
3 *Eating an ice cream or lollipop*

EXAMPLE 5

Use any available drawing media – Biro/pencil/felt pen. Keep the pattern of tone-lights/darks consistent over the eight frames.

Using the above example to guide you, develop *one* of the following themes in its natural setting:

1 *My house*
2 *My favourite meal*
3 *The family car*
4 *A personal object*

Normal view	Bird's eye
Overhead	Worm's eye

You should develop your chosen theme in the form of drawings – line and shading – within the spaces. Please use any media available – pen/pencil/felts.

EXAMPLE 6

Pub sign design sheets, Estover School, Plymouth

Tony Preston

Worksheets designed to support an illustration project, and to present children with information and clues about how to approach designing a pub sign.

Look at these pub signs, and study how the various artists have treated their subjects – select one name from the list below and develop it in your own style using the materials suggested by the teacher – spend time looking for visual references for the different parts of your picture: sketch out three possible compositions in the boxes provided, then draw out the most successful design as a line drawing.

EXAMPLE 6

Keep your pictures simple as signs are seen from a distance and small details do not show up. The name of the Pub should be placed in the space at the top of the sign – The War and Peace – The Pig and Whistle – Dog and Duck – Snooty Fox – Cat and Fiddle – The Angel of Death – The Astronaut's Arms – The Circus Tavern – The Harlequin – The Motor Mechanic – The Shirt and Tie – The Man in the Moon – The Max. Headroom – The Fly in the Soup.

EXAMPLE 7

Self-portrait project brief, Coombe Dean School, Plymstock

Peter Hall *Head of Art and Design Department*

Self-portrait project brief for children in Year 8, which provides a clear view of the work expected of them over the next half a term.

COOMBE DEAN ART COURSEWORK UNIT YEAR 8

NAME TUTOR

Date Set Deadline

WHAT DOES THE TEACHER WANT ME TO DO? (PROBLEM)

LOOK AT ME (Critical and Expressive Process)
You will be shown a number of examples of portraits and self-portraits by famous artists. Notice how in different ways the artist reveals the character of the person painted through the clever choice of objects, possessions and clothes used in the pictures. Colour and tone, light and shade are also used to give further clues as to the mood and personality of the sitter. We want you to begin by making a detailed self-portrait at home, using light and shade to create a strong drawing. You could also use light and shade to create an expression or mood. Begin to collect photographs of yourself when you were small, make studies of your pets and of things important to you. Investigate colour and discover how it can be used to enhance feelings and emotions e.g. blues - sadness and despair: reds - warmth, happy, joyful emotions. In the art room put together all your studies and research into colour into a picture about you - your character, interests, possessions, hopes and dreams; your past, present and future. Use a strong composition to bind all the different elements together.

PLAN OF ACTION (ORGANISATION)

EXAMPLE 8

EXAMPLE 8

'Memories' project brief, Uffculme School

Penny Snow *Head of Art and Design Department*

A detailed project brief on the theme of 'Memories' for students in Year 10, which sets out the purpose of their work, explains the theme, describes some of its possible outcomes and lists the research tasks and homework that need to be undertaken.

Memories

Worksheet

I remember the cool scrubbed cobbled kitchen with the Sunday-school pictures on the whitewashed walls, the farmers' almanac hung above the settle and the sides of bacon on the ceiling hooks. The sound of chickens outside in the yard and the smell of baking. The sight of my Mother walking down the path of that applepie kitchen garden, ducking under the clothespegs, catching her apron on the blackcurrant bushes, past the beanrows and onion-bed.

This is one of my first memories. Without the past there would be no future. This collection of work is to include as many personal insights and visual descriptions as possible. The work may include your family, past and present, your home and surroundings.

Much of the work will require you to produce sketches and photograph to enable you to organise your finished images. DO NOT USE MAGAZINES. As far as possible, rely on your own drawn or photographic work. Old family photographs may be used.

You may wish to use the landscape which surrounds your home, or you may be interested in steam power such as trains, tractors or organs. Look through your family album, you will be surprised what information you will find. You may be as diverse as you wish.

Memories

Completion Details

On completion, your project should contain the following items of work.

1. At least one completed coloured piece of work.

2. A portrait of someone in your family. Past or present.

3. You should keep all of your sketches for they will be needed to show your starting points. Hopefully they will show how your ideas have evolved during this collection of work. We would consider a collection of eight sketches a working number.

4. You will need to find an artist who has used the same subject matter as yourself. Make some notes on the similarities in your work. Consider the techniques used in their work.

5. We would expect to see a variety of media used in this collection of works. Take care that you do not rely totally on the media that you feel "safest' using.

6. Make notes and reminders to yourself as you go along. These are often very helpful and will jog your memory.

7. At the end of the course of work, you will receive a self assessment sheet. This must be completed carefully and honestly, for it is part of your continuous assessment.

EXAMPLE 8

Homework

Choose FIVE of the following homeworks. Produce one a week.

1. Medals of honour.

2. Objects from campaigns.

3. A folded uniform or battledress.

4. Trunks or bags.

5. Bucket and spade.

6. Deckchairs and bright towels

7. Photographs of places, people and sea. Produce a drawing from one.

8. Picnic baskets, with containers.

9. Christmas decorations.

10. Baskets of fruit or vegetables.

11. Baking day.

12. Crumpled wrapping paper.

13. Streets as they were.

14. Transport, trams, steam trains, old cars, delivery carts.

15. Private hideouts.

16. The Gang.

17. Street parties.

EXAMPLE 9

Use of homework, Teign School

Garry Hutton *Head of Art and Design Department*

Homework sheet for children in Year 7 following their viewing of a tape/slide sequence about the work of Vincent Van Gogh.

You have just watched a slide show and listened to a tape about the artist Vincent Van Gogh. You have seen a selection of his paintings and heard the story of his life.

Homework 1 Try to remember what was said about him, and in your own words write an account of his life. Begin with the attempt to work amongst the poor miners in Belgium. What was the name of the famous painting that he made of a family sat around a table? Describe the scene.

Try to recall his travels: his father's rectory; his stay in Paris and his frequent visits to the French countryside. What pictures can you remember?

Who were Theo, Roulin, Gachet and Patience Escalier?

What sort of house did he live in with his artist friend Paul Gauguin?

How did they fall out with one another, and what happened to make Gauguin finally decide to leave him?

What terrible thing did Vincent do to himself afterwards?

What began to happen to him and how did his life finally end?

Homework 2 I have photocopied a selection of the paintings you saw in the slide show. Select one of them and describe it in your own words, as if writing to a friend who has never seen it.

Homework 3 Imagine that you were alive at the same time as Van Gogh and you overheard him talking to a friend at a local café. Describe how he looks, how he talks, but more importantly what sort of personality he has.

5 TEACHING DRAWING

Everyone can draw

The importance of drawing to children has already been discussed in Chapter 3, 'Structure and sequence':

> The point at which children recognise that the drawings and images they make have public consequence is a crucial one. It is the point at which they begin to compare their drawings both to the real world and to all those other images in the real world that surround them in pictures and photographs and in film and television.

Children rarely say 'I can't draw' much before the age of eight, but when they do it is a clear sign that they want help and support to make the 'real images' that will satisfy their need to describe and explain the complexity of the natural and made world they see about them.

In very positive ways, you can provide the source materials, resources and help in looking and focusing that will encourage them to begin to describe and communicate through their drawings as well as to use them as a means of personal expression.

When children draw they are responding to different kinds of experience. What they draw and how well they draw will depend in a large measure upon the questions or problems you pose them. For example, the children's response to the problem of making an image of a house is determined by the way in which you present the task to them, by what questions you ask, by what experience you give them of the idea of a house.

If you ask the children to draw a house – any house – without any supporting talk or discussion, they will usually produce very standard stereotypes for a house – a rectangle, with a central door and a window in each corner and a triangle for its roof.

Those with more mechanical dexterity will perhaps draw a more 'skilful' stereotype and may be confident enough to add a little more detail like a door knocker, or curtains or a garden path and fence. Even at thirteen or fourteen years of age, children will cheerfully resort to making 'six-year-old' stereotypes for houses when, as here, the task of drawing the house has not been properly defined or focused.

Talk to the same group of children about the houses they live in and, through discussion and questioning, draw from them verbal descriptions of differences between their houses, and then ask them to draw their *own* house, and their drawings will have more purpose and authenticity because the drawings are based upon some kind of experience – their ability to recall what their houses look like has been focused through talk and discussion.

Take the same group of children to a nearby terrace of houses and get them looking and talking, making notes, writing down words, making diagrams – beginning to identify how the houses are subtly different from each other – and it is even more likely that their drawings will have some authenticity.

Show the children a doll's house with the front removed so that they can see it in section, talk about this view and then ask them to make a sectional drawing or diagram of their own house to show how it is lived in, and the quality and appearance of the drawing will change again.

Ask the children to invent the house that will house strange or mythical or funny creatures – especially those described in poetry or prose – and the drawings that follow will have a different kind of quality and purpose.

Give the children clip boards, graph paper,

rulers and sharp pencils, sit them down before a row of houses and teach them to construct the facade of the house by using the front door as a module of measurement, and their drawings will again have a different purpose and quality.

These different ways of responding to and recording the appearance of a house all have different and valuable functions. They involve the children in recording, analysis, conjecturing, imagining and communicating both ideas and information. It is essential that teachers understand and make positive use of the variety of ways of drawing that may be used to help children to be competent in their use of drawing, both to observe and to comment upon the world as they see it. The ability to draw is an essential tool of communication that can be taught to the vast majority of children. Drawing is not just a mystical gift of the favoured few – it is a useful educational tool that all children can learn to use.

Drawing is much more than acquiring the skills of accurate representation. It is not so much a skill to be learnt as a process to use for learning. Too often in schools the aim of drawing is to learn how to make drawings of those familiar and traditional objects that can be found in most art departments: wine bottles, Coca-cola cans, bones and boots. It is not enough simply to teach children to draw drawings. One of the best ever descriptions of drawing came from an eight-year-old child who, when asked how he made a drawing, replied, 'I think and then I draw a line round my think.' This chapter draws together a wide range of tried and tested methods for helping children to think visually – and then to draw.

Drawings as recording

The most objective function of drawing is where drawing is used to record – or describe – the appearance of things, either for the pleasure of knowing and recording them well or as the means for collecting information about the real world. The simple act of looking closely and carefully at real things provides a genuine stimulus for children and has much greater value than any

Fig. 5.1 Shop facade on Bideford Quay; pencil on graph paper (17 × 28 cm). 10-year-old, Westcroft Junior School, Bideford. *Using graph paper as an aid to measurement when making drawings in which the accurate measurement of proportion and shape are necessary.*

amount of copying from existing pictures or from photographs.

When children are being asked to use drawing as a means to record the appearance and qualities of things seen in the environment, the teacher needs to provide support in two essential ways:

in the use of supporting talk and discussion;
by making available to the group those materials

which best enable them to cope with the problem of recording.

Choice of materials

Before starting any drawing with children, it is important to give very careful thought to what materials should be used that will best help them to make an analogy in drawing media for the things they are observing, for example:

sharp hard pencils to draw small twigs and plants;
fine brushes and inks to draw black feathers;
chalk, charcoal and grey paper to draw a stone church;
coloured felt pens to draw a stained glass window etc.

Listed below are the most familiar drawing materials matched against those visual elements more easily recorded with them in order of effectiveness:

pencils (hard)	line	tone	texture
pencils (soft)	tone	texture	line
felt pen	line	colour	
Indian ink	line	texture	tone (when used with water)
coloured inks	colour	tone	line texture
wax crayon	colour	texture	line
conte crayon	line	tone	texture
charcoal	tone	texture	line
water- colour	colour	tone	line
powder- colour	colour	tone	texture

Similar care should be given to the choice of paper, both for its colour and its size. Some subject matter will demand drawing on a very small scale using very sharp pencils or fine brushes, and others will demand a larger ground and the use of ink or paint with large brushes.

Figures 5.2 and 5.3 are of drawings made on very contrasting scales. In one, a 12-year-old has made a drawing of a small piece of bark in ballpoint pen, a little larger than life-size, and in the other, a 15-year-old is making a large drawing of a root using brush and inks.

Helping children to explore the qualities and characteristics of different media is an important support to drawing. Experiments and exercises with different media can be very dull for pupils if taken out of context. Always use exploration for a specific task in drawing, so that the skills and qualities absorbed can be quickly and directly used. For example, children should be asked to experiment with HB, 2B and 3B pencils to discover their possible range of tone, before going on to make careful studies of small pebbles and shells, or to experiment with charcoal, black ink, white paint and white chalk to see what textures they will make in combination, before painting and drawing domestic animals like rabbits or pigeons.

Example 1 shows an extract from a drawing work-sheet used to remind children of the importance of practising making grades of tones with a pencil before moving on to make the drawing, and provides technical advice about observing and using tone effectively.

Preliminary exercises to drawing a feather should include the practice of making subtle changes in tone with a variety of grades of pencil, practising making gentle curves, practising placing curved lines very close to each other etc. This kind of preparatory work will provide children with more confidence in making the drawing.

The careful choice of materials and scale can be used very positively to help children to seek different kinds of information through making a drawing from a common starting point. Figures 5.8 and 5.9 are of drawings made by 15-year-olds working from the artificial landscape illustrated in Chapter 4 (Fig. 4.30). During this session they were asked to make three drawings from the landscape using different combinations of materials and scale each time. This led to some useful discussion about how choice of material influenced what you were able to 'see' and record in the landscape.

Figs 5.2 and 5.3 *are of drawings made on very contrasting scales. In one, a 12-year-old has made a drawing of a small piece of bark in ballpoint pen, a little larger than life-size, and in the other, a 15-year-old is making a large drawing of a root using brush and inks.*

Fig. 5.2 Piece of bark; Biro (25 × 18 cm). 11-year-old, Notre Dame School, Plymouth.

Fig. 5.3 Drawing from a root. 15-year-olds making full-sized studies of roots and branches using inks and brushes.

Four drawings showing good choice of media to observe close detail. These children have clearly been encouraged to explore the growth patterns of feather and hair with great care.

Fig. 5.5 Collar and tie; pen and ink (12 × 14 cm). 15-year-old, Great Torrington School.

Fig. 5.4 Feather; white chalk on black ground (32 × 55 cm). 12-year-old, Teignmouth High School.

Fig. 5.6 Jar of pickles; pencil (15 × 22 cm). 15-year-old, Great Torrington School.

Fig. 5.7 Pebbles; pencil (35 × 25 cm). 15-year-old, Dawlish School.

Figs 5.8 and 5.9 Beach studies; chalk, charcoal and pastels. 15-year-olds. *Studies made from an artificial landscape, where the children were asked to make three studies in different media and compare how the choice of material affected the way they made the drawing.*

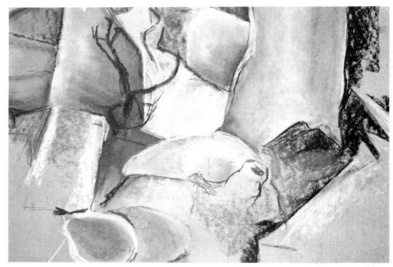

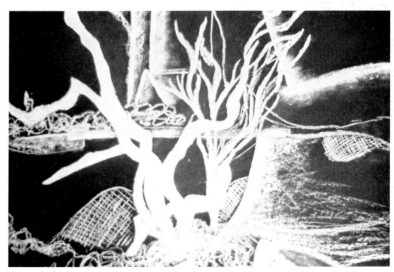

Looking and talking

The importance of talking – describing, questioning, discussing – as support for drawing cannot be overemphasised. It is through talk as much as through looking that children come to see the world about them more clearly and perceptively. (Some of the ploys that can be used in association with looking have already been discussed in Chapter 4, 'Teaching strategies and resources'.)

Talk can be used in a variety of ways, the simplest being the way that a series of questions associated with looking can help children to see and select what is before them. For example, children looking at a feather which they are going to draw with pencils, and having made some experiments with different types of pencils, might be asked the following questions:

1 Where is the feather strongest?
2 Where is the quill thickest?
3 Where are the fibrils longest?
4 How wide is the base compared with the tip?
5 How is its length compared with its width?
6 How much does it curve?
7 Where does it curve most?
8 Where is it softest?
9 Where are the finest hairs?
10 Where is it dark?
11 Where is it light?
12 Where will you need to use a very fine point?
13 Where will you have to draw very delicately?
14 Where will you use your softest pencil?
15 Which part is most difficult to draw?
 etc.

In this kind of description through questioning, look for differences and contrasts within the form that is being drawn so that children begin to see the subtleties that are there. Always include questions about how the media might be used in this particular drawing (e.g. Questions 12, 13 and 14). Where the children have made preliminary experiments or exercises with the media, use these in association with the looking so that the children can identify directly techniques and effects that can be used to create the right analogy for the thing to be drawn.

An alternative to direct questioning is for you to make a detailed written questionnaire to help the children's looking, as in the 'Shoe questionnaire' from Great Torrington School (Example 2).

Encourage your pupils to observe more thoughtfully by asking them to talk to each other in pairs about what they see or to write down ten different words that describe the object they are to draw.

Comparisons and analysis

One of the simplest and most direct ways to help children to look is to place before them two similar things and ask them to look for the differences between them – simple things like leaves or pebbles, complex things like two children who are similar in appearance. Comparison makes for careful observation, and children become conscious of subtleties of form, colour and surface. You can also help them to look by giving them an observation game to play, such as drawing one of their fingers so carefully that it is possible to identify straight away which finger has been drawn, or by sitting several children round a table to draw an eyebrow, nose or mouth of another so carefully that it can be quickly identified with its owner.

There are other more active forms of comparison. Using mirrors, children can observe how parts of their face change as they change expression. What happens to the eyebrow when it is raised or lowered in a frown? How does the mouth change as they pout, smile or snarl?

Figure 5.10 is a self-portrait by a child in Year 7 which was one of a series of drawings where the group were asked to explore aspects of themselves using mirrors to observe the way that their faces changed in appearance in response to changes of mood.

They can be asked to make a series of drawings to show how a biscuit or an apple changes as they eat it, or what happens to a small lump of clay or Plasticine as it is pinched or pulled into different shapes.

A natural extension of this is to use drawing to explain how things change as they grow, develop

Fig. 5.10 Self-portrait; biro (16 × 20 cm). 12-year-old, Notre Dame School, Plymouth.
One of a series of self-portraits made to record changes of expression and mood in a self-portrait.

and age. Ask pupils to bring to school photographs of themselves at different ages and to compare these with photographs and reproductions of paintings of people at different stages of life. Alternatively, they can make a series of drawings and studies over a period of time to describe the changes that take place in, for example, the growth of a bud to blossom, the transition from frog spawn to frog via tadpole, the changing forms of familiar fruits and vegetables as they rot and decay.

They can be asked to use drawings to examine polarities and to make comparisons between things that are:

rough and smooth;
old and new;
regular and irregular;
opaque and transparent etc.

Focusing

Where children are making studies from complicated forms – small studies of patterns and surfaces taken from a piece of driftwood, an eroded shell etc. – ask them to use a simple viewfinder – a small hole torn in a piece of paper – to select which bit they are going to draw and to isolate that part for special attention. Instead, they might use a rectangle cut in a piece of card like a camera viewfinder to select part of a landscape, a row of houses, a group of people, part of a room etc. that they are to draw. Here it is important that the shape of the drawing paper relates to the shape of the viewfinder so that what is seen through the viewfinder can be made to fit on to the piece of paper.

Children enjoy using irregularly shaped or challenging viewfinders – keyholes, circles, letterboxes, the space between fingers, cylinders, matchboxes etc. Very often you can make use of things in the environment that are themselves viewfinders and that help to place what is seen firmly in place or into context. The most familiar viewfinder is the window frame or window pane. Where a classroom has very big windows, a miniature frame made from paper can be stuck on to put a daunting view or panorama into more manageable proportions.

Other familiar viewfinders:

mirror;
reflections in a bottle;
shiny car bonnet or bumper;
doorway;
gap between houses;
space between trees etc.

A familiar focusing device is the magnifying glass or lens: it clarifies small details and can place familiar things into a new, unfamiliar and exciting context. Viewed through a magnifying

115

Figs 5.11 and 5.12 Portraits; pencil
(24 × 42 cm). 11-year-olds, Exwick Middle
School, Exeter.

Figs 5.13 and 5.14 Self-portraits through
concave and convex lenses; pencil. 12-year-
olds, St Luke's High School, Exeter.

Fig. 5.15 Biscuit eating; pencil (9 × 25 cm). 11-year-old, South Molton School.

Using changes in familiar things as a stimulus to careful observation.

glass, woodlice become strange and lumbering monsters, a cluster of television valves becomes a space city, a few twigs a complete forest. Place a familiar object upon an overhead projector and it suddenly fills a wall. Metamorphosis is an important means of stimulating looking and response.

Perception of familiar things can also be sharpened by placing them in an unfamiliar context, such as when they can be felt but not seen, when familiar things are wrapped in paper, black plastic sheeting or cooking foil, or when familiar things are seen distorted, as in the surface of a shiny spoon, or when objects are seen through reeded or frosted glass. Familiar things transformed challenge children's observation and their imagination, and when the two are harnessed they can produce drawings and responses that go beyond

Using comparison between children in the class to encourage them to observe fine differences. The children compared themselves as seen in a mirror (Figs 5.11 and 5.12) and then in concave and convex lenses (Figs 5.13 and 5.14). Similar comparisons can be made using a shiny tablespoon.

Fig. 5.16 Felt pen distorted in glass of water; pencil (36 × 40 cm). 17-year-old, Plymstock School.

straightforward recording and into personal expression.

Description and talk can also serve as an imaginative focus by placing the looking into a different kind of context. Ask the children to 'see' something on a different scale or from a different

point of view: the bird's eye view of your house and garden, a worm's eye view of your shoes, a clump of grass or a group of plants drawn as though it were a jungle.

Changes of scale and of context and meaning all help to transform the routine process of observation and recording and to place them within an expressive context. The child drawing an old boot methodically and carefully is engaged usefully in one kind of drawing. The child who views the surface of an old boot through a tiny viewfinder, like a space traveller hovering over a strange planet, will see and respond to the boot in a different kind of way and produce a different kind of drawing. Both the observed response and the imaginative response are equally valid. There is a close parallel between children's ability to use drawing as a means of personal expression and their competence in using drawing objectively. Children's expressive and imaginative response through drawing is best placed within the context of real experience. The space traveller across the old boot may well achieve something more personal and meaningful than the child whose space travels are determined too much by 'Dr Who', 'Star Wars' and 'Star-Trekkers' of film and television.

Texture, pattern and tone

In order to help children make some kind of sense and order from a busy and complex environment, you can select or isolate certain elements of visual forms for particular study. For example, you can ask the children to make rubbings or impressions of all the different kinds of textures and surfaces they can find around the school, or make diagrams of all the patterns they can find in a collection of shells, or record the construction and shape of television aerials in the vicinity of the school.

Children can look for the patterns, tones, surfaces and structures within the man-made and natural world – to develop this visual skill and to provide them with information for their work in design and the crafts. It is very important that this kind of analysis is closely related to a study of the real

world, if it is not to be an artificial and academic exercise.

These are some examples of how such studies can be used in other craft and design media:

making studies of fine patterns in leaves and shells to use as designs for work in batik;
taking rubbings from car tyres, bark and iron work to be used as studies for relief patterns in pottery;
making drawings to extract essential information for designs for print-making in a variety of media.

In all analytical drawing the choice of media is crucial and has to be closely related to the element or quality that is being analysed or recorded through the drawing. The children must have a clear understanding of what they are looking for – pattern, texture, colour etc. – and be given media to use that will encourage them to operate in those terms. For example:

Tonal studies may well be 'drawn' in torn newspaper or constructed in strips of black and white paper, or drawn using three different weights of pencil – whichever helps the children to make the analogy most effectively.

When you use analytical systems of drawing with younger children in secondary schools, you must relate them closely to real tasks – either of recording aspects of the environment or in design exploration for a particular project. The formal language of space, form, structure, surface and colour can be useful to younger children, but it has little meaning if taught and practised in isolation.

Children become confused unless a close relationship is established between looking, thinking and making. They need to know why they are using drawing to collect information and for what purpose, why they need to make these studies in order to be better equipped to make a print, construct in clay, weave or carve.

Figures 5.20 to 5.23 are all analytical drawings made in the process of collecting visual information about the structure and quality of natural forms that is an important part of preparing to design and make in a variety of media. The development of National Curriculum Technology in recent years

Fig. 5.17 Using a window as a viewfinder; pencil (48 × 28 cm). 15-year-old, Axe Valley School.

Fig. 5.18 Using the space between branches as a viewfinder; ink (40 × 28 cm). 15-year-old, Ivybridge School.

Fig. 5.19 Using a rear view mirror as a viewfinder; tempera colour (50 × 28 cm). 15-year-old, Ivybridge School.

Focusing children's attention through the use of familiar viewfinders and focusing devices.

Figs 5.20 and 5.21 Analytical studies of feathers; pencil and pen-and-wash. 13-year-olds, Great Torrington School.

has brought with it an increasing demand for children to use different drawing systems to seek out this kind of information, in order to be able to examine the structure and appearance of a range of artefacts in preparation for designing.

Figures 5.24 and 5.25 are analytical drawings by 14-year-olds in which the main purpose has been to explain how these training shoes were designed and constructed. To do this the children used different recording systems to explain the structure of the shoes, including photocopying, taking rubbings and drawing descriptively and diagrammatically.

One of the most valuable contributions that art departments can make to the development of Technology is the inventive use of drawing systems to collect information about the appearance and structure of made forms and to explore the possibilities for designing. The use of analytical drawing in support of designing has also been strengthened through the introduction of computer-

aided drawing systems into many art and design departments. The use of the 'electronic sketch book' has significantly accelerated the speed and efficiency with which children can now explore ideas and alternatives in designing. These developments are explored in more detail in Chapter 8, 'Craft, design and technology'.

Drawing for communication

Drawing can also be used to convey different kinds of information about the world the children live in – as in a diagram or pictorial map, a series of drawings to explain how something works, a form of visual 'story telling' or to record changes and events over a period of time.

This kind of work can be useful in keying children into the constructive use of images, symbols and diagrams. Children all go through a stage where they are fascinated by comics and cartoons, and it is useful to capitalise upon that interest by

Figs 5.22 and 5.23
Analytical studies of plant
forms; various media. 17-
year-olds, Ivybridge
School.

involving them in problems of how to use the techniques of graphic design to tell simple stories or to explain such things as how they get from home to school, how they get up in the morning, what they like about school, how they tie their shoe laces etc.

In addition to this kind of source material, there is a whole host of visual communication forms which children are familiar with and which might be used as triggers for different kinds of communication problems and projects for them. These include road signs and symbols, badges, games of all kinds, pop-up books, playing cards, picture puzzles and diagrammatic conventions of various kinds. It is a genuine challenge to children to involve them in problems of communicating information and ideas without using words, in order that they can learn something from the

techniques and language of the information media as well as be entertained by it.

Children do absorb at an early age a whole vocabulary of image and symbol association that enables them to 'read' the messages conveyed through the communications media. It is a vocabulary that is rarely tapped and used by teachers.

Drawing as a means of personal expression

Some techniques that can be used to help children towards using drawing and painting as a means of personal expression have already been described in Chapter 4 'Teaching strategies and resources'.

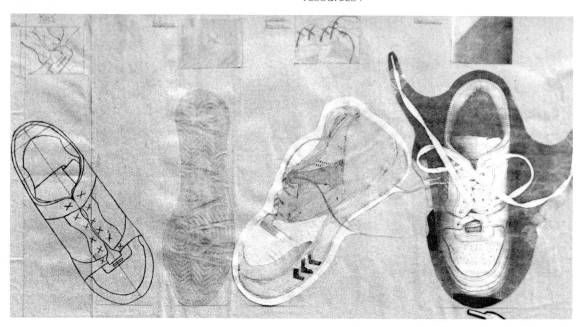

Figs 5.24 and 5.25 Analytical studies of training shoes; mixed media. 14-year-olds, Eggbuckland School, Plymouth.

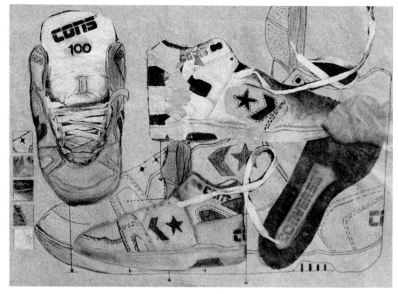

Drawings used to convey information, both about familiar events and possessions and also as a means to invent alternatives to familiar experiences.

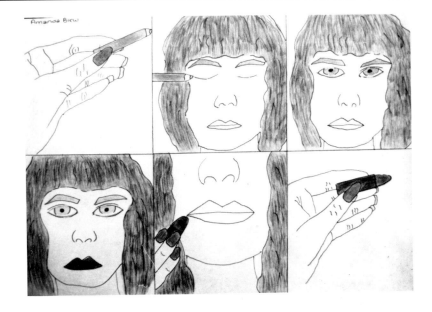

Fig. 5.26　How to apply make-up; felt pens (38 × 27 cm). 14-year-old, Tavistock School.

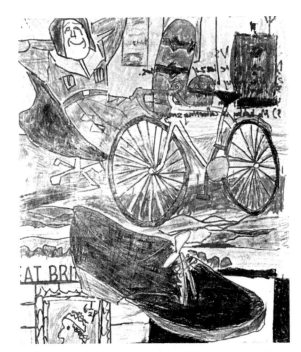

Fig. 5.27　My favourite possessions; pencil (36 × 48 cm). 11-year-old, King Edward VIth School, Totnes.

Fig. 5.28　Factory inside my head; pencil (45 × 30 cm). 11-year-old, Plymstock School.

Fig. 5.29 View of Exeter from the classroom window (with additions and embellishments);
pencil (58 × 36 cm). 12-year-old, Exwick Middle School, Exeter.

Children will use drawing expressively when they are confronted with drawing tasks that require them to move beyond simple description or the straightforward business of conveying information. As with all kinds of drawing, their response will largely be determined by the context within which you place the drawing task. It is one thing to be asked to draw what you look like, but quite another to be asked to draw what is going on inside your head. It is one thing to be asked to draw what you look like now, but quite another to be asked to draw yourself as you would like to look, or as others see you.

Although this kind of drawing may begin with the desire to record and understand the appearance and structure of familiar things, the children's perceptions will inevitably be coloured by the associations, ideas and images evoked by the physical experience of looking and engaging with real things. Children will draw with more feeling when the source material has meaning for them over and above its appearance. 11-year-olds enjoy drawing things that are personal to them – their possessions, things they have collected, their favourite food, themselves and familiar things

that are unusually or intriguingly presented to them. 15-year-olds taken to draw at the site of a derelict factory, or an impoverished part of town, will respond to the quality of that environment as well as its appearance.

One way to encourage children to draw expressively is to choose subject matter that has special meaning for them, another is to encourage them to be inventive. At a literal level children can describe how they get from home to school through a series of drawings, but they can also make invented journeys, through a strange landscape, into their own bodies, into the future etc. The act of transforming familiar things into strange things can both challenge and stimulate children, and frequently their best imagining is based upon their trying to find ways to make a metamorphosis from one form into another. They will do this with more assurance if they first observe the familiar object very closely, be it their thumb, their own shoe, their own features etc. (See Example 3.) Children can only be truly inventive where their 'imagining' is based upon experience or knowledge.

You can reinforce the observation of familiar

Two expressive drawings based upon experiences familiar to the children and reinforced through story telling or the use of supporting prose or poetry.

Fig. 5.30 Memories of a dream; pen and ink (42 × 29 cm). 11-year-old, Teignmouth High School.

Fig. 5.31 Windy day; pencil (40 × 28 cm). 11-year-old, Axe Valley School.

Fig. 5.32 Funny faces; charcoal and chalk (41 × 60 cm). 14-year-olds, Priory High School, Exeter.

Fig. 5.33 The skull becomes alive; pencil (20 × 26 cm). 15-year-old, Audley Park School, Torquay.

Using photography to try to generate fresh interest and stimulus within the convention of portrait drawing. This project began with a 'funny faces' competition. The teacher photographed each child's attempt to distort their own faces, and the children then used these photographs in conjunction with observation of themselves in mirrors to make a drawing of their own 'funny face'.

Fig. 5.34 Cripple man; pen and ink (28 × 40 cm). 16-year-old, Dawlish School.

things and events to encourage an expressive response using different kinds of stimulus. The drawings made by 11-year-olds in response to a walk through a small copse near their school were expressively focused by poems and prose describing the feelings evoked by woodland and passages of music that were descriptive and pastoral. In the walk through the wood that followed upon the music and readings, the children were encouraged to try to find ways to make their drawings describe the mood and quality of what they saw as well as its appearance.

The task of making a self-portrait by a class of 14-year-olds was expressively focused by turning a routine exercise into an amusing one – the children were asked to pull as strange or as funny a face as possible, and these were photographed so that they had photographs of their 'funny faces' as well as their reflections in mirrors to use as source material (Figure 5.32).

These techniques are especially useful when dealing with the kinds of tasks which children have to repeat, especially in preparation for some examination papers – drawings of portraits, life drawings of the figure, drawings of those familiar and everyday objects that are part of the still-life tradition. You can find ways to prevent these necessary exercises from becoming repetitive and mechanical through using a variety of ploys to regenerate children's response to making the drawing and to encourage them to draw more freely and expressively.

Figs 5.35 and 5.36 Self-portraits; mixed media (18 × 27 cm). 12-year-olds, Eggbuckland School, Plymouth.
Using different artists' systems to record different parts of the face in a self-portrait drawing.

Using other artists' drawing systems

The most logical way to extend childrens' understanding of the variety of ways in which drawings can be made and how drawing systems can be used expressively, is to give them access to the work of other artists who have used different kinds of drawing systems to respond expressively to familiar experiences. Children will learn a great deal about the possibilities of drawing through looking at other drawings and through examining the way that artists have used different media and techniques to create different kinds of atmosphere and effects in their work.

Example 4 is a worksheet used to help children examine the way that Vincent Van Gogh used a variety of mark-making techniques in his landscape drawings to create both effects of space and the movement of water. In studying such examples of artists' drawings, children will begin to grasp the wider possibilities of mark-making and drawing.

It can also be valuable to use comparisons between drawings made by different artists to help children to explore the variety of ways they might make a drawing. Figures 5.35 and 5.36 are self-portraits by children in Year 8 in which they were required to use a different drawing system or style for each of the seven components of the face using a range of artists' portrait drawings and paintings as reference material. In making these studies, the children were becoming familiar with the range of drawing conventions that can be used to make an analogy for the appearance of the head. The study of drawings can also be used to help children see how an artist might explore an idea, collect information, or deal with a particular task or problem similar to their own.

Example 5 is a worksheet based upon the drawings for a landscape painting by Graham Sutherland, which show how the artist observed and selected from the landscape those elements present in the painting. Figure 5.37 is a drawing/collage of a personal journey made by a 13-year-old in which the ideas for presenting the journey home as a collection of things seen, remembered and possessed were generated through studying the work of the artist Tony Foster, who has similarly presented visual accounts of journeys.

The use of the work of artists and designers as valuable reference and support material for children's work is dealt with in greater detail in Chapter 7, 'Using and understanding works of art and design'.

Fig. 5.37 Personal journey home; mixed media (30 × 20 cm). 13-year-old, Eggbuckland School, Plymouth.

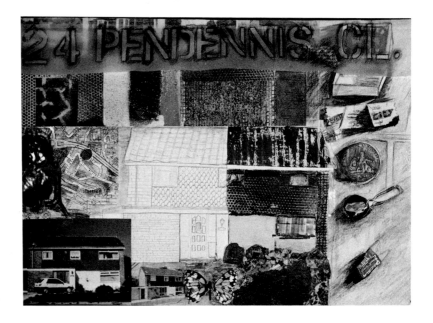

EXAMPLE 1

Worksheet – 'Using tones', Estover School, Plymouth

Tony Preston *Head of Art and Design Department*

Worksheet designed to support the careful exploration and use of a range of tones in a drawing.

STAGE 2

You must not start this stage until your line drawing has been checked.

This week you are going to add TONE to your drawing. TONE is a means of representing LIGHT and DARK.

Check your pencil - it will be impossible to do this work without a 2B or similarly soft pencil. To become aware of the tone that can be obtained from your pencil, fill in the boxes below putting the lightest possible tone into No. 1 and the darkest possible tone into No. 10. Graduate your tone very carefully filling the boxes in the following order - 1 10 5 7 3 2 4 6 8 9.

Now move to your object. It will help you a great deal if you light the jar from <u>one</u> direction using a window, a table lamp etc.
Look closely for the lightest and darkest areas.
You must interpret the lightest area as No. 1, the darkest as No. 10, thus always using the entire range of tone.

Beware of the following -

1. SMUDGING - rest your drawing hand on a piece of scrap paper at all times and when you move it, lift it carefully - do not slide it!
 - if you use a rubber do not remove rubbings with your hand - blow pieces off or use a very light brush.

2. GREYNESS - nothing looks worse than a greyish drawing that only uses the middle range of tones such as 4 5 6 and 7. Using the full range of tone produces a clearer and more interesting drawing.

START by introducing your tone lightly with the side of your pencil point. Gradually build up the tone, darkening it by increasing the pressure and finally for the darker tones and detail by changing your grip and holding the pencil more vertically.

You will need to try out techniques to find the best interpretation of the texture of the contents. Use scrap paper or the bottom edge of your page.

RE SHARPEN YOUR PENCIL EVERY MINUTE OR SO.

EXAMPLE 2

EXAMPLE 2

Shoe questionnaire, Great Torrington School

John Broomhead *Head of Art Department*

A written questionnaire used as the starting point for a project on shoes. The questionnaire was designed both to encourage children to observe their shoes more closely and to begin to consider different aspects and functions of their shoes.

Questionnaire

?
SHOES

Answer the questions below

about the shoes you are wearing now.

1 What size shoe do you take? _____
2 Exactly what colour are your shoes? _____
3 Are the laces lighter, darker or the same as the rest of your shoe? _____
4 If you have no laces, how are your shoes kept on? _____
5 Can you describe the pattern on the sole of your shoe? _____

6 How are the uppers attached to the bottoms? _____
7 What are your shoes made of? _____
8 Describe in detail any patterns on your shoe. _____ _____

9 Do your shoes come above or below your ankle? _____
10 Have your shoes got low or high heels? _____
11 If your heels are high, how high? _____
12 Do your shoes have any particular job to perform? _____ _____

13 How worn are your shoes? _____
14 When did you buy them? _____
15 Where did you buy them? _____
16 Do you like them? Give reasons. _____ _____

17 Are they comfortable? _____
18 Give reasons for your answer above. _____
19 Are your shoes fashionable? _____
20 Do your shoes smell? _____
21 If they do, why? _____
22 Describe how your shoes feel to the touch. _____ _____

23 Do your friends like your shoes? _____
24 Do you look after your shoes? _____
25 What do you clean them with? _____
26 How often do you clean them? _____
27 Do you think your shoes are happy or unhappy? _____
28 Do your shoes let in the wet? _____
29 Do your shoes keep your feet warm? _____
30 If you could go out and buy a new pair of shoes *now*, what would they be like? _____

EXAMPLE 3

EXAMPLE 3

'Myself' project – Year 9, Great Torrington School

John Broomhead *Head of Art and Design Department*

A one-term project based upon exploration of the self-portrait and how it may be used as the basis for personal and expressive work.

'Myself' Teaching objectives

1 To use the visual elements of colour, line, tone and surface.

2 To use appropriate artists' work to support own practical work.

3 To explore a personal starting point with an expressive emphasis, leading to a finished piece of work.

4 To improve the selection and control of appropriate materials.

Assessment objectives

1 Use of materials.

2 Ability to express, invent and develop ideas.

3 Drawing.

4 Interest and involvement.

Week 1 The way I look
Introduce project about faces, self-portraits, dress, posture and the way we look.
Faces are unique and are used for recognition and displaying emotion.

Questionnaire The way I look

1 Describe your face as you see it in the mirror.
2 What colour eyes have you got?
3 Have you a pale, dark or rosy skin? Is there anything else you can say about your complexion?

4 What is the colour and length of your hair? How would you describe its style? Is it thick or fine?

5 What colour are your eyes? Are they large or small? How close together are they? Measure them.

6 Are your front teeth even? Have you any missing? How would you describe their colour?

7 Do you usually look happy or sad?

8 Are you fat or thin?

9 Are you tall or short?

10 What is your main distinguishing feature?

11 Are you an extrovert or an introvert?

12 What are your favourite clothes; rocker, punk, casual, sporty, smart?

13 What is your favourite pastime or hobby?

14 Is there anything else which is important about the way you look?

Working in pairs:

Give out cue cards with different expressions written on them: horror, sadness, serious, drunk, cold, joy, hunger, excitement, in love, shock, sickness, as if insides eaten out by worms.

One pupil to communicate the expression by pulling the appropriate face and standing in appropriate posture.

To clearly identify and note down the specific parts of the face and body which communicate each expression.

Homework: To bring a silly hat to next lesson.

Week 2 **The way I feel**
Everyone to practise pulling funny faces using mirrors, standing in different positions and working in pairs.
 During lesson take photographs of each pupil wearing a silly hat, pulling a funny face and standing in chosen posture to communicate feeling.

Week 3 **Funny faces**
Hand out photographs from previous week – comments!
 Using pencil, crayon and biro to make coloured studies

EXAMPLE 3

from their photograph, trying to communicate both feeling and appearance.

Look at examples of the work of Lowry and Giacommetti.

Weeks 4–10 **Face collage/figure construction**

Pupils use their own photograph, drawings, mirrors and examples of artists' work to make a 'funny-face' self-portrait or model of themselves. To emphasise their feeling and mood as much as appearance.

Pupils to select artist(s) portraits and/or figure paintings which they can use to help with technique and style. The work does not have to be straightforward, but can be developed in an unusual style.

Pupils to describe in words the general mood of the resources and the precise way in which specific expressions are communicated by different parts of the face and body. What areas of the face should be focused upon?

Figures and faces to be built on card base. Look at range of techniques and materials:

painting	collage
card	drift wood
wire	rope
string	netting
cork	straws
fabric	papers
glues	sand
moss	twigs
sandpaper	varnish
wood off-cuts	coloured wool
papier mache	sharp knives
scissors	drills

If time allows:

Show examples of black and white illustrations of people. Briefly discuss and demonstrate technique.

Each pupil to select a portrait/full-figure, and using black felt pen make a drawing from the picture emphasising the way they think the subject is feeling. Concentrate on developing techniques and observation.

Week 11 Mount all work.

Week 12 Record, self-assess and assess project.

EXAMPLE 4

Investigating drawing systems

A worksheet designed to help children study the drawing and mark-making techniques used by Vincent Van Gogh in the drawing *Fishing Boats at Sea* (Solomon R. Guggenheim Museum, New York).

Can you, by making studies from this drawing, distinguish between the ways Van Gogh has drawn the sea and the sky?

EXAMPLE 4

EXAMPLE 5

Drawing upon the landscape

A worksheet designed to show how Graham Sutherland selected information from the landscape in preparation for his painting *Midsummer Landscape*, 1940 (City Museums and Art Gallery, Birmingham).

By making studies from these, can you see how Graham Sutherland has explored different views of plant forms in preparation for the painting?

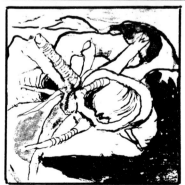

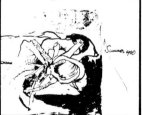

EXAMPLE 5

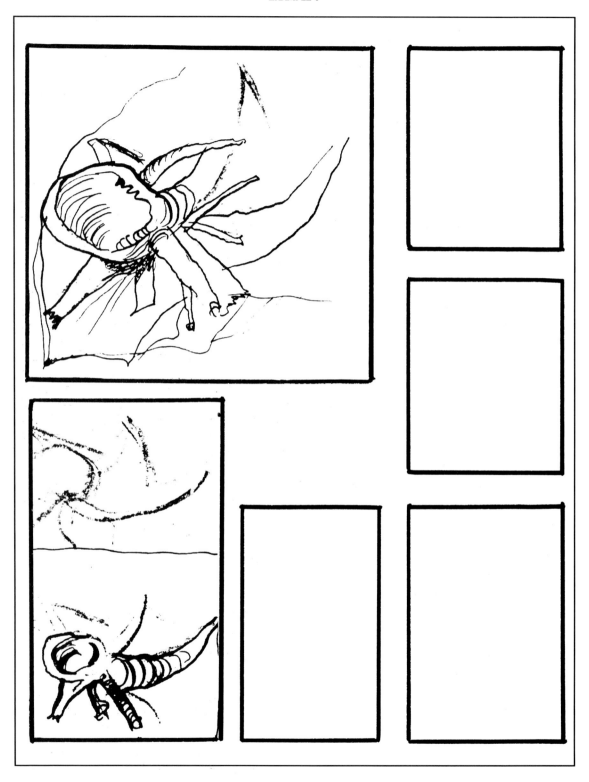

6 PAINTING AS AN EXTENSION OF DRAWING

For children to paint with confidence they have to be taught how to use both colour and pigment and to be given some understanding of the relationship between drawing and painting.

Many children at the age of eleven will arrive at their secondary school having done little painting since their first couple of years of schooling. Many will view painting as a means of colouring in drawings – and will have been frustrated by the number of times they have ruined a perfectly good drawing by trying to paint over it!

The National Curriculum in Art will address this lack of continuity in the long run by requiring teachers in Primary Schools to be more consistent in building upon the generally good practice in the teaching of painting in Key Stage 1 with more considered attention to the teaching of colour and painting in Key Stage 2.

The programmes of Study relating to the teaching of painting in Key Stages 1 and 2 are now as follows:

In addition, and in Attainment Target 2 'Knowledge and understanding', there is now the requirement that children in Key Stages 1 and 2 should have much more experience of seeing and discussing the work of other artists and that they should learn how to use other artists' methods and systems constructively and imaginatively in support of their own work. There is no doubt that children learn a great deal about making a painting through looking at the work of other painters. In many primary schools, this principle has been well established through good practice in recent years and the advent of the National Curriculum in Art should ensure a wider acceptance of this basic tenet. Painting has to be seen as an extension of drawing and not as the second stage where you apply colour to a drawing. The choice of subject matter is also crucial to giving children confidence in their approach to making a painting. You need to be much more selective in the use of content and source material as a support to the teaching

Key Stage 1

AT1 Investigating and making

(i) Record observations from direct experience of the natural and made environments.

(v) Explore how images can be made using line and tone, working with a variety of tools and materials.

(vi) Explore colour mixing from primary colours.

(vii) Explore and recreate pattern and texture in natural and made forms.

Key Stage 2

(i) Select and record images and ideas from firsthand observation.

(vi) Experiment with different qualities of line and tone in making different images.

(vii) Apply the principles of colour mixing in making various kinds of images.

(viii) Experiment with pattern and texture in designing and making images and artefacts.

of painting than you do when embarking upon drawing with children. In addition to teaching children about colour – how to see it and how to use it – there is a real need to match their knowledge of colour to content they can handle, to make a proper marriage between content and form. It is also valuable to make consistent use of the work of other painters in support of the children's own work.

Colour and pigment

Children need to be taught about colour – how it works and how it may be differently applied. There is a tendency amongst some teachers to over-elaborate the teaching of colour theory, reflecting back perhaps to their own art school training. Children respond better to the more direct teaching of colour, where there is a clear link between making colour and using it. It is for this reason that the making of the standard colour wheel is a fairly pointless exercise. It may take up four whole lessons to put together, and in the end the children are still unlikely to be able to relate the theory to the practice of using colour in a picture. This kind of exercise is also misleading in that it frequently separates making colour from using pigment.

Understanding of colour is best taught through a combination of demonstration, and playing colour games.

Demonstration

Range and quality of colour can easily be demonstrated to children in a variety of ways. You can use an overhead projector and a combination of coloured Cellophanes and gelatines to demonstrate quickly to children the basic colour changes between primary and secondary colour. Use colour source material from colour supplements and magazines to display for children the subtle range of colour that can be achieved through various kinds of mixing and overpainting. Use colour charts produced by paint manufacturers, the material swatches to be found in most tailor's shops etc. Display source material of this kind together with real evidence of colour in natural and man-made forms, as in the use of the conventional colour table. See pages 65–70 for more information about how the source material may be ordered and arranged in such a way as to underline its meaning.

Games

Children will learn most about colour and more quickly when they explore colour properties in small groups, each group within the class comparing and contrasting their findings with those of other groups. These preliminary investigations are very simple: how colours mix, how to make them change, matching colours, seeing how colours vary depending upon ground and pigment etc. It is more productive to set a group a variety of tasks and then to compare the results, than to require every child to work their way through a whole series of exercises. The table overleaf shows a range of games, and the materials needed to play them, with examples from the red/pink/orange/purple range of colour.

Example 1 gives a variety of further colour explorations children might undertake as part of their Year 7 course.

It is for this reason that some care has to be taken in the choice of subject matter or content when you are looking for ways to follow up the familiar colour exercises described above.

You may choose to make a clear distinction between collecting information by making colour studies and drawings, and using these in a painting. This is particularly useful when children are working from the environment and where their initial studies will be followed up by working directly in paint on a much larger scale. Children learn a great deal about painting by being required to paint directly – to draw with paint and to add colour and detail entirely through the application of pigment. It is also a most useful way of showing the children that paint is a very flexible medium – that it doesn't matter if mistakes are made in the early stages because they can be painted out. Figures 6.1 and 6.2 show examples of children's use of direct painting methods, where they have followed up initial studies with larger scale paintings.

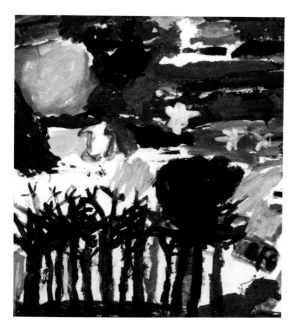

Fig. 6.1 Winter landscape; powder colour (30 × 42 cm). 9-year-old, Thornburt Primary School, Plymouth.

Another way into painting is to establish a logical link between drawing and painting by asking the children to make a series of studies that lead them through the use of different media into making a painting.

The palette

If children are to learn how to make and use colour effectively, you need to give them the right palette and media to use. For the beginnings of work in colour, there is no doubt that powder colours are the most effective medium. Although the Redimix colours can provide greater density and range of weight, because they are 'ready mixed' in tubes, younger children tend to use them too much like toothpaste! The very fact that powder colours have to be mixed with water before they work at all encourages the children to work with different densities of paint. The difference between using powder colours and Redimix colours is rather like the difference between learning to play the piano

Two good examples of the free use of pigment. This is more common in younger children who are less inhibited about drawing with paint and make less separation between drawing and painting. Older children frequently have to be set direct painting problems to overcome their tendency to draw elaborately before starting to use colour.

Fig. 6.2 Winter trees; tempera (40 × 60 cm). 15-year-old, South Molton School.

and the violin. The notes on the piano are already there – all you have to do is to learn how to play them in the right sequence. Notes on the violin have to be made by the performer.

The basic palette should be white, yellow, vermilion, crimson, ultramarine and black. As the children gain more experience, then both cobalt and Prussian blue might be added to extend the range. Once the children have mastered the basic skills of colour-making and using paint in powder colours, you can gradually introduce Redimix colours, gouache etc. as they begin to need a more sophisticated range of media to match the more demanding content of their work.

In the same way as in the teaching of drawing

you can encourage children to experiment with and practise different ways of making marks and combining different media, so in the teaching of painting it is valuable to pursue with the children the variety of ways that paint may be applied and used. As they learn about colour, you need to provide activities and experiments to help them to see and enjoy the plasticity of pigment – how it may be differently applied even with a paintbrush, how it may be used transparently and opaquely, how it works when mixed with other media etc. All this experimental and exploratory use of colour should be directly related to using colour for a specific task, so that there is a clear link between learning about colour and using it. For example, you can follow up an investigation into the range of colours between cream and orange with direct paintings from simple groups of such fruits as bananas, lemons, oranges and peaches set against a cream or white ground. Some of the preliminary work on how to apply paint differently is then used to match the different surface textures of these fruits.

Example 2 is a description of a Visual Research

Resources	Activities
Overhead projector Gelatine and Cellophane sheets Slide projector Colour slides Windows Cellophanes, coloured tissues, sweet papers etc. Colour spectacles, viewfinders with colour inserts, pieces of coloured glass, colour paddles and prisms etc.	Making and observing colour change. Mixing colours on an overhead projector by placing different gelatines and Cellophanes over each other. Projecting colour slides over different objects and parts of the room. Looking at familiar things through coloured spectacles. Making colour charts and patterns on windows using tissue papers and other transparent materials.
Powder colour (vermilion), water and different coloured papers. Powder colour – vermilion, yellow, ultramarine, white. Powder colour – vermilion, crimson, ultramarine, white, yellow and black.	Experimenting to see how many colours you can make with one colour by using different amounts of water and by painting over different coloured papers. How many colours can you make with vermilion plus one other colour? How many shades can you make between one and the other? How many colours can you make using vermilion mixed with varying quantities of two other colours, e.g. vermilion plus white plus yellow, or vermilion plus crimson plus ultramarine, or vermilion plus ultramarine plus black, etc?
Selection of colour charts. Natural and man-made objects. Colour range: reds/pinks/oranges/purples.	Arrange and display colour charts divided into four main groups: oranges, pinks, browns and purples. Oral colour mixing – comparing colours made with colours in display. Work in pairs – mixing and matching colours – children to challenge each other to match particular colours. Colour mixing from memory – choose an object and match its colour unseen etc.
Small display groups – selection of coloured papers against which are displayed natural and man-made forms. One group each of papers and objects which are red, pink, orange or purple dominated.	Use viewfinders, select small part of one group. Paint the colours and shapes you can see – from memory, from observation. Introduce use of collage in association with painting. Project colour slides over group and observe changes in colour. Paint the change that takes place etc.

Project undertaken with children in Year 7, where experimenting with colour and media plays an important part in preparing them to move into work in painting and collage.

The transition from drawing to painting

It is a comparatively simple task to teach children about colour and how to apply colour in making colour studies or paintings from direct observation of natural and man-made forms. It is more difficult to establish a proper relationship between drawing an image and painting it. By the time they are ten or eleven, many children tend to view painting as being a second stage to drawing – first you draw the image and then you colour it in with paint! This frequently leads to much frustration, as most

children at this stage can draw with some precision but find it difficult to add the paint to the drawn image without ruining it. This is often because there is a mismatch between the scale of the drawing and that needed for a painting, and because the children do not possess the skill or experience to use paint with the same precision as they can draw.

As has already been discussed in Chapter 5 and illustrated in Figs 4.46 to 4.49, there are occasions when you can support the transition from drawing to painting through the use of the photocopier, by copying and enlarging a drawing onto good quality paper so that children can retain the original drawing and take it into a painting on a larger scale. This is a particularly useful ploy where the children are making paintings from drawings with a great deal of detail and where the task of re-

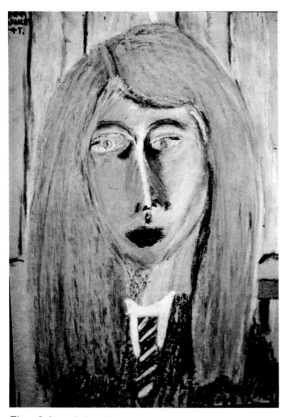

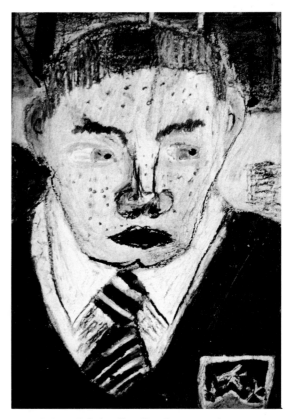

Figs 6.3 to 6.6 *Colour studies into paintings. 11-year-olds, Churston Grammar School.*

Figs 6.3 and 6.4 Studies for portraits; crayon and pastel (20 × 29 cm).

143

drawing the detail is both time-consuming and daunting!

Figs 6.3 to 6.6 are portrait drawings and paintings by children in Year 7, where the initial drawings in crayon and pastel helped the children to focus upon the study of the qualities of colour they could see in the head. After making these colour studies of the head they were then asked to make protrait paintings working directly with colour, drawing with the paint and building up the image entirely through the direct use of pigment.

The sequence from drawing in line to drawing in tone to drawing with colour, before moving on to making a painting, is particularly helpful in the early years of secondary schooling, because it capitalises upon the greater confidence that children have in their drawing.

Intermediate studies are a valuable support to children's painting and, even when working from comparatively simple source material, can help children to approach a painting with more confidence. The choice of media for these studies will obviously vary depending upon the subject matter – and may range from making simple colour charts to tonal studies to detailed colour studies in a variety of media. Figures 6.7 to 6.8 show examples of intermediate studies for paintings in a variety of media and for different kinds of content.

If children are given experience of a variety of ways into painting, and are helped to see that the way they approach a painting is considerably influenced by the subject matter, they are more likely to face with confidence those more complex painting tasks they will need and want to work on in their later years in the school.

Content and sequence

The general principles of developing sequence and structure in the teaching of art apply particularly

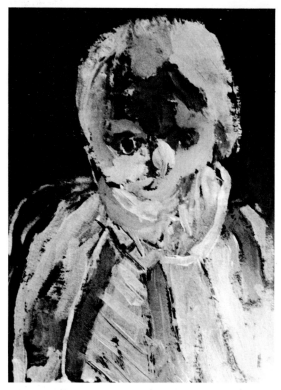

Figs 6.5 and 6.6 Portraits; tempera
(20 × 29 cm).

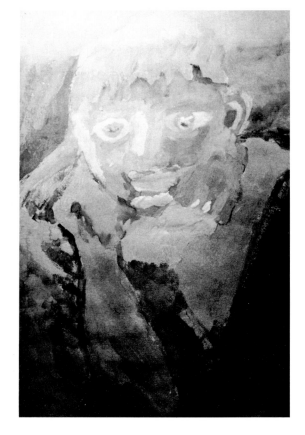

Fig. 6.7 Dartmoor study;
pen and wash
(30 × 25 cm). 11-year-old,
Woodfield Junior School,
Plymouth.

Fig. 6.8 School playing
fields; chalk, charcoal and
pastels (30 × 40 cm). 12-
year-old, Priory High
School, Exeter.

*Intermediate studies in
preparation for painting.
Using different materials in
preliminary studies to help
children begin to see
some of the possibilities
within the subject matter
for developing paintings
from the same source
material. The materials
used help them to focus
upon those colour and
surface qualities that are
an important part of
painting.*

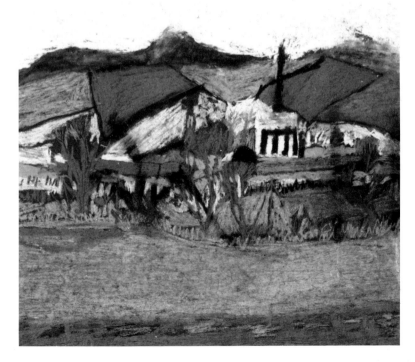

to the teaching of painting, especially in the first two years of secondary schooling. In these early years it is essential to match the painting task carefully to the colour and handling skills that have been taught. It makes little sense to jump from some elementary work in, say, the difference between warm and cool colours to asking the children to paint imaginary landscapes which are either 'hot or cold'. Children in this age range find it very difficult to draw from recall or memory, let alone to recall the subtleties of colour or to invent them to match an 'imaginative' theme.

Because of the complexities of constructing a painting, it is rarely satisfactory to ask children to paint as a one-off activity. It is more sensible to set aside something like a half-term unit of five or six sessions to take the children through a series of activities that will give them a combination of handling and colour skills and the opportunity to apply these skills directly in response to simple painting tasks. Examples 1 and 2 both illustrate how such a sequence might be established, and how there might be a gradual build up of colour skills related to more demanding painting tasks. In both programmes there is an emphasis on direct experience of colour as the most useful way to help children in their painting. Unless children are given this kind of grounding it is unlikely that they will be able to tackle the more demanding, complex and personal themes that become more appropriate later in the school.

Figs 6.9 to 6.14 are drawings and paintings by children in Year 7, made over a period of six weeks and based upon studies from the window of the art studio in this school. The children first used both view-finders and the window panes to isolate sections of the townscape and the fields beyond and made studies in pencil. These studies were further developed in charcoal, and then they chose the section of landscape they wished to paint and made tonal studies of these, working with black and white paint only. After making these three studies and thus building up a knowledge of the detail of the landscape and its tonal qualities, they made their paintings, working directly in colour.

Figs 6.9 to 6.14 *View from the art room window. 11-year-olds, South Molton School. Using drawings and tonal studies as preparation for making a painting of the view from the art room window working directly in pigment.*

Fig. 6.9 Charcoal study (23 × 13 cm).

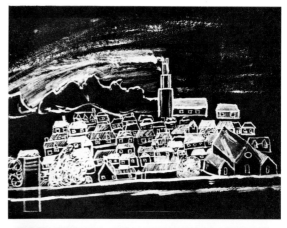

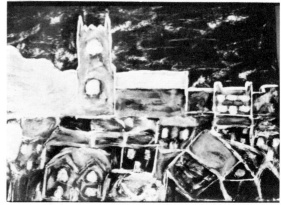

Figs 6.10 and 6.11 Tonal studies; white paint and chalk on black ground (29 × 20 cm).

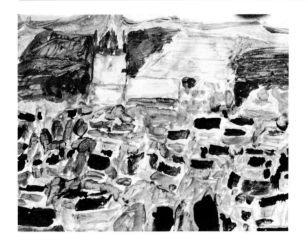

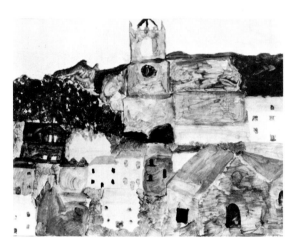

Figs 6.12 to 6.14 Tempera (40 × 30 cm).

Using other artists' systems and methods

The value of using other artists' systems as reference points in teaching art and design has already been touched upon in Chapter 5 and is developed fully in Chapter 7 'Understanding and Using Works of Art and Design'.

Just as children can learn much about the possibilities of drawing through looking at other artist's drawing systems, they can learn a great deal about making a painting by looking at other paintings. Such learning can operate on a number of different levels, from simply learning about how to use and apply colour making direct studies from the work of other painters or 'working in the style' of another artist, to learning about such complex matters as how a painting is planned and constructed or how painters create atmosphere and mood in their work.

You can introduce new methods of using paint and colour by direct reference to the work of other artists as in Fig. 6.15. Here, children in Year 7 have been asked to make a portrait painting from a photograph using similar painting methods to Vincent Van Gogh. In Figs 6.16 and 6.17, children in Year 9 have been encouraged to explore the subtleties of colour to be observed in the surface of a white coat after observing and talking about drawings and paintings by Jim Dine.

Figs 6.18 and 6.19 are of paintings made in Year 9 where the children were asked to first study a landscape painting by another artist and to reconstruct its foreground, middle-ground and background in separate layers and then to apply the same method to making their own painting of a local landscape.

Figs 6.20 and 6.21 were made by students in Year 11 following upon a visit to the Tate Gallery to study Max Beckmann's painting 'Carnival' (Fig. 6.22). Here, they attempted to recreate in their own narrative paintings something of the rather menacing atmosphere to be seen in the work by Beckmann.

In these examples, direct reference to another artist's work was the initial stimulus to the

147

Fig. 6.15 Portrait in the style of Vincent Van Gogh; 11-year-old, tempera (20 × 30 cm). Teign School.
Making a portrait from a photograph using similar painting methods to those used by Vincent Van Gogh.

Figs 6.16 and 6.17 White coats; 14-year-olds, tempera, emulsion and charcoal (30 × 40 cm). Eggbuckland School, Plymouth.

children in making their own work. It is often more appropriate to introduce reference to other artists' work part-way through a project, in order to build upon what the children have already grasped. In Example 3, 'How White is White', other artists' work was used to extend what the children had already learnt about working in a subtle range of colours.

The preparation, thinking and organisation that go into the making of a painting can be logically taught, especially where the process is laid alongside and compared with the way that artists work. Example 4 illustrates the way that a group of

10/11-year-olds were encouraged to research and build up information for a painting of activities in their own playground, in direct comparison with the working methods used by another artist.

In teaching painting, and through using reference to the work of other painters, you can very obviously increase the childrens' knowledge about the different ways that a painting can be made. Where such methods are used systematically, with reference to a wide range of artists' work, you can also give them a greater understanding of the possibilities of painting, and of the range of ideas and meanings that paintings can encompass.

Figs 6.18 and 6.19 *Using artists' methods. Studying the way that an artist represents foreground, middle and background space in a landscape, and applying these methods to making a landscape painting in the locality. 14-year-olds, Westlands School, Torquay.*

Fig. 6.18 Study from *Landscape at Auvers* by Vincent Van Gogh; tempera (25 × 50 cm).

Fig. 6.19 Urban landscape near the school; tempera (40 × 56 cm).

Figs 6.20 and 6.21 Carnival figures; tempera and mixed media. 16-year-olds, Dawlish School.

Paintings of carnival figures based upon the study of Carnival *by Max Beckmann, where there was a conscious attempt to recreate something of the atmosphere of a Beckmann painting.*

Fig. 6.22 *Carnival* (1920), Max Beckmann; oil on canvas (186 × 91 cm). Tate Gallery, London.

EXAMPLE 1

A red programme for children in Year 7

Robert Clement

1 Display of photographs and reproductions of works of art that are red dominated, plus selection of different coloured papers and materials.
Discussion about these and differences between different reds. When does red become orange or pink or mauve? Discussion about use of 'red' words colloquially, e.g. pillar-box red, scarlet, rouge, red for danger, I saw red etc.

2 Demonstration of how different reds are made by placing tissue papers, Cellophanes and gelatines over each other and using a light source – window or overhead projector.

3 Children play colour-making games – working in pairs and challenging each other to make more reds using combinations of:

red plus yellow;
red plus blue;
red plus white;
red plus black.

4 Children to collect and bring to school a variety of man-made and natural objects – all in different shades between orange/purple and pink/brown.
Colour selection and matching exercises using colours made in previous session and colours in display against objects found.
Oral colour mixing – describe how you might make this or that red.

5 Simple groups of found objects set up against paper and material grounds. Children to observe groups through viewfinders and to select a small part which has interesting shapes and a variety of reds and – after observation and discussion – to paint their chosen part from memory.

6 Children to play colour and pigment games.
Comparing the differences between mixing vermilion and crimson with other colours and working on different coloured grounds and with variations of colour density, e.g.

EXAMPLE 1

compare crimson plus white on black ground with vermilion plus white on white ground.

7 Children to make small paintings/collage from a choice of objects and working from direct observation. Emphasis to be upon accurate colour-making.

Rusty objects
Orange or tomato sections
Kipper
Autumn leaves
etc.

8 Discussion about and appraisal of a selection of reproductions of paintings in which reds, pinks, oranges, mauves etc. play an important part, e.g. paintings by Matisse, Renoir, Van Gogh, Soutine, Seurat, Gauguin etc. Children to make notes and studies of the use of colour in these paintings and, in particular, of the way that these artists have both applied paint and used colour selectively to convey certain moods and feelings.

Children to make direct studies from sections of these paintings.

9 Children to make paintings from direct observation of subject matter similar to those listed below after detailed discussion about the possibilities within each of these for the use of simple composition – placing shapes within shapes, using colour selectively etc.

Goldfish in a bowl on red and white check tablecloth
Ginger cat sitting on red patterned mat or cushion
Tortoise in a box of autumn leaves
Figure dressed in highly patterned dress or dressing gown sitting against a red ground
Prawns on a red dish
Orange, red and purple fruits against a variety of pink and brown grounds
etc.

EXAMPLE 2

Visual research project, Lipson School, Plymouth

Christopher Killock *Head of Art and Design Department*

Project undertaken with children in Year 7, where there is an emphasis upon preliminary exploration of colour and media as preparation for making a painting/collage.

Year 7: Texture Process: Visual research.

Aims: To introduce the notion of picture building as an exciting opportunity for experiment. To provide opportunities for pupils to see the descriptive possibilities of a variety of media.

Description: Experimentation with media, kept very loose at first but gradually linked to observational studies.

Stages:

1 Introduction to mark-making implements and materials; use of a variety of media; discovery of unusual ways of using pencils, pens, etc; home-made implements used.

2 Analysis/description of marks, e.g. drip, spill, slop, swill, drop, oily, dusty, scrape, smudge, smear. Experimentation to find suitable marks; selection of words which describe a texture effect, e.g. rough, smooth, slimy, oily, grimy.

3 Making contrasting marks; combination of marks to describe textures directly observed, e.g. wood, concrete, hair, leaves.

4 Introduction of marks made by painters (e.g. watercolour/impasto); looking at specific use of marks (e.g. Impressionist paintings of foliage); discussion of techniques, use of local environment to do direct work from Nature, e.g. summer foliage/winter branches; introduction of notion of selecting marks and techniques to develop work.

5 Develop in texture painting/collage.

EXAMPLE 3

EXAMPLE 3

How white is white?

Robert Clement

A Year 9 colour programme.

Resources/Development	Activities
1 Display a variety of white and off-white material backings – paper, calico, muslin, scrim etc.	Class to work in four groups with the following materials: (i) white paper, black ink and water; (ii) grey paper, white paint, charcoal; (iii) black paper, white chalk and white crayons; (iv) buff paper, white paint and black paint. Colour-mixing exercise (30 minutes). How many very pale colours or tones can be made with these materials (10 cm² patches)? Arrange colours in sequence white to off-white.
Add colour sequences to display. In consultation with class, add other objects (feathers, shells, bones, scraps of material etc.) to the display that correspond to the colours made.	
2 Selection of white and off-white objects, as above, arranged against white and off-white papers.	Same range of materials as in Session 1. Drawing/painting using mixed media from chosen object or part of an object. How close to the colours can you get using these materials?
Display paintings with objects. Discuss colour accuracy. What other colour would be needed to make the colours absolutely right?	

3 Add paintings made in Session 2 to the display.

Class to work in four groups with following combinations of colour:
 (i) white plus crimson plus vermilion;
 (ii) white plus black plus ultramarine;
 (iii) white plus vermilion plus ultramarine;
 (iv) white plus ultramarine plus yellow

Experiments to see what range of pale colours can be made with above media.

Add to display selection of reproductions of paintings in which there is subtle use of white and pale colours. Discuss and compare.

Cut up and arrange colours in sequence: white to pink; white to pale brown; white to pale blue; white to grey; etc.

4 Small groups of natural and man-made objects arranged so that each group contains objects that have both warm and cold whites within them.

Using viewfinders, children to select part of the group and to make small paintings/collage.
Full range of colours available.
Emphasis upon seeking out the subtleties of colour.

Use of separate practice sheet to test colours and possibilities of overpainting and marking the paint while wet.

Use collage (torn paper) only when colours can't be obtained absolutely accurately using media.

5 Rearrange display to include small selection of reproductions of paintings, together with studies made in Session 4, together with some of the natural and man-made objects used.

Discuss and compare.

Against a white wall, string a washing line of clothes that are white or near white and which have a variety of surfaces or patterns.

Direct paintings of part of washing line to include at least three garments:

full range of colour
no drawing materials grey paper

Children to draw directly with paint and with emphasis upon seeking ways to use paint to explain differences between the surfaces of the materials. Fast painting (45-minute time limit).

EXAMPLE 3

6 Display three or four reproductions of paintings of figures in white or near white clothes, e.g. by Renoir, Modigliani, Manet, Degas etc.

Display with these a selection of the paintings made in Session 5. Discuss and compare these.

Pose as model, girl in white dress plus a cardigan and a white hat.

Seated or standing against ground with same colour and pattern in it. Light from one side.

Further selection of reproductions and of photographs of people appropriately dressed for reference and comparison.

Full range of materials.

Full palette of powder colour and white Redimix, white chalks and crayons plus charcoal.

Grey or dark brown paper – A2 size and A4 size.

 (i) Make small studies on A4 paper of different whites and surfaces to be seen in figure.
 (ii) Make 4 small trial drawings of figure or parts of figure. (Use of viewfinders to select aspects.)
(iii) Start paintings.

Encourage children to work directly with paint and with minimum of preliminary drawing.

EXAMPLE 4

Children's games (see page 149), Ashburton Primary School

Rosaleen Wain

First session Looking at Pieter Bruegel's painting *Children's Games*

Discussion points:

What is the picture about?

When do you think it was painted?

What makes you think that?

Is anything still the same today?

How do you think it was painted? (Working drawings, scaling up, master and apprentices.)

Look at the patterns of shapes and spaces. Look at the groups of people. Can you imagine what they would look like if the group turned round?

Are some people nearer than others?

Why does this seem to be so?

Why does the painting look as though you could walk into it, when it is really flat?

There are lots of people. Are they all facing the same way? Are they all standing up? Standing still? Same size? Same shape?

Do you see only part of some people?

Why is this?

Do you think the people are more important to the picture than the buildings or the landscape?

Would the picture be as interesting if there was just a flat wall behind?

If the artist had been able to take a photograph would it have told us as much as the painting does?

If you half close your eyes, can you see a pattern of light and dark shapes?

EXAMPLE 4

Fig. 6.23 Playground games; pencil and crayons.

Fig. 6.24 Building study; pen and wash.

Working like an artist. Drawing studies and paintings by 10/11-year-olds who, after studying the painting Children's Games *by Bruegel, were encouraged to embark upon a painting like an artist – first making preliminary drawings of children's games in their own playground and studies of buildings within the playground, before making their own painting of 'Children's games in my school'. 10/11-year-olds, Ashburton Primary School.*

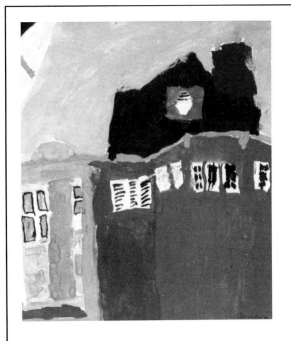

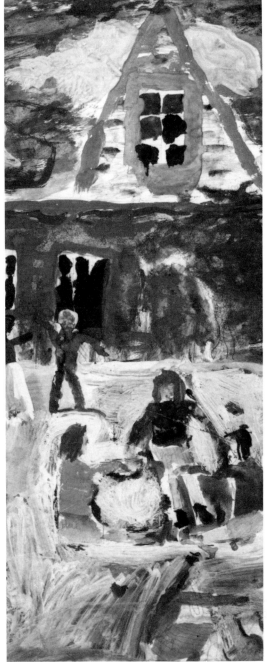

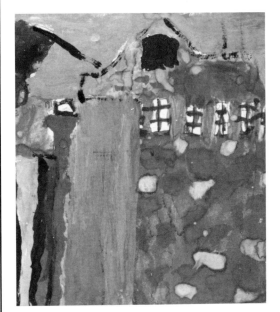

Fig. 6.25 Building studies; powder colour.

Fig. 6.26 Children's games at Ashburton Primary School; powder colour (35 × 50 cm).

EXAMPLE 4

What sort of colours are used?

Are all the reds, blues, greens and browns the same, or can you find different sorts of red or blue?

Do you like the picture?

Is it an easy picture to understand?

Can you read the picture, like a story?

If you were making a picture like this, is there anything you would want to be different?

Second session **Looking around the playground**
Look for changing shapes of moving groups of children. Do two or three children make more interesting shapes than one child alone?

You can make different shapes in PE with a partner, or in threes, than you can by yourself. You can do this in a drawing too.

Can we sometimes guess what children are playing by the shapes they make? e.g. leapfrog, marbles.

Look at the shapes of the spaces between feet. How many heads are tilted one way or another? How many hands are up in the air? How many children are sitting or bending down?

Drawing
In groups, take turns in posing and drawing. Set up a few children in an interesting position that they can keep for five minutes. Make quick drawings with chalk, crayon or charcoal.

Walk round them and decide which is the most interesting view.

Look at the shape of their feet on the floor.

Look at the way arms and legs bend.

Are there any 'windows' through the figures? What shapes are they?

Make as many quick drawings as you can of different groups.

Make your drawings different sizes.

Don't try to do detailed drawings – there won't be time.

You can look at faces and hands more carefully later.

Third session **Looking at school playgrounds and surrounding buildings**
Find an interesting part.

Look for corners, paths, different levels, steps, roof shapes, windows, doorways, railings, walls.

Make a working drawing of the place you have chosen, to give you as much information as possible.

You can write about colours and textures on your drawing.

Look at the size of one building against another. How big does a door or window look against a whole house?

Look for the differences between one building and another.

Do the windows look light or dark?

Why do stone walls look different to brick ones?

Fourth session **Making a picture**
Look at all the drawings you have made. Do you want to use them all?

Make a little plan of your picture.

If you want the children to be the most important part they will have to be quite big, and will probably overlap the drawing of the buildings. Decide which part of the background you want to see.

Make rough cut-out figures like your drawings and move them round on your picture.

Do they need to be bigger or smaller, closer together or further apart?

Which looks best?

Make your picture. Decide whether it is going to be a painting, collage, pastel, crayon or pen and ink drawing. Choose the right size and sort of paper.

7 UNDERSTANDING AND USING WORKS OF ART

Critical and contextual studies in the National Curriculum

The National Curriculum has reinforced the developments of the last decade through which an increasing emphasis has been given within schools on using the work of artists and designers to support children's own making of images and artefacts, and to extend their understanding of the nature and purpose of their work.

The way that children can learn about drawing or painting through examining the methods and systems used by other artists has already been referred to and illustrated in Chapters 5 and 6. Making in art is clearly enriched for children through studying the work of other artists and designers in much the same way that their personal use of language is supported through reading the work of other storytellers and poets. Through reading widely, they come to an understanding of the possibilities of language: through familiarity with the work of other artists they can begin to grasp the possibilities of image-making.

In addition to the requirement that children should learn how to use other artists' methods and systems practically and imaginatively in support of their own work, the National Curriculum in Art also requires that they should be given a better understanding of the way that artists have worked in different times and in a variety of cultures and contexts. This need is summarised in the final report from the National Curriculum Art Working Group *Art for Ages 5 to 14* as follows:

> We believe that it is important for pupils to gain a developing awareness of the work of others. The history of art and the diverse ways in which art occurs in other cultures and contexts used to be taught in their own right. Until pupils have gained sufficient experience to make informed judgements they must proceed intuitively, by simple likes and dislikes rather than by knowledge and reason. As pupils get older, this process should be complemented by the study of art history and social, economic, religious and cultural contexts. Such study requires knowledge, skills and understanding. Pupils need the ability to 'engage' with an artefact, i.e. be willing to devote time and energy to responding and relating to it.

These requirements are summarised in the End of Key Stage Statements for Attainment Target 2 'Knowledge and Understanding' in Key Stages 2 and 3 as follows:

Key Stage 2	Key Stage 3
a) Identify different kinds of art and their purposes.	Identify the conventions used by artists and assess critically their effect.
b) Begin to identify the characteristics of art in a variety of genres from different periods, cultures and traditions, showing some knowledge of the related historical background.	Demonstrate a knowledge and understanding of the principle features of our artistic heritage and appreciate a variety of other artistic traditions.
c) Make imaginative use in their own work of developing knowledge of the work of other artists.	Apply imaginatively the methods and approaches of other artists in the presentation of their ideas and feelings.

For many teachers of art and design, these will be new and demanding requirements. You will certainly need to look to a careful marriage of practical and theoretical work in order to ensure that these requirements do not result in the imposition of a rather artificial teaching of a stereotyped 'history of art' upon your work.

There are many occasions when you will be able to match the study of the work of other artists and designers to your own studio-based work with children, and so bring together practice and appraisal. The study of other artists' systems of drawing or methods of painting can lead naturally to consideration of the artists' work in the wider context of why and where it was made, in addition to studying how it was put together.

The 'Critical studies homework' (Chapter 4, Example 9) illustrates how practical work in the studio can be used to encourage children to read about and research into the work of the artist whose systems they are exploring and using.

Example 1 'A letter from Vincent Van Gogh' is another example of a homework sheet being used to link studio work to the wider consideration of an artist's work. In this example, the teacher has also included a glossary of terms with the copy of the artist's letter so that the children can fully comprehend its meaning in relation to the painting Vincent is describing. In doing this, the teacher is also encouraging the development of that kind of art vocabulary which is essential to an understanding and appraisal of the work of others and which is discussed further in the section 'Writing about art'.

Engaging with works of art and design

Perhaps the most important aspect of working in critical studies with children is in finding ways to encourage them to give proper time, attention and focus to the work of other artists. Because they are so bombarded with visual images in their daily lives through television, film, advertising and the media, it is all too easy for their reading of images to become very undifferentiated. The profusion of images that children see in books and magazines, on the screen and the advertising hoardings, tend to encourage them to 'scan' rather than to pursue images, and to make instant decisions about things they 'like' or 'dislike'. When children or adults visit an exhibition or an art gallery they will often shuttle from one picture to another at great speed, pausing only at those that force their attention upon them.

As in the teaching of drawing and in focusing their looking, there are a variety of ways in which you can encourage children to be more positive and critical in the way that they view the work of other artists and designers. The simplest way of engaging children in some kind of appraisal is to give them a selection of prints or reproductions, to ask them to select the one painting they particularly like and to explain and expand upon their choice. You must remember that 'liking' a picture can be as dismissive as 'disliking' it, and that you will need to pursue the question of like and dislike vigorously by, for example, asking them to distinguish between their liking for the content (what story the painting tells) and their liking for the way the artist has used the elements of visual form to put the image together.

As described in Chapter 4 'Teaching strategies and resources', it is nearly always more productive to engage the children in preliminary discussion amongst themselves and in small groups before trying to generate class discussion about a painting or a group of paintings. One method is to divide the class into six groups to give each group the same set of postcard reproductions of paintings, asking each group to determine democratically their order of preference. Compare the findings of each group and the qualities they find in the most popular work. A group of 11-year-olds placed Degas' L'absinthe top of their list for the following reasons:

> it was realistic;
> the colours were harmonious;
> it looked old fashioned;
> the use of angles to draw your eyes into the picture;
> there was a lot of good detail;

163

it was easy to understand;
they could identify with the characters;
etc.

The selection and choice of those works you present to the children for their appraisal is particularly important. Random choices may be useful to generate discussion in some circumstances, but it is more frequently useful to select a group of works because they lend themselves to specific and detailed comparison as in the following:

paintings in a limited range of colour;
paintings with dramatic light and dark contrasts;
paintings which reveal different treatments of similar subject matter;
etc.

The thematic use of works of art can be particularly useful – both to encourage comparison between the work of one artist and another and to help children to understand that there are many ways of seeing and responding to things as familiar as the traditional components of a still-life group. The selection of work in this way can also be of invaluable support to the children's own studio work. Example 2 describes how one teacher used a group of reproductions of paintings of people as a core element within a project on using the head as the starting point for different kinds of work. This use of works of art – as focus for things seen – is dealt with in more detail later in this chapter.

Because images are so familiar and such an everyday part of our lives, it is sometimes necessary to help children in their looking at pictures through using focusing devices. A picture may take on significance beyond the cursory glance if, for example, you give children small viewfinders and ask them to find the three most interesting parts of the painting, or three areas of the painting that are very different to each other. When children are being asked to examine very complex paintings such as Bruegel's *Children's Games* or Rembrandt's *The Night Watch*, then a viewfinder together with a magnifying glass may be used to put together a 'story board' of the painting – a series of little drawings and descriptions to explain what is happening in the painting.

Some teachers have made good use of oral descriptions of paintings as a means of focus by selecting a work that is appropriate to the level of drawing within the group and then describing it to the children in as much detail as possible. An outline description is given first, so that the children understand what the picture contains, followed by a more detailed description of parts of the painting presented slowly enough for the children to keep pace in their drawing. The children can then compare their version with that of the artist whose work has been presented to them through description, and this leads inevitably to detailed and interesting discussion about the artist's work. For this method to be really successful, you need to be able to describe well, but you also need to think carefully about the size of the drawing you ask pupils to make and about the medium they should use. Detailed and complex paintings are best dealt with in pencil and on a small scale, whereas much simpler subject matter, such as portraits by Modigliani and Van Gogh, can be drawn with colour.

Example 3 gives an account of a project with 15-year-olds, where the children were asked to act as both observer and critic of a chosen painting and to put together a detailed written commentary that another child might work from. In this work, the children were asked to describe the painting objectively and in detail and also to provide clues as to the atmosphere and meaning within the painting. Two parallel classes then exchanged the written commentaries and the children produced a painting based upon the written descriptions. This coming together of appraisal and studio work produced a range of work of considerable interest and some quality (Figs 7.3 and 7.4) and a great deal of discussion when, at the end of the project, the original painting, the commentary and the painting from the commentary were exhibited together.

The use of description to generate children's responses to a work of art needs to take into account the stage the children are at in their own image-making. For younger children, simple objective

 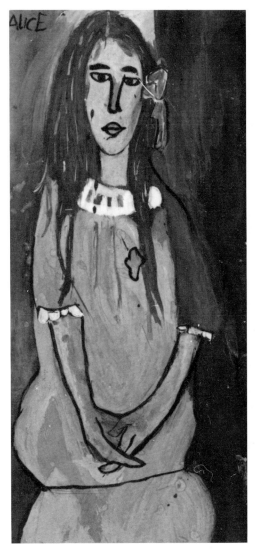

Fig. 7.1 Alice (after Modigliani); powder colour (14 × 25 cm). 8-year-old, Bridgetown C of E Primary School, Totnes.
The children were asked to choose from a large selection of reproductions the one painting they would most like to have in their bedroom. They wrote about why they liked it and then painted their own version for their own room.

Alice Modigliani

I think Alice is sad. I think she has got a sad look on her face. Her eyes are slanted and they are brown. Her dress is pale blue and if I had this picture I would put it in my bedroom. My bedroom is white. I think she looks sad because she has a pursed up mouth. She is thinking very hard about something.

Dunstan Ferris Age 8

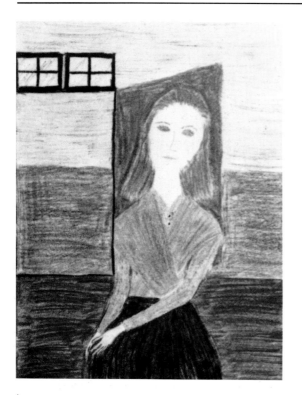

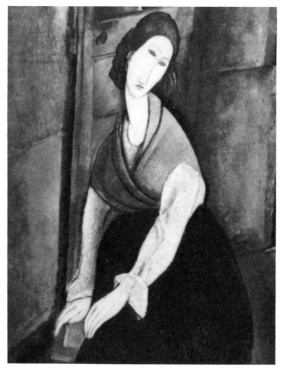

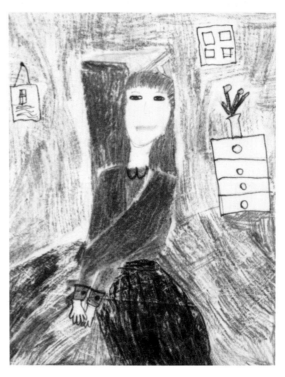

Fig. 7.2 Drawings from oral descriptions of the painting *Jeanne Hebateurne* by Amadeo Modigliani; coloured pencils (15 × 20 cm). 10-year-olds, St Margaret's C of E Primary School, Torquay.

The teacher described this painting to the class and they drew their version in response to the oral description. This task generated a great deal of talk about the painting when the children came to compare their own versions with the original painting.

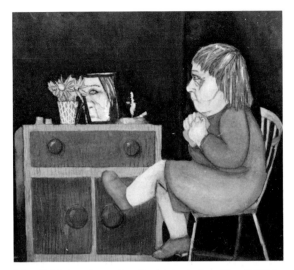

Fig. 7.3(a) A soul called Ida (after Fig. 7.3(b); tempera (50 × 38 cm). 15-year-old, Audley Park School, Torquay.

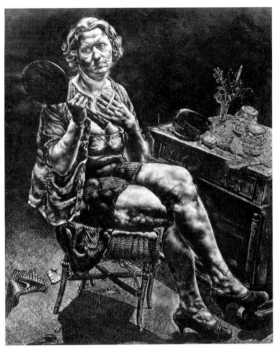

These paintings were in response to written descriptions of paintings made by the children themselves. Two parallel classes undertook an appraisal and description of a favourite painting. The two classes exchanged written descriptions and the children then made paintings based upon these descriptions.

Fig. 7.3(b) *Into the world there came a soul called Ida*, oil on canvas, 1929–30 by Ivan Albright (140 × 118 cm) from the collection of The Art Institute of Chicago. © The Art Institute of Chicago. All Rights Reserved.

Fig. 7.4 After *The card players* by Paul Cézanne; tempera (50 × 38 cm). 15-year-old, Audley Park School, Torquay.

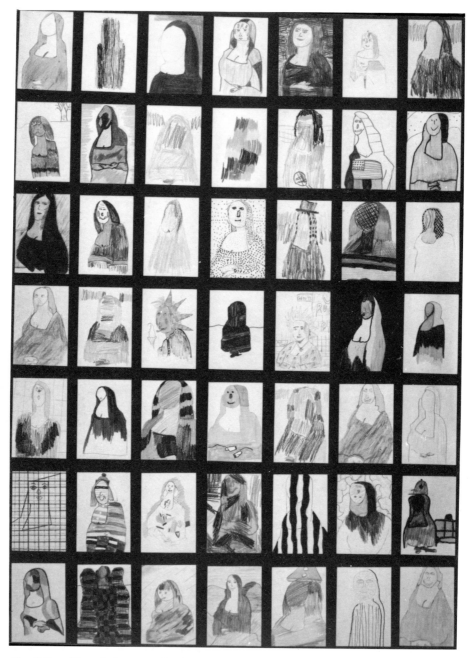

Fig. 7.5 49 variations on the *Mona Lisa*; various media (10 × 14 cm). 12-year-olds, Audley Park School, Torquay.
These variations on the Mona Lisa *were made following upon a discussion about the painting and about the publication* Mona Lisas *(Studio Vista), which contains the work of many graphic designers who have responded playfully to this archetypal image.*

description of content is frequently enough to arouse their interest. Older children need more than objective description to maintain their interest, as they are often as much concerned with what the painting means as with what it appears to describe. They respond well to works that have layers of meaning (which goes some way to explaining their interest in surrealism and fantasy), because they have begun to realise in their own response to images that images have meanings over and above their appearances.

It is natural for many children to want to draw their favourite paintings in support of their comments and written descriptions. For many, the drawing or copying of a painting is a genuine form of appraisal and may give them understanding of the work which would be difficult to achieve through the more formal means of language.

Direct studies from works of art

There are various ways of working directly from works of art, whether in their original form or in reproduction. There has been considerable controversy surrounding the notion of copying or 'borrowing' from the work of other artists. Despite the fact that a great deal of copying is done in schools, the idea of using a painting or the reproduction of a painting in this kind of way has been seriously questioned by some teachers. There is a significant difference between an image created by an artist, in which he has observed and refashioned some aspect of the world, and the image created by the mechanical eye of the camera lens. By observing an artist's work, children can learn much about how things seen, imagined or remembered can be translated into media. Even in reproduction, it is difficult to observe any painting by Cézanne, Van Gogh or Matisse without being aware of the way in which the artist uses both pigment and colour. Once you move away from studio based work and into the environment, many of the phenomena we might want to ask children to observe and use are both complex and transitory – changes in light and in atmosphere and continuous movement make it

very difficult for children to observe such things as water and clouds with any certainty. Children can learn much about how to paint clouds by observing paintings by Constable. Similarly, they can gain better understanding of the rendering of water through studying David Hockney's paintings of swimming pools.

Although it can be valuable to use artists' work in this way and children can learn a great deal from making a 'copy' of another artist's work, such use of pastiche has to be managed carefully and its purpose placed in context. It is useful for children to know that copying 'the Masters' was once an important part of the way that artists were trained, and that its purpose was to encourage the apprentice painters to explore systematically the way an established painter had made a work. Copying had value to artists when their own work was illuminated by making the copy!

It is worth remembering and illustrating for children the way that Vincent Van Gogh, whose work is so assiduously copied in schools today, made many copies of drawings and paintings by other artists during his own training. He studied artists whose work he wished to emulate and whose influences he absorbed into his own remarkable and individual way of working.

Making a copy of another artist's work can be valuable if, in making the copy, the children's skills and understanding are moved forward. There is no value in making a copy for its own sake and using pastiche simply to provide children with easy access to making nice pictures. Making a copy is a natural way to begin exploring the different methods and systems used by other artists, but it is only the first step towards helping children to use other artists' systems to inform their own work.

Children in primary schools seem to be cheerfully uninhibited in their 'borrowing' from works of art. They enjoy the challenge of making a picture 'like' that painted by a famous artist and one which they themselves like (Figures 7.6–7.9). In their first two years in secondary schools, they respond particularly well to paintings that are descriptive and which in reproduction provide

Fig. 7.6 After *Favourite courtyard at Fez* by Patrick Proctor; water-colour (30 × 21 cm). 10-year-old, Woodford Junior School, Plympton.

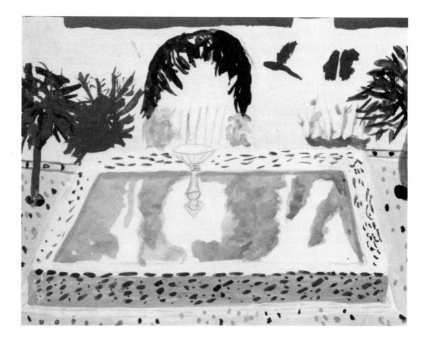

Fig. 7.7 After *Self-portrait* by Vincent Van Gogh; powder colour (24 × 28 cm). 11-year-old, Woodfield Junior School, Plymouth.

Direct studies from works of art. These copies or 'borrowings' were made by children from paintings they found particularly pleasing – either for their content or because of the way the artist has used colour. All of them show how much children are encouraged to use colour and paint very positively when they are asked to study a painting very carefully.

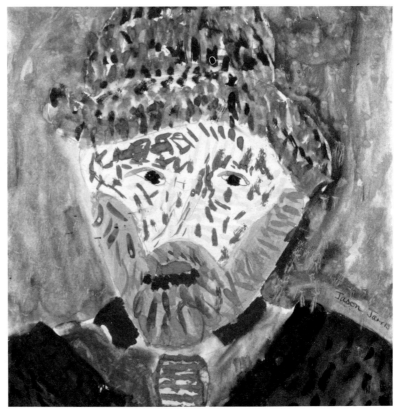

Fig. 7.8 Detail study from *The Doctor* by Sir Luke Fildes; charcoal and pastel (19 × 24 cm). 11-year-old, Manor Junior School, Ivybridge.

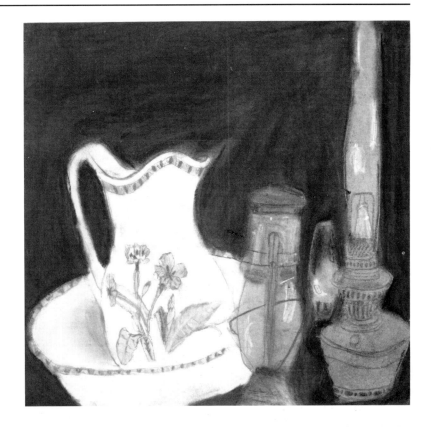

Fig. 7.9 Detail study from *Portrait of the Infanta* by Velasquez; tempera (22 × 35 cm). 15-year-old, Uffculme School.

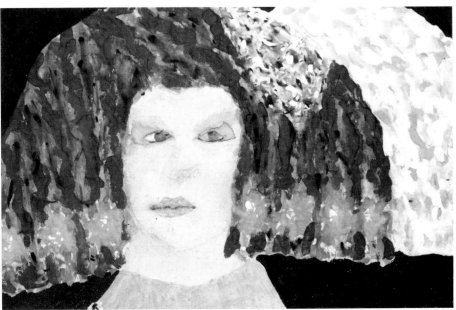

helpful evidence of the way that paint has been used and applied, as in the work of many of the Impressionists and Post-Impressionists. As the need to make more complex images of personal meaning grows in children, they can gain much support through the study of work of painters, illustrators and graphic designers who have dealt with similar problems. There is some limited value in copying a favourite painting in its entirety – especially when the work is chosen to help the student deal with certain elements or properties in the making of the copy.

Working directly from works of art has a more immediate and general use when different methods are used to focus the children's attention upon particular things they can learn through the study of a painting. Perhaps the most familiar of these is the use of various kinds of viewfinders and grids to select one part of the work that provides interest and useful study. Many paintings can be used in this way as the vehicle for group work in colour: a reproduction is divided into sections and each child in the group has to reproduce that section carefully enough to match its neighbours. Similarly, a slide of a painting may be projected onto a wall that has been divided into a grid. The children choose one section for themselves that they like and want to match in other media.

Paintings, drawings and prints can be used very directly as source material for work in other media. It can be very valuable to children to ask them to make studies of the properties of colour, pattern, surface and design within other works and then to translate or re-work these in different materials and through using different processes. Figures 7.10 to 7.13 illustrate the way that sources as diverse as Lowry paintings and traditional Japanese woodcuts have been used to generate work in printmaking and ceramics.

Since children's experience of works of art is predominantly through reproduction, it is also worth using the fact that we become familiar with a work on a very different scale to the original. Where possible, it is useful to match a poster reproduction of a painting which may be close to the size of the original work with a set of postcards of the same painting, so that children can have their own small copy of the work being observed. Similar useful comparison can be made between a photographic reproduction of a painting and an enlarged projection of a slide of the same painting. Some good use has been made of group work combined with projection to enable a class of children to reproduce very large paintings at their original size. The sheer scale of some paintings needs to be experienced for them to be properly valued. In one school, all the children in Year 7 combined to reproduce one of the passages from Stanley Spencer's war-time paintings of engineering shipyards on the Clyde. Interesting work results from the reverse process – accepting the scale of the postcard and slide and asking children to work from these sources on the same scale as the reproduction (Fig. 7.14).

Paintings can also be used to set the children more subtle problems. It is usefully demanding to ask children to rework a painting in a different colour range, especially when different groups within the class are asked to use different combinations of colours. This can lead to some useful discussion about the way in which colour change can affect the mood of a painting. Older children can be set the challenging task of taking one painting and reworking it in the style of another artist – this works particularly well when they have already been comparing paintings similar in content but from very different schools of painting.

Interesting work can also be generated through considering the way that works of art are presented to us publicly and in many different contexts. Familiar paintings are used to decorate all kinds of everyday objects and we may find them on the lids of chocolate boxes, on stamps, matchboxes and tea-towels. Works of art are used widely to advertise all kinds of goods and services. Do we regard a work differently when we see it in a gallery, in a calendar or in an advertising hoarding? Does making a 'pop-up-book' version of a familiar work, or a cartoon strip to animate the story told in a narrative painting, extend our understanding of the work?

Relief prints using paper and card plates based upon the study of traditional Japanese woodcuts.

Figs 7.10 to 7.11 Japanese figures; colleotypes (15 × 26 cm). 13-year-olds, Teignmouth School.

Figs 7.12 and 7.13 The cripples; pencil and charcoal (24 × 16 cm), ceramic (27 × 21 cm). 16-year-old, Teign School, Kingsteignton.

Figure study from the painting The Cripples *by L. S. Lowry (City of Salford Art Gallery). One of a number of studies used as the basis for the design of the ceramic piece of a cripple with two dogs.*

Figures 7.15 to 7.20 are drawings, studies and collage made by children in Years 8 and 9 who were exploring the idea of framing, and how the portrait is read 'differently' when presented in different circumstances. They studied different kinds of framing and used their studies to generate the making of frames for photographs of themselves, where the 'frame' becomes the most important part of the work.

Works of art and design are very useful as direct reference and resource material, and can be used to generate a whole variety of different kinds of work, some of which have been described here. There is no doubt however, that their principle value in teaching is to demonstrate to children the wide range of methods and systems that artists have used to describe and comment upon their own experience, and which can illuminate for children their own making of images and artefacts.

Using artists' work as the focus for things seen

The value to children of referring to other artists' methods and systems of work in order to inform their own drawing and painting has already been discussed in Chapters 5 and 6, and illustrated in Figs 5.35 and 5.36, and 6.16 to 6.26.

The National Curriculum in Art now requires that there should be systematic use of reference to the work of other artists in order that children can be better informed: about both the technical and expressive possibilities of making images; about how colour may be used and applied and how it

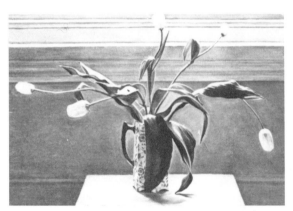

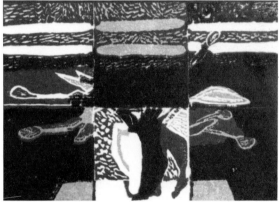

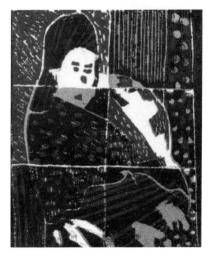

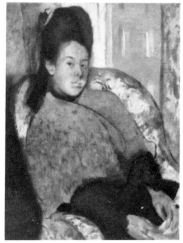

Fig. 7.14 Responding to the scale of works of art seen in reproduction; lino cuts based on postcard reproductions. 14-year-olds, Eggbuckland School, Plymouth.

Fig. 7.15 'England's Glory' matchbox; collage and inks (14 × 8 cm).

Figs 7.15 to 7.20
Framing a picture. 13 and 14-year-olds, Eggbuckland School, Plymouth. Work undertaken to explore the relationship between an image and its 'framing' and how a portrait may be 'read' differently when presented in different kinds of ways. The children explored different kinds of framing and went on to make their own self-portraits in which the frame was the most important part of the image.

Fig. 7.16 Self-portrait on a matchbox; pencil (9 × 14 cm).

Figs 7.17 and 7.18 Framing studies; pencil, inks and felt pens.

Figs 7.19 and 7.20 The frame as self-portrait;
photograph and mixed media (17 × 20 cm).

may be used to convey atmosphere and mood; about how to use mark-making both descriptively and expressively; about the different ways that clay may be used to construct a variety of forms.

Such systematic reference to, and use of, the work of other artists is also essential towards establishing a real working link between studio practice and critical studies, and in helping children to see the link between their own work in schools and that in the wider community of art and design.

By referring to the work of other artists, children can obtain valuable technical information about how to deal with a wide variety of subject matter and the alternative ways in which they can approach a familiar theme.

Figures 7.21 to 7.23 illustrate how children in Year 7 were encouraged to seek out the pattern formations and surface qualities in the familiar views from their own school windows through referring to the mark-making systems used by Vincent Van Gogh in his own landscape drawings. This reference to Vincent's work clearly invigorated their own drawing as well as informing them about the way that marks made with a pencil or ballpoint pen could be used in different ways to describe the complex patterns in the countryside about their school.

Similarly, in Figs 7.24 and 7.25, fifteen-year-olds have been given the confidence to make large and vigorous drawings of such daunting subjects as Exeter Cathedral through first visiting an exhibition of Dennis Creffield's drawings of cathedrals. Their own comments on Creffield's work illustrate how much they learnt from viewing the work of an artist before embarking upon such a task themselves:

> He has taken a lot of risks with the way he has drawn them, using lines and swirls. There is a great feeling of depth, height and heaviness in them that helps bring across the size of the buildings.

> The drawings are impressive. They are done in charcoal, freely and full of energy, lacking in detail. You really feel that he was putting all of his energy into them. They are large drawings and you can see where he has been smudging the whole drawing with his hand.

In these two examples of studying and using

177

Figs 7.21 to 7.23 *Using another artist's drawing system. 11-year-olds, Uffculme School. Making reference to other artists' drawing systems in preparation for making a landscape drawing of the school environment.*

Fig. 7.21 Photograph of the view from Uffculme School.

Figs 7.22 and 7.23 Landscape drawings; pen, brush and ink (27 × 20 cm).

Figs 7.24 and 7.25 Exeter Cathedral; charcoal, brush and ink (40 × 55 cm). 15-year-olds, Audley Park School, Torquay.

Drawings of Exeter Cathedral which made following a visit to an exhibition o, Dennis Creffield's drawings of English cathedrals.

another artist's drawing methods, the children may have also gained some insight into the way that technical methods may be harnessed to support a personal or expressive resonse to natural or made forms. Such links can be made more explicit when a variety of artists' work is used as reference and source material for making images based upon such familiar subject matter as the landscape, self-portrait or figure.

By presenting children with evidence of the different ways that artists have responded to similar visual problems to those confronting them, you will make them more aware of the possibilities within the theme other than that of straightforward description.

Figures 7.26 to 7.29 are figure drawings made by fifteen-year-olds. Children studied a number of old master figure drawings, to see how different artists conveyed the feeling of weight and balance, before making their own drawings of figures in the studio. They then compared their drawings with those by artists working in the twentieth century who have used very different means to describe the weight and form of the figure. By studying these, they have developed further drawings and paintings of the expressive figure.

Example 4 'Self as object' describes a project with children in Year 9 in which children explored the work of a number of contemporary artists who have used visual metaphors to describe themselves and others, before making their own self-portraits in this way (Figure 7.30).

Figs 7.26 to 7.29 *Figure drawings. 15-year-olds, Dawlish School. Figure drawings made following the study of a number of Renaissance drawings of figures, to see how other artists created a sense of weight and balance in representing the figure. These were further developed through comparison of children's own drawings with those by twentieth century artists using very different means to represent the figure.*

One of the most useful ways of helping children to understand how they might develop ideas is through giving them opportunities to compare an artist's working drawings or sketch books with the finished work. This will demonstrate to children the way that an artist works, and show the various stages between the first observations and the finished work. Many publications about the work of artists and craftworkers now include good reproductions of their working drawings. Many artists' working methods have been carefully documented, as in the good facsimiles that are now available of sketch books and working drawings by artists such as Leonardo da Vinci, Henry Moore and David Hockney.

In Chapter 5, Example 5, 'Drawing upon the landscape' working drawings by Graham Sutherland made in preparation for his painting *Midsummer Landscape* illustrate how he collected and selected information from the environment in preparation for making this painting.

Fig. 7.26 Standing figure; pencil (28 × 35 cm).

Fig. 7.27 Standing figure; pastel and chalks (38 × 55 cm).

Fig. 7.28 Standing figure; pencil (28 × 35 cm).

Fig. 7.29 Standing figure; charcoal and chalks (38 × 55 cm).

A selection of studies and self-portraits by children in Year 9 who were exploring the work of a number of contemporary artists who have used visual metaphors to describe themselves and others. (This work is described in Example 4.)

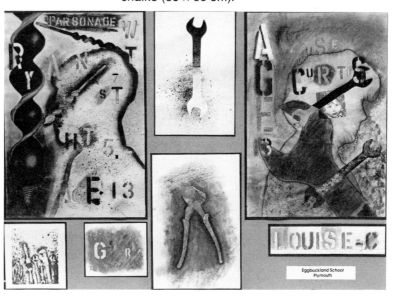

Fig. 7.30 Self as object; various media. 14-year-olds, Eggbuckland School, Plymouth.

In Chapter 8, Figures 8.21 to 8.27 illustrate how effectively children can respond to the opportunity to see both the artefacts made by a ceramicist and the working drawings that illuminate the process of her thinking and her making.

Reconstructing works of art

A familiar device, and a useful one towards helping children understand how a work is made, is to reconstruct for them an approximation to the source material for the painting. Some works are simple to reconstruct within the studio. Van Gogh's *Yellow Chair with a Pipe* and Matisse's *Still Life with Goldfish* may interestingly be compared with something very close to their real equivalent displayed alongside the painting. Discussion about, and comparisons between, the real and the painted images can be valuable starting points for the children's own paintings upon similar themes.

Figs 7.31 and 7.32
Reconstructions of still life groups.

Studio reconstructions of still life paintings by Vincent van Gogh and Georges Braque, used in association with reproduction of the paintings to generate discussion about how artists are selective in the information they use, even when working from such traditional source material as the still life group.

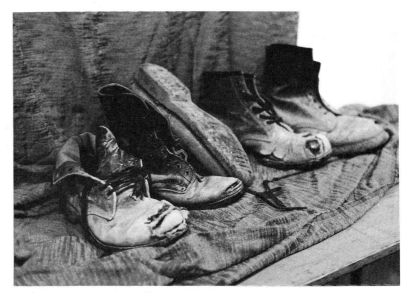

In making these comparisons, the children will come to see that even in such familiar and routine work as making a painting from 'still life', the artist is selective about the information that is drawn from the group. Further comparison can be made of the way that different artists have responded to the familiar clutter of still life groups.

Many interesting examples may be used to support children in their drawings and paintings of figures in the environment through reference to the work of other artists and reconstruction of the event within the art room. This is an area of work in which most children find difficulty once they need to move beyond the drawing of the single posed figure. Example 3 'Children's Games' at the end of the previous chapter has already described one such case. Figure 7.33 illustrates how one teacher used Henry Moore's wartime drawings of people sheltering and sleeping underground to generate some feeling into the routine of drawing the draped figure. Children were encouraged to observe and compare the differences between Moore's drawings and their equivalents posed and draped within the studio as a preliminary to making their own drawings.

In all this work, it is interesting to see the interaction between what the children have observed and their view of what has been achieved by another artist. The range and quality of response suggests that using works of art in these various ways helps to extend children's understanding of what it is possible to achieve within a drawing or painting. They are challenged by the confrontation with a work of art – even when it is only postcard-sized – and within this challenge engage with a greater vocabulary of possibilities.

The use of works of art in support of children's personal development

The work of other artists can be used as source material for the children's own personal work. Paintings – through their content – can encourage

Fig. 7.33 Sleepers. Paintings of draped figures in the studio following upon observation of and discussion about the wartime underground shelter drawings by Henry Moore; powder colour (45 × 50 cm). 14-year-old, Plymouth High School for Girls.

183

Fig. 7.34 Reproduction of painting *General and Mrs Francis Dundee* by Raeburn.

Fig. 7.35 'General and Mrs Dundee – five minutes later'; tempera (36 × 50 cm). 16-year-old, Ilfracombe School.

children to be inventive, sometimes at the simple level of story-telling. David Hockney's *Mr and Mrs Clark and Percy* is one of those paintings that lends itself admirably to different kinds of surmise, as does Gainsborough's *Mr and Mrs Graham*. There is something about the formal family group that encourages children to ask questions: How did this painting come to be painted? What happened before and after? What kind of people are they really like when they are not posing for an artist? How would I represent my own family within this kind of convention – which room and which possessions would best illustrate or flatter the status of my parents?

Imagining the painting as one still frame within a film can lead to interesting conjecture about what happened five minutes before or after (Figs 7.34 and 7.35)!

Using computer-aided and animation systems to explore the ambiguities in time which are evident in the work of the Surrealist painter Renée Magritte.

The use of computer-aided drawing and the capacity to make simple animations through using the new technology, allows children easy access to this notion of exploring the picture 'fixed in time' and its imaginative possibilities. Figure 7.36 illustrates the way in which a fifteen-year-old has used computer animation to explore the ambiguities inherent in René Magritte's series of works of bowler-hatted men.

The work of other artists may also be used to help children see how they can make image-making say things that have personal meaning and significance over and above appearance. Older children are frequently required to work on themes which make demands upon their abilities to use images in this kind of way. When faced with the problem of responding to such themes as 'Familiar and unfamiliar', 'Distortion' or 'Metamorphosis', it is of considerable help to children if they are given access to reproductions of the work of other artists who have explored similar areas of concern.

Sometimes it is possible to make an inventive

Fig. 7.36 The man in the bowler hat; computer-aided drawings. 16-year-old, Coombeshead School, Newton Abbot.

Examples of the result of asking children to recreate in contemporary terms a form of painting typical of previous conventions within art.

Fig. 7.37 Contemporary ikon; pencil (21 × 32 cm). 15-year-old, Eggbuckland School, Plymouth.

Fig. 7.38 Contemporary miniature, Princess Diana; mixed media (7 × 10 cm). 14-year-old, Eggbuckland School, Plymouth.

match between the work of one school of artists and a visual problem of concern to children. One teacher used medieval ikons with his students as the basis for exploring the theme of figures under stress (Fig. 7.37). The same teacher also used the Elizabethan miniature as a starting point for the children's paintings of contemporary heroes (Fig. 7.38).

It is clear that children do benefit considerably from the opportunity to examine their own personal and expressive work against that which has been achieved by other artists. This has some value where the children can be given access to the work of other artists in reproduction. It takes on an altogether deeper significance when children can be given experience of original works or direct contact with a contemporary artist at work through the 'Artists in schools' programme.

Developing an art vocabulary

The National Curriculum in Art requires that children be taught to develop an appropriate art vocabulary. Without this, they are unable to engage properly in constructive and informed discussion about their own work, or to reflect upon and appraise the work of others.

The development of an art vocabulary begins by including, in all talk about art, reference to and use of the appropriate art language, and of those

technical terms that will support informed dialogue about making and understanding art. For example, requiring children to describe colours by their proper and technical names, or to distinguish between such processes as montage, collage and frottage.

Because 'reading' works of art can be a complex process, you will need to provide children with a structure for their talking and writing about art that will enable them to engage with work in different kinds of ways. Just as they draw for different kinds of purposes, children may need to talk and write about art for different reasons.

Enabling children to enter into a 'dialogue' with a painting requires careful thought about the teaching strategies needed to help them focus upon what the painting is about, what it means, why it came to be made, etc. Engaging with a single work may be complex enough: making sense of a large exhibition containing many kinds of work is daunting, unless children are provided with some kind of structure to help focus their attention and interest.

The development of an art vocabulary may begin as in Example 1 'A letter from Vincent Van Gogh' where, in association with work based upon Van Gogh's painting of his bedroom at Arles, children have been given copies of Vincent's letter to his brother Theo about the painting, and the teacher has made the letter more accessible to the children by providing a simple glossary to explain some of the words and phrases used by Vincent in the letter. In the same school, the staff use homework assignments to reinforce access to, and understanding of, the technical terms used to describe different processes, methods and styles of working.

Example 5 'Art vocabulary homework' illustrates a typical vocabulary assignment and examples of the children's response.

It is a comparatively straightforward matter to ensure that children are helped to develop a basic and necessary technical vocabulary to enable them to talk and write appropriately about different kinds of art forms and the materials, tools and processes that help to shape them.

Children's ability to describe, talk, and write about what they can see in a work of art is influenced by the way that you focus their looking through good talk and discussion, just as you do when you use good talk to focus their looking in preparation for making a descriptive or comparative or analytical drawing. As in making a drawing, how they see the work and respond to it through discussion, note-taking or writing, will be influenced by the kind of questions you ask them and by the different tasks that you might set them in response to another artist's work.

Example 9 in Chapter 4 'A critical studies homework brief' is a good example of a task that might be presented to children in Year 7 in response to viewing an artist's work. This would encourage them to talk and write about different aspects of the work, and for different purposes. When presenting older children with the more complex task of making sense of an exhibition of an artist's work, you will need to use worksheets or questionnaires. Set them a variety of tasks that will encourage them to draw, make notes and write constructively about the work – to analyse aspects of individual works, to make comparisons between them and to seek a personal viewpoint.

Example 6 'An exhibition questionnaire' shows how a group of children in Year 10 were supported in their visit to a retrospective exhibition of the work of the painter Paul Nash through the use of a questionnaire, carefully planned to involve them in a variety of looking, verbal and written responses. These included drawing and notation, finding phrases to describe qualities in the painting, making comparisons between source material and the painter's response and making reasoned arguments in support of particular works within the group.

Where you are introducing children to work that may be unfamiliar, you may need to use some structured vocabulary to help them 'read' it. For example, you could introduce the work of such 'colour field' painters as Mark Rothko or Johannes Itten by first exploring colour associations through word play in order to help them 'key into' the nature of the work.

By encouraging children to use language with a variety of purposes, you will be helping them to acquire a vocabulary for reading and engaging with works of art, craft and design in different kinds of ways and for different purposes. They will, therefore, be able to 'read', appraise and understand the work of others more effectively.

Galleries and museums

Children's access to original works of art is very dependent upon local circumstances. If you teach in London or in one of the major provincial cities, you are able to give your children generous experience of good collections of work and, in many cases, you will have the back-up and support of education officers and working spaces within the galleries. It is an enormous advantage to have a good permanent collection of work which you can get to know well, and which you can use selectively, within reasonable travelling distance.

Most galleries and museums have permanent collections of work on changing display and, in addition, touring and temporary exhibitions of the work of artists and designers. If you wish to use these collections, you will need to familiarise yourself with what is available in the permanent collection and make sure that your school is on the gallery mailing list so that you receive advance information about the programme of touring exhibitions.

Where your local museum or art gallery has a good permanent collection, it is useful to collect any books, posters, slides or postcards relating to works in the collection that you would like to study with children in your school. You can use these as the basis for discussion and study about the works before you visit the gallery, and to familiarise the children with the range of original work they will be able to see.

This is nicely exemplified by the primary school teacher who gave each child in her class a postcard of one of the works in their local gallery, which they studied and wrote about before making their visit. Their first task was to find 'their'

painting, and make notes about the differences between the original work and its postcard reproduction. This brought home to them the significant difference between a work of art in its original form and in reproduction. A postcard of a painting gives no indication of its real size, and very little information about the way that it is made through the application of pigment upon a ground of paper, canvas or wood. It is even more difficult to understand how such three-dimensional forms as ceramics, sculpture and carvings are made from the study of a photograph on a postcard. They need to be experienced in the round and, where possible, to be handled in order to appreciate their tactile qualities.

Gallery visits must be made for a real purpose. Open-ended visits can too easily result in the children achieving little more than visual indigestion. Focus the visit so that only a few works are used for discussion and comparison and make your choice carefully to support and extend current studio work in the school.

If you work and teach a long way from a good permanent collection, you have to rely on the occasional day trip to see major exhibitions. Visits to touring exhibitions do need some preliminary preparation. It is essential that you see the exhibition before you take the children to visit it. Many exhibitions need the support of well prepared study sheets and questionnaires to make them accessible to children and to help them use the visit constructively.

Sometimes – in collaboration with gallery staff and local advisers – it is possible to set up other kinds of back-up to visiting exhibitions. In Exeter, we were able to support the visit of a major exhibition of the work of Matthew Smith by filling the museum's schools room with reconstructions of many of the still-life paintings in the exhibition. This meant that children visiting the exhibition were able to benefit from the opportunity to work directly from source material similar to that they had seen in the paintings.

Many of the smaller and independent galleries will give enthusiastic backing to proposals to involve children in workshops and other activities

that are related to the content of the exhibitions they provide.

Artists in schools

The most immediate way for children to learn how art and design is made is to see artists and designers at work in their own schools, to be able to hear them talk about their work and to see the work in progress. More than anything else, the artist's presence in school will help children to recognise the reality of being an artist, and that making a drawing, a tapestry or a ceramic sculpture is 'real' work requiring serious thought and endeavour!

You can give children some sense of the artist and designer at work through using many of the very good films and videos that are now available about the work of individuals and groups of artists. These generally show the artist, craftsworker or designer talking about a body of work, revealing the references and sources for their ideas and demonstrating how their work is made. Although these can be very useful in providing evidence of the rich variety of forms and processes that artists may use, they are no substitute for the real experience of the artist's presence.

You can have access to the work of artists and designers at many different levels, ranging from an afternoon's visit by a local craftsworker to talk about and demonstrate their work, to a full-blown residency by an artist that may last for up to a month or so.

You will need to become familiar with artists, designers and craftsworkers working in your local community who might be willing to visit your school. In most communities you will find those who have trained in one of the art and design disciplines, who are practising artists and whose experience might be called upon. These may be as various as a local potter or book illustrator, a designer working for a local company, or art teachers and lecturers working in local schools or colleges. Some colleges and faculties of Art and Design use their local schools to give art and design students opportunities for work experience in the local community, and there are also a number of post graduate courses where students training to be teachers are encouraged to undertake residencies in local schools as part of their own training and preparation to be teachers.

There is now a long history of successful residencies by artists in schools, and considerable evidence to show how effectively such occasions support, excite and enrich the work of children. Residencies can work in a whole variety of ways and are most successful where there has been careful negotiation between the artists and the teachers concerned as to how best to make use of the artist's presence. The main purpose of a residency should be to give children the opportunity to see an artist at work and to witness the progress of making a work from the first ideas to some kind of resolution. In addition, many artists enjoy the opportunity to work alongside and teach children during the course of a residency, and through this to influence the way in which children embark upon similar work and projects for themselves.

Figures 8.21 to 8.28 in the following chapter illustrate well the influence of an inventive ceramicist upon the work of a group of 16 and 17-year-olds who had the opportunity to spend three days working with her.

If you wish to use a professional artist-in-residence, you will have to explore the various funding opportunities available to you in your area. The average cost of a residency is about £100 per day, including travelling expenses. The Regional Arts Associations are the principal source of funding for such ventures, and most of them publish a directory of artists, craftsworkers and designers who are available in your region to undertake residencies in schools. It is a general principle that the schools should match such funding from their own resources. Up until the advent of the local financial management of schools, it was common practice for Local Education Authorities to provide funding for residencies. However, as the bulk of funding for education is now within the schools this practice has declined. Nevertheless, many schools have used the new funding systems to initiate their own

programmes of professional residencies for a range of arts activities, and frequently these are undertaken in association with the organisation of Art Weeks or Festivals by the schools and their communities. These can be significant occasions for the school to act as the focus for celebrating the arts within the local community.

There are also increasing opportunities for commercial and industrial sponsorship of the placing of artists in schools, both through funding from such major national companies as Sainsbury's and Marks and Spencer, and such local initiatives as the primary school's neighbouring company which has agreed to donate £200 per annum to the school so that they can have regular visits from artists working in the local community.

Bearing in mind that the majority of art specialists in secondary schools are themselves practising artists, there is plenty of opportunity for informal exchanges of teachers between schools to give children experience of watching an artist at work. It can also be of value to children to be able to witness your own work as an artist. Art is one of those rare subjects in schools that is actually taught by practitioners. When you draw with the children or show them and talk about your own work, you are adding something to their understanding of the making of art.

The dialogue between artist and children helps children to appreciate that making a drawing, a painting, a print or an artefact depends as much upon perseverance as it does upon inspiration.

EXAMPLE 1

A letter from Vincent Van Gogh, Eggbuckland School, Plymouth.

Peter Riches *Head of Creative Studies Faculty*

A homework sheet used to link work in the studio to the wider consideration of another artist's work. Van Gogh's painting of his bedroom at Arles is illuminated through the inclusion of his letter about this work to his brother Theo. The teacher has included a glossary of terms with the copy of Van Gogh's letter so that the children can fully appreciate its meaning in relation to the painting Vincent is describing.

VAN GOGH LETTER CRITICAL STUDIES 1/5/90

Years 7 & 8

	Words	Meanings in Context of Letter
1.	Sketch	A rough drawing
2.	Canvas	Strong coarse cloth used by artists when painting in oils
3.	Lilac	Pale purple colour
4.	Inviolable	Undisturbed/left untouched
5.	Suppressed	Prevent from being seen
6.	Tarascon diligence	Title of another painting by Van Gogh

EXAMPLE 1

My dear Theo, [Arles, mid October 1888]

At last I am sending you a small sketch to give you at least an idea of the form which the work is taking. For today I am all right again. My eyes are still tired, but then I had a new idea in my head and here is the sketch of it. Another canvas of size 30. This time it's just simply my bedroom, only here colour is to do everything, and giving by its simplification a grander style to things, is to be suggestive here of *rest* or of sleep in general. In a word, to look at the picture ought to rest the brain or rather the imagination.

The walls are pale violet. The floor is of red tiles.

The wood of the bed and chairs is the yellow of fresh butter, the sheet and pillows very light lemon-green.

The coverlet scarlet. The window green.

The toilet table orange, the basin blue.

The doors lilac.

And that is all—there is nothing in this room with closed shutters.

The broad lines of the furniture must again express inviolable rest. Portraits on the walls, and a mirror and a towel and some clothes.

The frame—as there is no white in the picture—will be white.

This by way of revenge for the enforced rest I have been obliged to take.

I shall work at it again all day tomorrow, but you see how simple the conception is. The shadows and the thrown shadows are suppressed, it is coloured in free flat tones like Japanese prints. It is going to be a contrast with, for instance, the Tarascon diligence and the night café.

I am not writing you a long letter, because tomorrow very early I am going to begin in the cool morning light, so as to finish my canvas.

How are the pains? Do not forget to tell me about them.

I hope that you will write one of these days.

I will make you sketches of the other rooms too some day.

With a good handshake,

Yours,
Vincent

EXAMPLE 2

Myself and others, Eggbuckland School, Plymouth

Peter Riches *Head of Creative Studies Department*

Introduction

The whole idea of physical appearance (gesture and expression) is inextricably linked to notions of attitude, value and habit at different stages of development, and germane to personal and social development in schools across the curriculum. In traditional terms, it might impinge on parallel work in English (including drama), history (economic and social) and on art and media studies. This scheme made a genuine attempt to employ historical art material both to stimulate and to support creative work.

Theme

The theme 'Myself and others' encouraged a more particulised kind of looking and recording. At this level of operation, children were required to use specific data – culled from painting reproductions, drawings of themselves and/or their family, photographs of themselves and/or their family – to enrich their general visual and linguistic knowledge of 'themselves and others'.

Within the overall framework, four areas of activity were pursued:

(a) self – the idea of recording stages of development (*drawings*);
(b) others – the manner of artistic interpretation in a pre-photographic age (*written descriptions*);
(c) self and others – the focus on facial expression related to age, personality and emotion (*paintings*);
(d) self and others – the translation of abstract thoughts into visual form (*card constructions*).

Programme

Self
In the way people *physically* change from birth to death, there is a wealth of interesting facial data to be collected at each 'general' stage, i.e.

infancy ⟶ childhood ⟶
adolescence ⟶ maturity ⟶ old age.

EXAMPLE 2

Employing themselves as the central piece of evidence in this chain, the children recorded three faces in developmental sequence, e.g.

childhood \longrightarrow adolescence \longrightarrow maturity.

Apart from recording themselves in HB pencil with the aid of a mirror at early adolescent stage, they were encouraged to collect information of themselves and their parents and their grandparents (and great grandparents!) for use in the project.

Paintings of faces

To commence this phase of the scheme, the film strip 'Who do you think I am?' (BBC Radiovision) was screened alongside slide examples of Rembrandt and Van Gogh self-portraits, illustrating dramatic changes over a period of their working lives.

The discussion following the visual information centred on the artistic interpretations employed in the pictures. The children gave their ideas and opinions of age, situation (social and economic circumstances) and cultural background of the persons shown. Questions were directed particularly at:

How can children look older than they are?

How do rules and regulations govern actions at a particular age?

How does our society endeavour to hold back the onset of old age?

How do feelings, habits and interests change with age? etc.

A critical study – written descriptions and diagrammatic drawing – was now undertaken in response to six reproductions of paintings illustrating physical change. The following artists were chosen for the stages indicated:

Reynolds – infancy and childhood;
Murillo – adolescence;
Cézanne – adolescence and old age;
Van Gogh – old age.

Face and landscape

In order to heighten drama and expressiveness of the human face, it was thought useful to combine it with landscape. The extravagance or tranquillity or anxiety of personality as conveyed by the face might well be blended with symbolic landscape to create a particular feeling or emotional mood.

To emphasise the joy or suffering evident at various stages of life, the children were asked to select an archetypal face of how they see themselves/others developing. The rhythmic combination of face and landscape displaying movement, distortion and linear pattern was further enhanced by the impact of emotive colour schemes: *angry* reds and oranges; *cool* blues and greens; *youthful* yellows and sap greens; *mature* browns and maroons etc.

Apart from investigatory work into colour theory, the tormented and haunting paintings of Eduard Munch were found to be of most help. Munch's deep visual insight into moods and emotions both threaten and seduce. His fascinating linear technique and dramatic handling of colour in his most famous painting, *The Scream*, enabled most pupils to see the connection between feeling and form quite clearly.

Inside the head

The last phase of the project sought to give visual form to thought: ideas, feelings, nostalgic reminiscences *inside* the head. Again, the children made the choice between (a) themselves, (b) others and (c) a composite form selecting the best elements from both (a) and (b). A variety of visual symbols were investigated to convey particular meaning(s).

In the translation of ideas into an appropriate art material, corrugated cardboard was selected as having the right kind of multi-layered 'peeling' quality for the subject matter. The analogy between medical dissection and what the artist feels should be revealed behind the facial mask is a very useful one. Surfaces within the low relief constructions were decorated with textural materials – sand, sawdust, string, glues, embossed wallpaper and adhesive tape – as well as using the natural torn and cut corrugations of the cardboard itself.

The resultant head 'maps' contained the distilled ideas and meanings of many weeks' work. In conception and execution they were carefully controlled designs going some way to understanding the thoughts, feelings and fears in 'themselves and others'.

EXAMPLE 3

EXAMPLE 3

Describing and painting, Audley Park School, Torquay (see page 167)

Robert Chapman *Head of Art Department*

1 Children in two parallel groups made written appraisals and descriptions from a collection of reproductions of paintings. The two groups then exchanged written descriptions, and the children were asked to make a painting from another child's written appraisal.

The reproductions were given out at random (to avoid any arguments about who should have which painting), and pupils were asked to make a careful study of their picture before producing a piece of written work based on their appraisal of the painting. This could be a straightforward description, or a more imaginative piece in the form of a story or poem. (Most pupils managed to produce both in the double lesson that was allowed – 1 h 10 min.)

The written work was collected and passed on to children in the parallel group. Here an element of chance entered the proceedings – the more successful descriptions would not necessarily reach the pupils who could best realise their potential – so the distribution of the written pieces was not quite as random as the pupils were led to believe.

The pupils in the second group were then asked to produce a painting based on the written appraisal they had been given. It was stressed that the object of the exercise was not that they should be trying to guess what the original picture looked like, but that their painting should be their own interpretation of the description they had received, and that they could be selective about which elements of the description they chose to incorporate in their picture.

These pupils worked individually, each on a different picture, and the success of the finished work depended to a large extent on the quality of the descriptions they were presented with.

2 One group of children made a written appraisal and description of Salvador Dali's *Metamorphosis of Narcissus*.

These descriptions were passed to children in a parallel group who were asked to make a painting based on the written appraisal they had been given.

Pupils in the first group were specifically asked to produce a piece of imaginative writing, rather than just a straightforward description. The symmetry in the picture was most often interpreted in terms of life and death, or good and evil ('one side is alive and bright, the other is more abstract . . . the two sides seem to symbolise either life or death'). Some elements of the picture were almost universally misinterpreted, most commonly the repeated image of the hand and egg in the background which became 'some sort of animal in the hills', or 'a grey figure', even 'a Yeti', and for some reason these were emphasised when the descriptions were translated back into visual terms.

Unlike the first exercise, where children were working in isolation on their own individual pictures, here the pupils in both groups (writers and painters) were working from a common starting point, and a consensus of opinion was quickly reached between children sitting close together. So the chess board became an important element in one group of compositions, while in others it was only a minor detail.

As the paintings were nearing completion, pupils in the second group were allowed to see the original reproduction, and this helped them to resolve some of the details in their own pictures (amid accusations that the first group hadn't given them enough information, particularly in regard to the relative scale of the objects described).

Despite the obvious difficulties in interpreting the content of Dali's picture, the original painting received widespread approval.

3 Children were allowed to choose a reproduction of a particular painting that they liked. They were then asked to produce a new piece of work based on this painting, working directly from the reproduction.

Pupils' interest was aroused by the individual pictures used in the first exercise, and they asked if they could work directly from the reproductions (often the one that they had studied and had made a written description of). After careful study and preparatory drawings, they were asked to make a new version of the painting by rearranging the composition, or by selecting just a part of the composition (perhaps by the use of a viewfinder), or isolating one figure

EXAMPLE 3

from a group of figures, at all times trying to retain accuracy of representation of the original.

Their main problem was in trying to reproduce an oil painting technique in a water-based medium, particularly when working from portraits. Some pupils' work was very imaginative, but in general the most successful were those which deviated very little from the original.

(All three of these projects were carried out with third- and fourth-year pupils, 13/15 years-old, in groups of 25 and of mixed ability, within a secondary modern school.)

List of reproductions used in the first exercise

The Tempest (Giorgione)
The Land of Cockayne (Bruegel)
The Card Players (Cézanne)
The Triumph of Death (Bruegel)
The Peaceable Kingdom (Hicks)
The Conversion of Saul (Bruegel)
The Starry Night (Van Gogh)
Luncheon In The Studio (Manet)
The Beggars (Bruegel)
The Parable of the Blind (Bruegel)
The Arnolfini Wedding (Van Eyck)
Christina's World (Wyeth)
The Duel (Mephistopheles I) (Munch)
Nighthawks (Hopper)
The Village Street (Munch)
House by a Railroad (Hopper)
The Peasant Wedding (Bruegel)
The Bellini Family (Degas)
Angry Masks (Ensor)
The Collector (Daumier)
The Therapeutist (Magritte)
The Lacemaker (Vermeer)
Gertrude Stein (Picasso)
Interior at Antibes (Bonnard)

Island of the Dead (Bocklin)
The Balcony (Manet)
Into The World Came A Soul Named Ida (Albright)
The Vision after the Sermon (Gauguin)
Arrangement in Grey and Black No. 1 (Whistler)
The Ship of Fools (Bosch)
The Fall of Icarus (Bruegel)
Ia Orana Maria (Gauguin)
Sunday Afternoon on the Grande Jatte (Seurat)
The Anguish of Departure (de Chirico)
The Lonely Ones (Two People) (Munch)
The Passion of Sacco and Vanzetti (Shahn)
Bonjour Monsieur Gauguin (Gauguin)
Mystery and Melancholy of a Street (de Chirico)
Executions of the 3rd of May (Goya)
Hotel by a Railroad (Hopper)
Evening (The Yellow Boat) (Munch)
The Poor Fisherman (Puvis de Chavannes)
The Dream (Rousseau)
Apparition of Face and Fruit-dish (Dali)

The Painter And His Model
 (Matisse)
The Temptation of St Anthony
 (Bosch)
The Saltimbanques (Picasso)

Uncle And Niece (Degas)
The Sleeping Gypsy
 (Rousseau)
Portrait of Emile Zola (Manet)

Rob Chapman April 1984

EXAMPLE 4

EXAMPLE 4

Self as object, Year 9 painting project, Eggbuckland School, Plymouth

Vincent Stokes *Creative Studies Department*

A painting project undertaken with 14-year-olds in which they explored the work of a number of contemporary artists who have used visual metaphors to describe themselves and others before making their own self-portraits in this kind of way. (See Fig. 7.30, page 181.)

Self as object Year group: 9
Group size: 21
Length of project: 6 weeks – 3 × 70 min. periods per week.

(In Years 8 and 9 all pupils have 3 lessons of art and design per week for one term only. The advantages of an intensive one-term art experience are considered to outweigh the more widespread practice of each pupil having one lesson per week throughout the year.)

Programme of study

The pupils were introduced not only to the idea of representing themselves as a piece of clothing, but also to the viability of using several different ways of drawing within a single study. A number of Claes Oldenburg drawings were shown to reinforce this point.

Each drawing should include:
- part of a photocopy of the article,
- part of a rubbing of the article,
- part of a plan drawing of the article,
- part of a drawing/painting of the article,
- part of a collage of the article.

An examination of the *Tool* and *Robe* drawings of Jim Dine led to the selection of a tool to reflect an individual's personality. The drawings of Jasper Johns were also analysed, in particular his drawings of letters and numerals. Studies were made using stencils, and the principle of 'controlled expression' explored. The ability to combine highly defined edges with those that are virtually destroyed increased with

practice. Pupils were then asked to produce a self-portrait drawing incorporating a life-sized silhouette, appropriate tools, relevant personal information in stencilled form from a photograph or part photograph of themselves. In the light of their practical experience in making drawings of this kind, each pupil wrote an appraisal and comparison of two Jim Dine prints. The use of technical vocabulary was stressed.

Resources and references
Slides, reproductions, photographs of prints and drawings of J. Dine, C. Oldenburg, J. Johns.
Drawings of Jasper Johns – exhibition catalogue, Hayward Gallery, 1991.
Jim Dine Prints 1977–85 – D'Oench & Feinberg, Harper Row.

EXAMPLE 5

EXAMPLE 5

Art vocabulary homework, Year 10, Eggbuckland School, Plymouth

Peter Riches *Head of Creative Studies Faculty*

A homework assignment set for students in Year 10 which required them to undertake some reading and research to become familiar with the meaning of a range of techniques and processes used by artists and designers.

Year 10 homework

Art language
Dictionaries/Art books . . . (References).

Group 1	*Group 2*	*Group 3*
Genre	Chiaroscuro	Pointillism (Divisionism)
Trompe L'Oeil	Pastiche	Hatching
Plein-Air (Painting)	Motif	Monochrome
Golden Section	Scumble	Sgraffito

Group 4	*Group 5*
Montage	Chroma
Impasto	Gouache
Form	Alla-Prima
Hatching	Stippling

- Choose *one* of the above groups.
- Define *each* of the art terms in that group.
- Provide an illustration/photocopy/tracing or drawing as a response to *one* term.

**Peter Shore:
Art homework**

Art language
Alla prima painting – is a technique in which the first layer of paint is usually the last. The ground may be white or coloured with an imprimatura or toned ground. There is a purity about this approach which makes it very appealing as the paint is not disguised in any way. It can show great freedom and fluency in execution but is a difficult style to master and one artists usually arrive at after using more controlled techniques.

Impasto – refers to painting done with thick paint. This is usually applied with a painting knife or with a bristle brush. The paint is heaped up in ridges to create a heavily textured surface. In oil painting, an excessive use of impasto is said to threaten the durability of the paint film. With acrylics, impasto is more permanent.

Scumbling – is a technique similar to glazing. But while the effects of glazing are produced by using transparent colours over lighter tones, scumbling uses lighter semi transparent or opaque colours over darker tones. The paint is usually applied patchy so that patches of the tone show through.

Monochrome painting – is a method of painting in different tones of a single colour – usually grey. This is used as a form of underpainting so as to get the forms and tones accurate before colour is added either opaquely or by glazing with transparent colours. It's customary to paint in tones that are more subdued than in the finished painting.

Trompe L'Oeil – is illusionistic painting that deceives the observer into thinking that the objects depicted are real.

Jayne Souter: Art homework

Hatching – the use of finely spaced parallel lines to suggest shading. The technique is found mainly in drawing and engraving, but is also used for example, in tempera painting. When crossing sets of lines are used, the term cross hatching is applicable.

Montage – term applied to a pictorial technique in which cut out illustrations, or fragments of them are re-arranged and mounted to the picture so made. Ready made images alone are used, and they are chosen for their subject and message; in both these respects montage is distinct from collage and papier colle. The technique has affected advertising. Photomontage is montage using photographs only. In cinematic usage, the term montage refers to the assembling of separate pieces of film into a sequence of superimposed image.

Impasto – thickly applied opaque paint retaining the marks of the brush or instrument of application. Impasto is a feature of oil painting and certain types of acrylic but it is not impossible with water colour or tempra. Among artists associated with the use of heavy impasto are Rembrandt, Van Gogh and Anerbach.

EXAMPLE 6

EXAMPLE 6

An exhibition questionnaire, Year 10, Eggbuckland School, Plymouth

Peter Riches *Head of Creative Studies Faculty*

A questionnaire used to support a visit by students in Year 10 to a retrospective exhibition of the work of the painter Paul Nash.

The questionnaire requires students to undertake a variety of looking, verbal and written responses to the work in the exhibition including drawing and notation, finding phrases to describe qualities in the paintings, making comparisons between source material and the painter's response and making reasoned arguments in support of particular works within the group.

Year 9 Exhibition Questionnaire

Date Tuesday, 30th January (a.m.)

Place Royal Albert Memorial Museum, Exeter

Exhibition 'Paul Nash – Places'

Paul Nash, born 100 years ago this year, was one of the greatest of all English landscape painters. Like other poets and painters in the Romantic tradition, Nash aimed not just to reproduce the external appearance of a place, but also what he called its 'spiritual personality'.

The 'Paul Nash – Places' exhibition focuses on a handful of locations: Iver Heath, The Wittenham Clumps, The Chilterns, Dymchurch, Avebury and Boar's Hill. For Nash, each location provided different natural and historical inspiration, and his artistic style changed accordingly. Whatever the location, however, the artist has combined real and imagined images to produce an 'unseen' aspect of landscape.

Before attempting any of the questions, have a general look around the whole exhibition (15 minutes).

1 Find No. 6 *In the Garden* (1914) and No. 7 *Summer Garden* (1914). Carefully draw *Summer Garden* in outline form and include the three figures from *In the Garden*. Place figures according to space and near/far considerations.

2 'Trees are the heroes of Nash's work.'
Record *two* examples from the range of tree studies available in the exhibition.

3 Go and find No. 14 *The Wood on the Hill* (1922).
There are no figures evident in this picture, but there are indications of human presence in the landscape. List or describe these 'signs' of human involvement on this particular site.

4 The Dymchurch pictures view the sea as a hostile force – bleak and alien at times during a calendar year.
Looking particularly at No. 29 *Night Tide* (1922), No. 33 *The Sea* (1922) and No. 36 *The Tide* (1920), try to develop a list of words or phrases that describe the curved and angular patterns evident in these pictures. e.g. overlapping steel plates, etc.

5 Compare No. 49 *Monster Study* (1939) and No. 50 *Monster Study 2* (1939) with the attached photocopied photograph of the same view.
Look at the differences of detail and interpretation between the photograph and the paintings. Are the paintings more or less impressive than the photograph? Why?

6 Analyse the colour range employed in *one* of the Boar's Hill paintings (Nos. 55–63).
Colour description
e.g. Pastel blue/grey, etc.

Can you find any evidence of *pure* black in these pictures?

7 Select *one* picture that has particularly impressed you.
Support your choice with carefully reasoned argument.

8 CRAFT, DESIGN AND TECHNOLOGY

From handwork to technology

There is a long history of craft and design teaching within school art and design departments. This dates back to the introduction of art into the school curriculum in the nineteenth century, when it was seen principally as a means to train the hand and eye of those future artisans who were so essential to the successful development of trade and commerce in this country.

Initially, the crafts were taught under the label of 'Handwork', 'Handicrafts', and then as 'Light Crafts' and 'Heavy Crafts' when teaching was divided between teachers trained in art and design and those trained in the disciplines of woodwork and metalwork. Additionally, in the post-war years, teachers of domestic science who had been trained to teach dress-making and needlework broadened the scope of their work to introduce the teaching of some aspects of textiles and fashion design.

In recent years, with a growing emphasis within the faculties and schools of art and design upon training students in the design-based disciplines, there has been a significant increase in the number of art and design students entering teaching as well-qualified designers, particularly within the fields of graphic design, fashion, textiles and ceramics.

These developments have meant that the teaching of craft and design in schools has been complicated by being taught under three different subject headings: art and design, craft, design and technology (CDT), and home economics.

In the past twenty-five years, there has been a steady growth in the establishment of design-based courses and design faculties in schools, where the different concerns and interests of teachers of art, CDT and home economics have been focused and brought together in an attempt to find some common ground – especially in their teaching of craft and design. Even where these subjects have been grouped together to form a design faculty, it has been comparatively rare to find within that group of teachers any consistent attitude towards the teaching of craft and design.

In many design departments and faculties there has been in the past too much emphasis upon trying to relate the crafts to some generalised notion of design, to which the constituent subjects must conform, rather than by seeking ways to rationalise and balance the different kinds of learning which the teaching of craft can promote and the different contexts within which designing can take place.

The development of the National Curriculum and the introduction in 1990 of the new National Curriculum in Technology has necessarily accelerated teachers' thinking about the way the teaching of craft and design should be managed in our schools. How should teachers of subjects associated with designing and making respond to the principals of cross-curriculum delivery enshrined in the new National Curriculum in Technology, and how should they capitalise upon the introduction of the new computer-based technologies that are an important element in the teaching of technology?

The National Curriculum in Technology

In the National Curriculum, technology is identified as a cross-curricular subject which requires the co-operative efforts of teachers of art and design, CDT, home economics, business studies and

information technology to ensure its delivery in Key Stages 3 and 4. In addition, there are important contributions to be made through cross-reference to the other Core subjects of mathematics, science and english. The introduction of technology into the National Curriculum has required teachers of different subjects to face the challenge of planning and working together to make the delivery of technology effective, and to help eliminate those elements of overlap and repetition of experience between subjects that has been one of the major principles behind the National Curriculum. Some of the principles of making technology work in day to day practice in schools are discussed later in this chapter.

As in all cross-curricular work between subjects, it is essential that subject teachers bring to these developments a clear view of the contribution that their subject can bring to combined areas of study. It is also essential that they have an equally clear view of those aspects of their own subject that have to be taught, and that cannot be delivered through co-operative teaching with other subjects.

The four Attainment Targets for design and technology capability are described as follows:

AT1 *Identifying needs and opportunities*

Pupils should be able to identify and state clearly needs and opportunities for design and technological activities through investigation of the contexts of home, school, recreation, community, business and industry.

AT2 *Generating a design*

Pupils should be able to generate a design specification, explore ideas to produce a design proposal and develop it into a realistic, appropriate and achievable design.

AT3 *Planning and making*

Pupils should be able to make artefacts, systems and environments, preparing and working to plan and identifying, managing and using appropriate resources, including knowledge and process.

AT4 *Evaluating*

Pupils should be able to develop, communicate and act upon an evaluation of the processes, products and effects of their design and technological activities and those of others, including those from other times and cultures.

The core of technology requires that children should be able to identify the need for designing and making activities within the social context of home, school, recreation, community, business and industry, and respond to these needs through designing and making artefacts, environments and systems.

The relationship between art, design and technology

If you place the Attainment Targets and Programmes of Study for art in the National Curriculum alongside those for technology it is quickly evident where there is common ground and areas of overlap.

There is significant overlap between the investigating aspects of AT1 in art 'Investigating and making' and AT1 in technology 'Identifying needs and opportunities'. In both subjects children will be using research and drawing skills to examine existing forms and to consider how they are structured and how they might be modified.

There is similar overlap between the making aspects of AT1 in art and AT2 in technology, 'Generating a design', where again there is reliance upon children being able to use drawings to plan and speculate how to respond to the challenge of designing and making.

In both subjects there is a high profile to making, and the way children will organise, use and manipulate materials and processes in support of their making. Both subjects require that children should be involved in appraising artefacts and environments made by themselves and by other craftsworkers and designers working in contemporary times and in other times and cultures.

You can make a useful start to establishing positive links between art and design and technology through mapping areas of common content across the statements of attainment for the two subjects, as for example in the matched statements below. This is a useful way to identify where, in your normal pattern of work in art, you are also delivering Attainment Targets in technology and where there may be opportunities for matching or collaborative work across the two subjects.

These examples are taken from the Statements of Attainment for Key Stage 3 in Art and from the Statements of Attainment at Levels 4/5 in Technology.

Because art and design and technology in the National Curriculum have these complementary aspects, there will be times when work undertaken in art and design departments will satisfy the Attainment Targets for both subjects, and other times when the work is centred entirely within the parameters for art. This is because the task of designing and making can be undertaken for different reasons, and it is with consideration of the motives that drive the designing and making that we can identify whether the work is focused within art and design or within technology.`

Differentiation between art, design and technology

One of the most radical elements in the new technology curriculum is the requirement that all designing and making should take place within a social context. Children are required to consider opportunities for designing within the context of their school, home, and local environment, or related to identified needs in recreation, business or industry. This is a most welcome development in that it places children's designing within the context of real experience, where the development of skills and processes is purpose-led. Previously, it has all too often been the case that children have been required to design and make things for entirely arbitrary reasons, where the things they have made have had little personal value or meaning for them.

In art and design teaching, children will be taught to design and make images and artefacts for a variety of reasons. Although they will frequently be asked to make things to satisfy a particular social purpose or function, much of their designing and making will be generated through a personal need to use their practical

Art and design	Technology
AT1b) Develop and sustain a chosen idea or theme in their work, investigating and explaining their use of a range of visual and other sources.	**AT2 5a)** Record the progress of their ideas, showing how they have clarified and developed them.
	AT2 5b) Seek out and organise information to develop their ideas and refine their design proposal.
AT1c) Apply a broad understanding of the elements of art and design and the characteristics of materials, tools and techniques to implement their ideas.	**AT4 4c)** Choose tools, equipment and processes suitable for making their design and use these appropriately.
AT2a) Demonstrate a knowledge and understanding of the principal features of our artistic heritage and appreciate a variety of other artistic traditions.	**AT1 4f)** Know that in the past and in other cultures people have used design and technology to solve familiar problems in different ways.

skills and knowledge to make images and artefacts to express ideas, observations and feelings about their experience in the world.

They will frequently be using very similar materials and processes to make images and artefacts within both a personal and a social context. They may use clay to model something they have experienced personally – an interesting event or a favourite possession (Figures 8.1 to 8.4). They can also use the same processes in clay to make artefacts in response to such practical and social needs as designing containers for house plants in the school environment, or to make a table piece to be used in a particular social occasion or ritual.

Similarly, they can use a range of processes in textiles to make images that describe or comment upon things they have seen or that fulfil a particular purpose. (Figures 8.5 to 8.8 contrast a political caricature in collage with a length of fabric based upon the study of made forms.)

In their work in two-dimensional design, children can use their skills in drawing, print-making and graphic design for a variety of purposes and within different contexts, ranging from straightforward description of things observed and translated into print, to illustrating a favourite story, or designing and making wrappers and containers for a whole variety of familiar foods and drinks.

Figures 8.9 to 8.13 illustrate a range of work in two-dimensional design and craft, undertaken for different purposes and including print-making, illustration and graphic design.

Fig. 8.1 Drawing three-dimensionally with clay, beach picnic. 11-year-old, Heavitree Middle School, Exeter.

Fig. 8.2 Sunbather; ceramic. 16-year-old, Estover School, Plymouth.

Using materials inventively to create images that are both determined and stimulated by the nature of the materials used. Good examples of image-making with materials associated with more conventional kinds of response.

Fig. 8.3 Plate of cakes.
14-year-old, Clyst Vale
College.

*The expressive use of
clay. A figure based upon
observation of the
characteristic expressions
of members of staff and
children within school.*

Fig. 8.4 Figure.

Fig. 8.5 Our leader; fabric collage, 14-year-
old, Estover School, Plymouth.

Figs 8.6 to 8.8 *Fabric design. 16-year-old, Estover School, Plymouth.*

Fig. 8.6 Studies of a chair and table.

Fig. 8.7 Working out the design.

Fig. 8.8 Printed fabric.

Figs 8.9 to 8.13 *A range of work in two-dimensional design and craft undertaken in different contexts and made for different purposes, and including print-making, illustration and graphic design.*

Fig. 8.9 Landscape; colleotype (24 × 18 cm). 15-year-old.

Fig. 8.10 Self-portrait; lino print (15 × 24 cm). 13-year-old, Tiverton School.

Fig. 8.11 Designs for sweet wrappers; fibre-tipped pen (28 × 38 cm). 12-year-old, Estover School, Plymouth.

Fig. 8.12 Design for a chocolate box; tempera and fibre-tipped pen (24 × 18 cm). 16-year-old, Estover School, Plymouth.

Fig. 8.13 Design for a calendar; ink (20 × 28 cm). 17-year-old, Kingsbridge School.

It should be obvious that you will need to provide opportunities for children to use their designing and making skills for a variety of purposes in your department. Each year there should be occasions for them to work both within a personal and a social context in the application of these skills. When children are working on design-based projects in response to a personal need, then they are clearly working within the context of art and design. Where such projects are based upon response to those social needs and opportunities identified in the Attainment Targets for technology, then you will be working within the context of technology whether you are working independently in your own department or collaboratively with other subject teachers associated with technology.

It is important to recognise this and to understand the balance between working independently within the field of art and design and working collaboratively with other colleagues, to help deliver the National Curriculum in technology effectively in your school.

Some of the practical issues raised by these new developments in technology are discussed later in this chapter in the section on 'Day-to-day practice'.

The contribution of art to technology

The contribution that learning in art may make to developments in technology are summarised in the Final Report from the Art Working Group, Art for Ages 5 to 14, published by the DES in 1991.

> We suggest that the following are among the important contributions which learning in art makes to design and technology capability:
>
> - drawing skills, which feature in all designing activities whether in the form of concept sketches, working drawings, plans, diagrams or the representation from observation of finished products, systems or environments.
> - competence in the handling of the range of materials used in art and design, which is probably wider than in any other subject.
> - an understanding of techniques in the sense of both practical processes strategies for dealing with design problems, including the processes of observation, speculation and visualisation which are inherent in two and three dimensional media.
> - the skilled and sensitive use of information technology which provides an opportunity to understand the presentation of ideas in visual form and has increasingly important applications in graphics, in the media and in advertising.
> - critical skills and judgements about the aesthetic dimension.

In many good departments of art and design, and especially in those where good attention is given to the place of designing and making, all these activities and processes will be present within the normal remit of their work. The new technology requires teachers, wherever possible, to generate with children open-ended investigation and enquiry in response to a range of problems and challenges. Many art teachers, through their training as artists and designers and their practice in teaching, are experienced in this way of working and well placed to make a significant contribution to the teaching of technology.

From drawing and investigating to making

There has already been reference to the importance of drawing in preparation for designing and making in Chapter 5 'Teaching drawing' (pages 108–28). It was emphasised how important it is for children to be taught to collect information, through drawing, about the structure and quality of natural, made and environmental forms, in preparation for designing and making in a variety of media.

Before embarking on any making activity in any of the traditional craft disciplines, it is obviously essential for children to collect information through making drawings and studies of those things they want to model, print or weave. The work in ceramics, print-making and fabrics illustrated in Figs 8.1 to 8.9 were all based upon preliminary drawings and studies made in preparation for the craft activity. In making preliminary drawings, children are becoming familiar with the appearance, content and structure of the form they wish to recreate, or make an equivalent for, in another media.

It is sometimes appropriate to work directly from observation in the craft media, as in drawing and modelling three-dimensionally in clay from figures posed in the studio or, as in Figs 8.14 and 8.15, to make a portrait drawing working directly in soft modelling wire.

When children are working with new or unfamiliar media, making the preliminary drawing not only gives children confidence about the appearance of the form to be made, but also sufficient knowledge about its appearance to be able to focus upon the new and technical problems involved in the process of making.

Drawing can be used, as described above, simply to collect and sort information about appearance needed to support the making activity. Figures 8.16 to 8.18 illustrate how both personal photographs and drawings have been used to support the making of a ceramic model of a derelict building.

Drawing can also be used to focus upon and select information needed to support design work. This is one of the most familiar strategies used in design. The designer makes studies of visual elements such as the surface, pattern and colour qualities in natural and made forms, and then selects those aspects to be used in the design. This is illustrated in Figs 8.6 to 8.8, where the

Fig. 8.14 Drawing three-dimensionally with wire, heads. 12-year-olds, Estover School, Plymouth.

Fig. 8.15 Trees; ceramic. 10-year-olds, Thornbury Primary School, Plymouth.

patterns and shapes found within a chair have been used as the basis for the design of a length of fabric. In Figures 8.19 and 8.20 12-year-olds have used the shapes and colours found in familiar sweet wrappings as the basis for the design for their first weaving.

This exploration of the visual elements that can be used in designing – (the qualities of line, colour, surface, pattern, shape and form – is common to most craft and design activities. Designers need to have a grasp of the basic grammar of visual form and to be familiar with the range of sources they can use to find such visual information. In teaching children such 'basic design' principles, it is always necessary to relate the visual investigation directly to a real designing and making task. The exploration of the visual elements for their own sake, in isolation from their application, can lead to rather sterile practice. This was observed in many schools in the 1970s, when the first attempts took place to find common ground between the teaching of art, home

215

Figs 8.16 to 8.18 *Derelict building. 16-year-old, Estover School, Plymouth.*

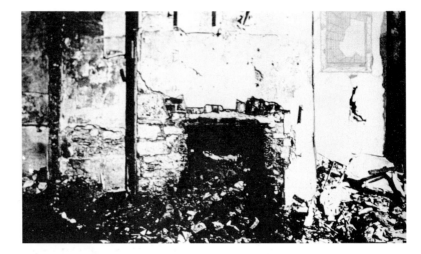

Fig. 8.16 Photograph of derelict building.

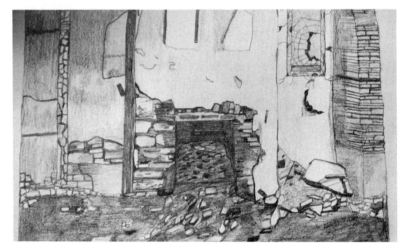

Fig. 8.17 Study in pencil.

Fig. 8.18 Ceramic relief.

Figs 8.19 and 8.20
Designing for a weaving;
mixed media. 12-year-
olds, Great Torrington
School.

*Using the shapes and
colours in familiar sweet
wrappers as source
material for the design of
a weaving.*

economics and CDT in the wake of establishing the first design departments and faculties in schools.

It is now common practice in primary schools for the teaching of the basic crafts to be linked to visual exploration of familiar natural and made forms, and for the children to be asked to collect information and make studies in preparation for working in a variety of materials and processes.

Example 1 'Textiles in the primary school' includes extracts from a booklet about the different kinds of work in textiles that can be attempted with primary school children. These illustrate some of the possible links between the exploration of a range of visual source material and working in different textile processes.

Example 2 'Three-dimensional construction' is a collection of visual resource sheets and work-sheets used to encourage children to explore and analyse different kinds of three-dimensional structures in the environment in preparation for working on three-dimensional design projects.

A valuable way to convey the importance of using drawing as a means of investigation in support of designing and making is to provide children with access to investigative drawings

217

made by other artists, craftsworkers and designers. The use of artists' drawings as a support to teaching drawing has already been discussed in Chapter 5 'Teaching drawing'. Drawings made by artists, craftsworkers, designers, architects and planners all provide useful clues to the ways in which drawing can be used to speculate and to explore ideas. Example 2 includes reproductions of drawings and notes from the sketch books of Leonardo da Vinci which are easily accessible in facsimile and provide very real evidence about the way that an artist and inventor can use drawing speculatively. Children can be encouraged to speculate and explore ideas visually by the kind of tasks they are set in association with keeping notebooks and sketch books to record their observations, the development of their ideas and personal resource material. Examples 5 and 6 in Chapter 4 'Teaching strategies and resources' are both good examples of homework tasks designed

to encourage speculation and the visualisation of ideas.

It should be possible to borrow craftsworkers' and designers' sketchbooks to show to children. The local School of Art will be a useful source. They may supply copy pages from such notebooks to use as examples.

Figures 8.21 to 8.27 show work by 16 and 17-year olds who spent three days working with a ceramicist in residence whose own work is based upon the use of studies and working drawings of reptiles and sea creatures. The children working with her were inspired to make similar visual explorations for themselves in preparation for making their own ceramic sculptures. They made studies of her work, drawings of fishes and speculative drawings to explore how they might construct their own piece of work. It is very evident that such visual exploration of a variety of sources supported their own making very effectively.

Figs 8.21 to 8.27 *A selection of work by 16 and 17-year-olds from various schools who worked for three days with a ceramicist-in-residence. They made studies of her work and of fishes, and speculative working drawings in preparation for making their own ceramic pieces.*

Figs 8.21 and 8.22 Studies of fishes.

Figs 8.23 and 8.24 Study sheets by individual students.

Figs 8.25 to 8.27
Ceramic fishes.

Investigating through computer-aided systems

The recent introduction of computer-aided drawing systems in art and design departments has had a very beneficial effect upon the development of analytical and speculative drawing in support of work across a range of craft and design disciplines. Quite apart from the facility the computer provides to enable the quick and easy exploration of such ideas and variations as colour-ways, letter forms and pattern combinations, it also opens up other possibilities simply through the way that it works!

Drawing with a computer is physically very different to drawing with conventional media in that the eye remains focused upon the screen while the hand draws independently with the mouse. This kind of focus, in itself, can generate intense periods of concentration, even within the noise and bustle of a busy studio, which can be of considerable benefit to some children. Similarly, many children respond particularly well to the computer's capacity to erase quickly, correct mistakes and maintain a near 'perfect' image.

Drawing with the computer will, for these reasons, give confidence to children who previously had difficulties with drawing, either because of an inability to concentrate or because they were easily discouraged by the first mistakes made in a conventional drawing – where they may have spent more time rubbing things out than drawing things in!

Since, in making a computer-aided drawing, you are working with points of colour and light, the drawing has its own discipline and one that supports a more analytical approach to making an image. This can be observed when you ask children to make a conventional drawing from observation and then to translate the drawing through the computer screen and compare the two images (Fig. 8.28).

Once the children have grasped some of the basic operations of the programme you are using, work should begin outside the computer, using conventional systems of drawing and planning, and then moving into the computer to experiment with the image and exploit the computer's capacity to manipulate it. Work should then again

Fig. 8.28 Driftwood; computer-aided drawing. 16-year-old.

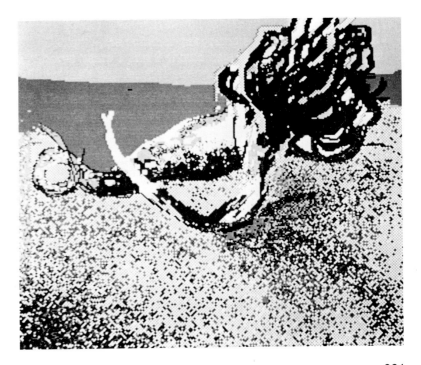

Figs 8.29 to 8.31
Designs for ice-cream
sundaes; computer-aided
drawings and collages. 13-
year-olds, Pilton School,
Barnstaple.

*Using computer-aided
systems to explore ideas
for an advertising
campaign for a new range
of ice-cream sundaes.*

move out of the computer, to use the information gained. Example 3 'Art through a computer' is a design brief presented to 15-year-olds in which the principle of working through the computer is established.

Figures 8.29 to 8.31 illustrate how the computer has been used initially to sort a number of ideas and variations in the design of a new range of ice-cream sundaes for an advertising campaign. The initial ideas were explored using the computer to set up a standard net for the shape of the ice-cream glass, and to explore varieties of colours and shapes within these before using the experiments as the basis for designing the sundaes.

The point about moving into and out of the computer is emphasised because of the tendency in some schools and departments for the computer-aided work to stay locked within the computer. There is a significant difference between using the computer screen as a doodle pad and an electronic sketch-book. The great virtue of using the computer in art and design teaching is not its capacity to make images electronically as an easy alternative to using more conventional means, but in the ability it gives children to explore ideas, variations and systems at considerable speed.

Within art and design and technology this is perhaps most apparent in the teaching of graphic design and textile design. Programmes are now available which remove from these disciplines the previously time-consuming and frustrating task of drawing and re-drawing design ideas in order to explore the subtle variations in colour, surface, placing and spacing that are such an important part of the process of designing in these media. Figures 8.32 to 8.36 illustrate the use of computer-aided drawing and designing programmes to explore colour and pattern variations in fashion and textiles design.

In many art and design departments the computer has been successfully absorbed into day-to-day practice. It is no longer the new and

Figs 8.32 and 8.33 Designs for a pinafore dress; computer-aided drawings. 17-year-old, Queen Elizabeth School, Crediton.

Figs 8.34 to 8.36 Designs for a fabric for a woollen jumper; computer-aided drawings. 17-year-old, Queen Elizabeth School, Crediton.

expensive electronic toy in the corner that everyone wants to play with, but has taken its place as an electronic sketch-book to be used when needed for its unrivalled capacity to support experimentation and visualisation.

Day-to-day practice in schools

The National Curriculum in Art requires that some teaching of design-based studies and some three-dimensional work should be undertaken in each key stage.

The general requirements for the Programmes of Study include the following statements:

Pupils should be given opportunities to:

- undertake a balanced programme of art, craft and design activities which clearly builds on previous work and takes account of previous achievement.
- make appropriate use of information technology.
- work in two and three dimensions and on a variety of scales.

There is specific reference to three-dimensional work in the Programmes of Study as follows:

In Key Stage 2

AT1 x) Plan and make three-dimensional structures using various materials and for a variety of purposes.

In Key Stage 3

AT1 vii) Explore and experiment with materials, ideas and images for three-dimensional work, and realise their intentions.

The day-to-day practice of teaching craft and design-based studies in your school will largely be determined by the pattern of timetabling and subject organisation adopted by your school. There is considerable variation in practice between schools. Although National Curriculum Technology does require collaboration between such subjects as art and design, CDT, home economics and business studies for its delivery, in many schools these are autonomous and free-standing departments. In others, these subjects have in the past been grouped to form faculties of subjects with such titles as 'Art and Design', 'Design', 'Creative Design' etc. In some schools you will find art and design as part of an even larger group of subjects called 'Creative Arts' or 'Creative Studies' which will also include music and drama and, sometimes, physical education. In others CDT and home economics have been combined to form 'Technology' departments, while the arts are grouped separately as 'Expressive Arts'. The reason for these groupings, and their implications for teachers of art and design are discussed further in the next chapter 'Art and other subjects'.

Within your own art and design department there should be little difficulty in establishing a proper working relationship between the more general work in drawing and painting and work that is craft and design-based. As already discussed in this chapter, there are strong links between investigative drawing and design-based work, to the extent that good work in craft and design is unlikely to exist without the underpinning provided through rigorous and investigative drawing.

Within the timetabling of art in your own school it should be possible to allocate at least forty per cent of your time to the craft and design-based disciplines in Years 7, 8 and 9. What range of work you will be able to offer will depend upon the size of your department and the experience and strengths of individual teachers. It is, in any case, better to concentrate the work on a limited range of materials and processes and to look for an interesting balance rather than great variety. In one year, the balance might be between using plastic and resistant materials, in another between using craft processes expressively or within design-based projects. It is certainly better to give sufficient time to one or two design-based disciplines in order that skills and confidence can be developed within that process, rather than to attempt too many at a superficial level.

Timetabling also needs to take account of the fact that teaching the craft and design disciplines needs more concentrated periods of time than other aspects of work in art and design, and that it benefits by being taught to smaller groups, as is common practice in the teaching of CDT and home economics. Where your work in art and design is block-timetabled with the other subjects associated with technology, this should not be a

problem. However, there are some schools which have, in response to the pressures of the National Curriculum, moved to a teaching week of 25 or 30 periods, with teaching modules of 50 or 60 minutes each. In these circumstances you will need to negotiate a more flexible use of time in the block-timetabling with other subjects, in order to obtain those longer periods of time, in rotation, which are needed to teach these disciplines effectively.

As children develop their skills and confidence in handling a particular craft or design discipline, they need the opportunity for greater specialisation. This could be through a choice of design areas in which to work in Year 9, or through the opportunity to specialise in a chosen discipline when they have opted to pursue their work in Key Stage 4 to GCSE. All the examination boards offer a range of craft or design-based courses for GCSE, and the proposals in hand for the development of combined art, design and technology courses in Key Stage 4 should lead to an extension of the opportunities for the design disciplines to have a significant profile in the National Curriculum.

The radical changes in the teaching of the design disciplines brought about by the National Curriculum technology need to be approached with sensitivity in order to accommodate the teaching of design across a range of subjects. Such changes as these, and the introduction of GCSE, have the virtue of stimulating review of current practice, and can contribute positively to the development of the subject. Although technology is in its early stages of development in our schools, there are already some indications of where the problems and the possibilities lie for teachers of art and design to contribute effectively to its development.

Making technology work

It is important for teachers of art and design to be actively involved in the development of technology, for those reasons already outlined earlier in this chapter. In some schools this may not be an easy task, since there are cases where teachers of art

and design have found themselves working in design faculties which may have been established more for reasons of administrative convenience than for any real regard for how the subjects might or should work in association. In these schools, although there has been advantage in the block-timetabling arrangements, with teachers of art and design working with smaller groups than when they are timetabled independently, such arrangements have frequently led to the establishment of a simple 'circus' or rotation of work between art, CDT and home economics, with little or no cross-reference across the subjects as to what was being taught! These arrangements have also led to a fragmentation of the children's experience of work in art and design and, occasionally, to a reduction in the amount of time allocated to the subject across the year.

There are many schools where the introduction of technology has led only to an attempt to force the new subject into the straightjacket of existing faculty arrangements and working practices. At its worst, this has resulted in a denial of the clearly stated holistic nature of the Attainment Targets for technology, with teachers of different subjects teaching those programmes of study they can relate to their present practice – frequently in unimaginative and logical sequence.

At the other extreme, there are schools where teachers have jettisoned years of sound practice in the teaching of the design disciplines across the subjects concerned to pursue a totally integrated approach to the teaching of technology, and acceptance of the subject being driven by Attainment Target 1 'Identifying needs and opportunities'. In these schools you will find children identifying design opportunities for which there is no need, or possibility, of a resolution!

Technology requires a more open-ended approach to designing and making than is traditionally apparent in many CDT and home economics departments, but there still has to be a realistic link between the theme or range of tasks proposed and their resourcing. If you present children with such an open-ended theme as 'Celebration' and a virtually free choice to design anything they

identify as being appropriate to times of celebration, it will not be surprising if many of them choose activities or tasks well beyond their means, or for which you will have considerable difficulty in finding appropriate reference materials and resources. In these circumstances, both children and teachers become de-skilled and consequently frustrated.

It is better in Years 7 and 8 to focus the investigation upon design possibilities within the home, school and local environment, where the investigation and identification of possibilities can be based upon real research. In the early stages of introducing technology in schools, there have been many useful design projects focusing on the design and function of familiar personal possessions – everyday artefacts such as the carrier bag and lunch box, and familiar environmental problems such as sign-posting the school or coping with its rubbish.

Example 4 'Two technology projects' are the working briefs for two Year 7 projects realistically related to children's experiences. These are achievable and sufficiently open-ended to allow for personal and individual response. They were initiated by teachers of art and home economics under the general theme of 'Transport', within which each of the departments concerned negotiated with the co-ordinator to present a balance of activities across the studios and workshops.

This method of working 'loosely' within a common theme, where teachers negotiate the best way to match the theme within their own subjects, is probably the easiest way to begin the difficult task of co-ordinating work across a range of disciplines. It is a common way of working within expressive arts faculties, where the arts seek accommodation with each other. Its success depends on time being set aside for the 'sharing' of work across disciplines at the conclusion of the project.

Working to a common theme within technology has some advantages where it is used with discretion, but does present problems if it is adopted wholesale, as experienced in the past where subjects have tried to co-ordinate their interests and common concerns. In the early

developments of design education in schools this working to a common theme sometimes resulted in teachers merely working to the lowest common denominator!

The range of subjects associated with technology all have their own concerns to address in addition to the shared concern to make technology work. It is not possible, for example, to deliver all the Programmes of Study for art within technology. There are areas of technical, personal and critical work that are essential to the subject and that would be distorted or lost if, as in some schools, art were subsumed within technology. The personal and expressive nature of essential work in art and design cannot, for example, be accommodated within the social context of technology.

In addition to working in collaboration, all subject teachers associated with technology need their own space and time to teach those aspects of their subjects which are essential to developing coherence and continuity in their work with children. This is particularly true of many of the skills and processes that have to be taught in the separate subjects and, as in art and design, have to be taught in a particular sequence to match children's growing maturity as they move through the school.

It is important to have this in mind when negotiating with colleagues about the best way to work in collaboration within technology. You will need to consider, for example, how much of the technology Attainment Targets and Programmes of Study you are already delivering within your own subject area, how much time you need to deliver the discrete programmes of study for art, and how much additional technology time you will need to make a proper contribution to its work.

A major factor in working in collaboration with other subjects is the amount of time you need to plan and implement cross-curricular work of any quality, to collect and prepare resources for the work and to properly evaluate its effectiveness collectively.

Some indication of this may be seen in Example 5 'Planning sheets for a technology

project on a Japanese theme'. This planning occupied a great deal of meeting time for a large group of teachers. The ambitious nature of the project required that time was spent on collecting and making reference materials and resources, and in negotiating with local Japanese interests. This effort was justified in the quality of the children's work and their response.

As demonstrated in the past, it is virtually impossible to work completely in collaboration with other subjects without distorting important aspects of your own teaching. It is important for both curriculum and political reasons that you work effectively with colleagues in delivering technology in your own school. You will do this best where you and your colleagues can negotiate the delivery of occasional and well-planned co-operative projects for perhaps thirty per cent of the teaching year, and where you look for opportunities for a natural overlap with technology in your own teaching of art and design.

Whatever system of joint working you and your colleagues adopt, and with what degree of success, will depend upon how well you jointly resolve the conflict between the need for children to have both a general understanding of designing and making within the remit of technology, and sufficient time in its constituent disciplines to develop the confidence and skills to craft with authority within art and design.

EXAMPLE 1

Textiles in the primary school, Chumleigh School and
Community College

Margaret Reilly *Head of Art and Technology Faculty*

Extracts from an in-service booklet used with primary
schools in the catchment area to demonstrate the links
between the exploration of a range of visual resource
material and working in different textile processes.

A strategy for textiles in art education

Aims

To develop drawings, when appropriate, through the
awareness of pattern, texture and colour, into the area of
textiles art.

Development

Small group work is the most successful strategy. The extension
of the children's awareness is primarily through focusing their
attention by talking and encouraging discussion as to the
surface appearance of their drawings and subject matter.

It is essential to introduce appropriate materials which will
easily translate into textile images i.e. line drawings of wood
grain can be easily translated into embroidery lines or Batik.
The children develop the skills necessary for weaving, collage,
sewing etc. through the theme or subject matter rather than
teaching the skill for its own sake. It should be a means for
realising their own ideas.

Starting points for textiles

As shown in a previous resources handout there are many
obvious starting points relevant to textiles:

1 *Festivities* – the seasons, church festivals, etc.
2 *Classroom* – windows, landscapes, bookcases, chairs, floor
patterns, woodgrain, radiators, children's hair, hands,
clothes, bags, etc.
3 *Natural objects* – fungi, shells, cut flowers, fruit and
vegetables, leaves, patterns of zoo animals, stones,
plants, etc.
4 *Man-made* – toys, parts of cars, wheels, machinery, clocks,
sweet packets, sweets, bottles, breakfast table, meals,
etc.

EXAMPLE 1

5 *History of art* – slides, posters, postcards and O.H.P.s of
artists' work, carefully selected,
i.e. Monet's water lilies,
Matisse's still-life pictures,
Mondrian's geometric shapes.

6 *Classroom displays* – unusual objects from School Museum
Service, historical artefacts; set up a 'beach display' in
a corner of the room or a 'washing line' with hanging
clothes.

**Skills and concepts
to be developed**

Particularly relevant to textiles are:

(a) *Skills* – gluing, cutting, sewing, weaving.
(b) *Concepts* – texture, pattern, colour, 3D-awareness.

Activities to try in textiles art

Age	Skill	Concept	Activity
7–9 years	starch resist	linear pattern	Using linear patterns found on zoo animals, or wood grain make felt tip/biro drawings emphasising line and pattern. Use these to make a starch resist pattern on material (white cotton strips). Dye with cold water dye.
7–9 years	hand embroidery	texture and pattern in nature	Look at landscapes through the window. Use a card frame to reduce amount of information. Then draw in pencil on white paper. Make sure there is a lot of talk before of texture and pattern to be seen, and select a view which includes the sky and something interesting. Translate drawings into embroidery using wools on hessian. (Carpet thrums come in subtle shades necessary for landscape.)
7–9 years	weaving	colour and texture	Look at skies, water, woods, leaves etc. Use the colours to make studies in pastels or paint of the range of colour seen. Use these colours to develop a weaving on card using correct colour wools, grading colours as appropriate.
7–9 years	printing (vegetables)	linear pattern and texture	Look at a cut vegetable such as a red cabbage. Draw patterns using felt tip, biro or pencil, trying not to let lines touch. Vary the space between them. From these drawings glue string on card (small pieces). These are then pressed into a sponge soaked with paint to create a repeating pattern in one colour only. Shapes touch.
9–11 years	hand embroidery	colour/ pattern/ texture	Using objects with a good pattern and shape such as fungi, cut fruit/peppers/feathers etc. Make drawings using pastel on black paper. Emphasise pattern and line and use these studies to build up layers of materials, and define with imaginative sketches using embroidery threads and sequins, French Knots and other stitches could now be introduced to create effects needed. Materials can be cut away to reveal a layer behind and other areas stuffed with cotton wool or padding to create an interesting surface.

Age	Skill	Concept	Activity
9–11 years	wax resist (Batik) or bleach resist solution	linear pattern development	Children draw the back of a friend's hair carefully – using pencil, felt tip or biro. Lines should not touch but make a pattern. Using this, draw in chalk or fabric crayon on material and create a pattern ready to Batik or bleach. Small group only and safety precautions are important. Wax or bleach may be put onto material with a brush. Wax must be boiled to liquid in a double boiler. Dye using cold water dyes or sponge on carefully using a base of newspaper.

EXAMPLE 2

EXAMPLE 2

Three-dimensional construction worksheets, King Edward
the Sixth College, Totnes

Christopher Killock *Head of Creative Arts Department*

A collection of visual resource sheets and worksheets
designed to be used in Years 7 and 8 to encourage the
exploration and analysis of three-dimensional structures in
the environment.

Year 7 Module

THREE-DIMENSIONAL CONSTRUCTION

The purpose of this module is to introduce children to the working relationship between drawing and three-dimensional construction.

It is based upon the study of natural forms and upon making connections between structures in the natural world and man-made structures in the environment.

EXAMPLE 2

WORKSHEET 1
COMPARISONS BETWEEN NATURAL AND MAN-MADE FORMS

WORKSHEET 2
JOINING AND FIXING STRUCTURES

Geometric Shapes in Structures

Look in your own house, on your journey to school and in the library for as many ways of joining materials as possible.

Think of both rigid and flexible materials, for instance, nuts and bolts, wood joints, clips, toggles, rivets, solders, compression joints, zips, studs, screws, and seams.

EXAMPLE 2

WORKSHEET 3
GEOMETRIC SHAPES AND STRUCTURES

Geometric Shapes in Structures

Look for geometric shapes in buildings,
machines and furniture. Use books as well as
your local environment. For example, cranes,
bridges, pylons, gantries, towers, markets,
stations, shops, offices, tunnels, greenhouses,
bikes and cars.

Example

WORKSHEET 4
JOINING AND FIXING STRUCTURES

Cross-sections of Structures

Look for these cross-sections in your local environment, but also use books on engineering, architecture and DIY building and car maintenance. Look out for posts, pipes, joists, lintels, girders, struts, glazing bars, preformed food packaging and all kinds of preformed metal and plastic sheets.

Example

EXAMPLE 3

EXAMPLE 3

Art through a computer, Cuthbert Maynre School, Torquay

Derek Doran *Head of Art and Design Department*

Design brief used with children in Year 10 to establish the principle of working through computer-aided systems.

Art through a computer Design brief

1 From observation of one of the following:
a) flower head b) shell or organic form c) section of man-made object
produce a straightforward representation of the subject using these four different media:
a) pencil b) chalk/charcoal c) mixed media
d) pc paintbrush.
These will allow you to explore your subject using four individual drawing styles. Make each drawing FULL A5 size and then mount the four drawings on A3 paper. You may use more than one type of paper (cartridge/sugar/newsprint etc.)

2 Choosing the most appropriate style of one of the preliminary drawings, develop it through the computer. You may decide to either directly record the drawing or even start to simplify or abstract your work. Be careful to abstract your drawing only if it enhances or makes more creative use of the subject. Make sure that you save your work at frequent intervals.

3 Design an image or pattern suitable for one of the following applications:
a) a textile design b) a company logo c) part of a packaging design.

4 Adding lettering, now apply your design to one of these uses:
a) Interflora b) a wholefood, greengrocer or delicatessen shop
c) an engineering or electronics company.

5 From all the work you have produced and developed so far, now try to form your own ideas and thinking about how any of the images can be taken further using conventional media ie. paint, pastel, printing etc.

6 At all times keep a record of your work recording thoughts and ideas, problems and future development.

EXAMPLE 4

Working briefs for two technology projects, Estover School, Plymouth

Tony Preston *Technology Co-ordinator*

Janet Griffith *Head of Home Economics Department*

The working briefs for two Year 7 Technology projects undertaken in the Art and Design and Home Economics departments within the general theme of 'Transport'.

Year 7	TRANSPORT
DESIGN BRIEF	For thousands of years bags have been used to transport things around. Identify a need for carrying something around. Design and make a bag to satisfy that need.
CONTEXT	RECREATION
Week 1	Introduction to the brief
	Analyse the requirements of the brief. Uses of a bag - spidergram to depict variety. Examples of bags - pictures and samples - Conduct enquiry and questionnaire. Discussion on the bags students already have and use. Consider limitations i.e. time, size, cost, skills, resources. Record ideas on assessment sheets. Identify Needs and Opportunities. Use sketch pads to draw some ideas - continue for homework.
Week 2	Designing the bag
	Students work on individual bag designs. Discuss practicability of designs, fabric, needs, size, techniques. Finalise designs - fill in assessment section on design. HOMEWORK EQUIPMENT WORKSHEET
Week 3	How to make the bag?
	Draw pattern pieces to correct size - use pattern paper. Label correctly. Identify straight grain - discuss bias and cross of fabric. Plan order of work/plan of action. List fabrics and notions needed. Record in Planning and Making Box on assessment sheet. HOMEWORK FABRIC CONSTRUCTION SHEET
Week 4	Cutting out
	Demonstrate method of pinning on a pattern - include straight grain, bias etc. Students pin on and cut out pattern pieces in fabric. Label fabric appropriately. HOMEWORK RECORD WORK OF THE LESSON.
Week 5	Construction of the Bag
	Basic seam and neatening methods - student sample and machine practice. Work on bag following plan of action. HOMEWORK - RECORD WORK OF THE LESSON.

EXAMPLE 4

Week 6 & 7	Construction

Students continue to work using plan of action. Worksheets and guidance on appropriate construction techniques for the individual. HOMEWORK – RECORD WORK OF THE LESSON.

Week 8	Evaluate the practical item. Display and discuss as a group, drawing attention to success and lessons learnt.

AT

1/2a	1/3a	1/4a	1/4c	1/5b		
2/3a	2/4a	2/4c	2/4d	2/5a	2/6a	
3/3a	3/3c	3/3d	3/4c	3/4e	3/5a	3/6a
4/3b	4/4b					

TRANSPORT 4

Project objectives	Graphics
	Packaging
	Product Design

Brief:	Design a graphic for the packaging for one item of airline food. Your design must relate to the country of origin of a particular airline.

Possible Critical Studies input

i.e.	America, Pan-Am – Imagery includes; American Football, Mickey Mouse, Coca-Cola, McDonalds, Warhol, Grand Canyon, Cowboys, Indians, Fast Cars, Movies, Surfing etc.
i.e.	Spain: Air Espana – Imagery includes: Christopher Columbus, Pirates, Galleons, Picasso, Miro, Holidays, Paella, Sherry, Football.
i)	Package construction is given as a card photocopy. Trace the net or development of the 3D package × 3
ii)	Use one of these to construct a collage relating to the country of your choice.
iii)	Select a section of the collage to reproduce on your second design as a coloured drawing.
iv)	Select a section of the drawing to reproduce on your third design as a painting (original photocopy).
v)	Add airline graphics. Collage various typography

vi)	Relate your design to paper cups and/or paper plates.

Resources:	Travel agents' glossy magazines
	Art Books
	Student input.

AIMS

Te1/2c	Te2/3a	Te3/2b	Te4/3a
Te1/3a	Te2/3b	Te3/3b	Te4/3b
Te1/3b	Te2/3c	Te3/3c	Te4/3a
Te1/4b	Te2/3d	Te3/5a	Te4/5c
Te1/6c	Te2/4b	Te3/5d	Te4/6b

EXAMPLE 5

Planning sheets for a technology project on a Japanese theme, Estover School, Plymouth

Tony Preston *Technology Co-ordinator*

Janet Griffith *Head of Home Economics Department*

Nick Hall *Head of CDT Department*

Planning sheets for a Year 8 cross-curriculum Technology project upon a Japanese theme. These projects which were based in different studios and workshops were negotiated with the Technology Co-ordinator to provide a good balance of different technological activities across the subjects concerned.

NAME . TECH. TUTOR'S NAME .

You must put a 1 by your first choice, 2 by your second and 3 by your third.

The development of some inner city wasteland to create a traditional Japanese Water Garden	
Designing fashion accessories to complement a "Japanese style'	
Entertaining Japanese guests	
How traditional Japanese design could be used to good effect as applied design on various items of present day clothing	
Design for a Japanese theatre production	
The influence of Japanese design on household appliances in the west	
Kimono design in Japan and how it has influenced Western fashion	
Japanese interest in leisure, sport and recreation – designing for this	

EXAMPLE 5

JAPAN

MANY JAPANESE HAVE ADOPTED A WESTERN STYLE IN THE THINGS THEY DO.

THIS IS CAUSING CONCERN WITH SOME PEOPLE WHO PREFER THE TRADITIONAL METHODS AND CULTURE THAT HAS EVOLVED IN JAPAN OVER THE CENTURIES.

A FASHION DESIGNER IN TOKYO WHO BELONGS TO THIS 'HERITAGE' MOVEMENT IS LOOKING FOR A RANGE OF FASHION ACCESSORIES TO COMPLEMENT HIS LATEST DESIGNS FOR THE JAPANESE MARKET.

IN CONSIDERING ACCESSORIES HE WOULD LIKE YOU TO LOOK PARTICULARLY AT JEWELLERY AND ESPECIALLY THOSE ARTICLES THAT CAN BE WORN IN THE HAIR, ON CLOTHING, ON THE HANDS, ON THE WRISTS OR AS A NECKLACE.

THE MATERIALS HE WOULD LIKE YOU TO USE COULD BE CONSIDERED TRADITIONAL AS THEY ARE METALS, WOOD & CARD.

Hokusai

comb designs

STEPS

- GATHER A VARIETY OF PICTURES AND OTHER INFORMATION THAT RELATE TO JAPAN.
- STUDY JAPANESE PAINTERS SUCH AS HOKUSAI AND UKIYO-E LOOKING FOR CULTURAL STIMULUS.
- MAKE DETAILED DRAWINGS OF THOSE ASPECTS WHICH INTEREST YOU.
- MAKE CARD AND WIRE MODELS TO GIVE IMPRESSIONS.
- CHOOSE WHICH YOU FEEL WILL BE THE BEST METHOD TO MAKE YOUR ACCESSORY.
- YOU WILL BE SHOWN SEVERAL METHODS PRIOR TO STARTING.
- THE MOST IMPORTANT POINTS OF THIS EXERCISE ARE CHOOSING THE BEST METHOD OF MANU-FACTURE AND THE QUALITY OF THE PRODUCT.

Brief

The Japanese are very keen and competitive at sports like squash, golf and games which involve great speed of reaction, or accuracy. You are to investigate and experiment to develop a skills game which involves the design of equipment.

The equipment should fulfil the following,
1. Be simple to transport and set up.
2. Be fun for one or more players.
3. Be comfortable to use.
4. To be strong and hard wearing.
5. Look good and be well finished.

EXAMPLE 5

Year 8 JAPAN

A Japanese theatre company is to produce their own interpretation of the film 'Labyrinth'.

As a group you will each produce both a design for the clothing and a mask for a particular character in the play.

Week 1 The ideas for the clothing and masks will be based on traditional Japanese themes, such as the various forms of theatre, Sumo wrestling, Japanese prints, Noh masks etc., so the first week will be spent watching appropriate videos, looking at relevant prints etc and then recording various ideas based on the above (concentrating on expressions - Noh masks) for both clothes and masks.

Week 2 Will involve watching a section of the video Labyrinth, identifying various characters (from book) making sketches of the character and producing ideas of how to promote the Japanese influence. (Mask and clothing designs).

Week 3 Demo of various ways of making masks
 a) Clay - vacuum form
 b) Card - full masks and masks on sticks
 c) Modroc on wire frame
 + Various painting methods - enamel/acrylic/spray paint and
 various additional materials, e.g. wool/cloth/wires etc.
 Use above knowledge to finalise own design and work out plan of making and materials required.

Week 4/5/6 Design and make mask
 Large Painting/Collage of shoulder to waist
 Section of clothing

Year 8 Technology Project 2

JAPAN

Design Brief

As a textile designer you have been commissioned to submit designs and fabric swatches for a kimono and obi.

Use traditional Japanese decoration and Art as inspiration produce 2 alternative design proposals and fabric swatches for either
a) Personal use b) A celebrity of your choice.

	MS	JB
Week 1	Intro: Investigation into history of kimono, terms and shapes	Mkt Research. What is available on the market. Cost, fabrics, decoration. What proportion are kimono style
Week 2	Drawings from motifs, items etc. collecting info: selecting areas of interest for use in design work	Mkt Research. Who, when and why do people use the kimono/ dressing gown
Week 3	Continuation of drawings	Look into the brief and own adaptation of western styles and eastern styles of diagram. Drawings of alternative designs/styles based on the rectangle
Week 4	Design work directed to previous weeks alternative styles. Border, overall, assymetric	CAD - Tessalation for background of geometric shape pattern
Week 5	Continuation of design work. Selection of 2 proposals	CAD - Decision for background on fabric swatches
Week 6	Practical - preparing fabrics and stencils for the dying/ printing	Completion. Comparison of fabrics - silk, cotton, nylon
Week 7	practical continued. Overprint	Presentation of CAD
Week 8	Evaluation. Mkt research into public opinion	Completion

Year 8 Design and Technology

Theme: Japan

Design brief

Some money has been given by a large Japanese
company to develop some derelict land in the
middle of town and create a traditional Japanese
water garden which will include some traditional
buildings and bridges. You are asked to:
1 research these buildings and bridges,
2 develop (by drawing) a range of ideas,
3 choose one or two and select appropriate
 materials,
4 make a scale model of your final idea(s).

a) The distances that the bridges have to span,
 and the floor space of the buildings required,
 are given on the accompanying sheet.
b) A list of material costs is available on the
 accompanying sheet.
c) The model bridges and buildings will be tested
 to see if they can withstand the estimated
 maximum forces that they are likely to be
 subjected to.

Your written evaluation should include the
following assessments:

- How well the model is constructed.
- How well it withstands the forces applied.
- How accurate are its scaled sizes.
- How accurately it resembles a traditional
 Japanese structure.
- How effective is the use of colour.
- How well it is finished.
- The estimated cost of the materials.
- The overall appearance of the model.

9 ART AND OTHER SUBJECTS

Art on its own?

The majority of secondary school art teachers are trained in colleges of art, and their post-graduate training may also take place in specialist centres. After five years of highly specialist training, it is sometimes something of a shock to the young art teacher to find that within a school he or she is simply a teacher of one subject amongst many and to find that art even has to be justified as a subject.

Secondary schools are almost universally subject-centred in their curriculum, and organisation and claims for time, space and resources within the school are subject to negotiation and barter between departmental heads.

This emphasis upon subject disciplines has been reinforced by the introduction of the National Curriculum with its core and foundation subjects, where only in the introduction of technology has there been recognition of the value of cross-disciplinary work.

In these circumstances, you must be able to make a good case for the place of art in the curriculum in its own right. It also makes good educational sense for you to have some understanding of the relationship between art and other subjects, and how your concerns and interests in the teaching of children both match and complement the work of other subject teachers.

You will not further the cause of art teaching if – like some art teachers – you retreat into your own specialism and try to turn your art room into a little oasis in which the sensitive might take refuge from the philistines!

That there can be a useful working relationship between art and other subjects is admirably demonstrated in many primary and middle schools, where this is easily effected through the good class teacher who will teach his/her own class for the bulk of the curriculum. Integration of subjects is most noticeable in those primary schools committed to the philosophy of teaching from direct experience. When children are exploring their own real world, it is natural to respond to it and comment upon it through a variety of subject disciplines.

Example 1 'A cross-curricular project on the study of the local woollen industry' illustrates how a teacher working with a middle school class of eleven-year-olds used different subject disciplines in combination as the exploration of the theme developed across the term.

Although the organisation of the secondary school timetable makes this kind of integration between subjects difficult, there are useful ways in which you can establish working relationships with other subjects. In doing this you may be able to enrich the work of your department in addition to extending the department's influence within the school.

Subject relationships

Different subject disciplines can be related either through their working methods and processes, through their common content, or because they share common purposes in the education of children.

As has already been discussed in detail in Chapter 8 'Craft, design and technology', there is now significant overlap in the processes of designing and making between those subjects associated with the new National Curriculum Technology. Although the working methods used

in the teaching of art and history are very different to each other, there is significant overlap of content so that in both subjects there is a dependance upon the study of work made by artists, crafts-workers and designers living and working in different times and in different cultures.

The arts themselves share with English a common purpose in that they are all used in schools as vehicles for the personal expression by children of their own ideas and feelings.

In recent years in primary schools, there has developed a good working relationship between art and science – especially in the environmental sciences, where the skills of observation and analysis acquired through drawing play an important part in the children's examination of natural and man-made phenomena.

At an informal level you can make good use of the work being done in other subjects in support of your work as an art teacher, simply by finding out *when* related work in other subjects is taking place. For example:

When do the children deal with the science of colour in their physics lessons?
When are the English staff planning a personal writing project with a year group on a theme that is relevant to their work in art?
When in geography do the children embark upon a detailed study of part of the local environment? etc.
Such occasions as these provide obvious starting points for shared work, where the skills and understanding developed in one subject may be used to support work in another.

The development of the National Curriculum, where each consitutuent subject has its own Attainment Targets and Programmes of Study which have to be taught at each Key Stage, has made it much easier to seek out and establish common content between subjects and identify similar working methods and processes. The National Curriculum makes the task of curriculum mapping that much easier, and helps teachers of different subjects to identify common concerns and where and when they can usefully work together.

Art and English

There is ample opportunity for the use of inter-play between art and language in the teaching of art and design. The importance of the good use of discussion and questioning in support of drawing has already been discussed in Chapters 4 and 5. Children will make better and more sensitive drawings from observation when their looking has been focused through using carefully structured talk about what they are observing. They will make more speculative and expressive responses to visual ideas where they have been given the opportunity for speculative and imaginative talk and discussion about the task in hand. There are times when asking the children to make notes or write about their intentions in making a painting or a model in clay will help to support and focus their ideas.

There are occasions when you will find it useful to consult with colleagues in English departments about what sources and resources they may be using with particular year groups to support children's expressive writing. Many teachers of English make good use of personal experiences, photographs and works of art to generate expressive writing with children. If a year group have spent several sessions of their work in English writing prose and poetry about something special they have observed in the local environment, or seen in a reproduction of a painting, they will have had experience that can be built upon within their work in art. Similarly, you may be giving children in your department visual experiences that can be built upon within their work in English.

In making images, children are communicating their observations, ideas and feelings in response to different kinds of experience: in writing a story or a poem, they will be using language for similar purposes. There are many opportunities here for linking and complementing work between art and English.

Figures 9.1 and 9.2 illustrate this complementary use of art and language in designing and making a school calendar, using children's writing and illustrations about such familiar experiences as their first day at school and a day on the beach

as source material. Example 2 'Project sheet: Illustrating a poem' describe how W. H. Davies' poem A *Thought* was used as source material for a graphic design project.

In this country there is a long tradition of quality book illustration. Many distinguished artists have worked in this field, and so there are also opportunities for linking the study of certain texts and the work of those artists who have illustrated them to practical art and design projects.

In many schools, there has also been good co-operation between teachers of art and design and English in setting up courses in Media Studies, to

Figs 9.1 and 9.2
Illustrations and poems for a school calendar; lino print and felt pen (27 × 20 cm). 12-year-olds, Cuthbert Mayne School, Torquay.

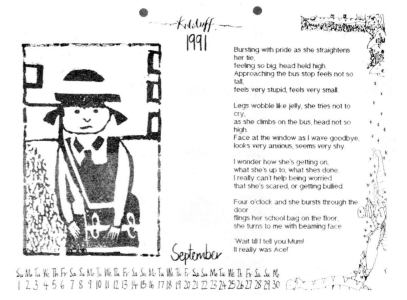

Fig. 9.1 September

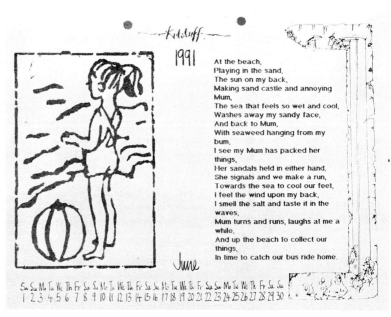

Fig. 9.2 June

248

share in the task of helping children to understand and use the way in which information is presented through the mass media in newspapers, journals, television and film. Such study is an important part of helping children to become visually literate, so that they can read and understand the way that images and language are used to communicate information and ideas and to persuade.

Art and the humanities

Children's ability to describe and communicate their findings through investigation and drawing has an impact upon their work in the humanities. It contributes effectively to their fieldwork in geography and to their ability to research and document historical evidence.

The Programmes of Study for both history and geography emphasise the value of learning about other cultures, places and times through direct experience, through study of the local environment and through studying real evidence. There is now, for example, a very strong link between Attainment Target 2 in art, 'Knowledge and understanding' and Attainment Target 3 in history 'The use of historical sources'. In history, there is an expectation that children will learn a great deal about the past through the study of the work of artists and designers whose work is such important evidence of past achievements.

There is also advantage in the fact that the National Curriculum in history now requires children to study a set pattern of times and cultures as they move through their schooling. This will make it much easier to co-operate with teachers of history about the possibility of putting together reference and resource materials that can jointly serve the needs of both art and history departments.

In many primary schools, there is already some good practice in using common resources for work in art and history in Key Stage 2, where the History Study Units include such periods as The Tudors, Victorian Britain and the Second World War, all of which are well documented through the work of artists.

The five Core Study Units for History in Key Stage 3 of the National Curriculum are as follows:

CSU1 *The Roman Empire*
CSU2 *Medieval realms: Britain 1066–1500*
CS3 *The making of the United Kingdom: Crowns, parliaments and peoples 1500–1750*
CS4 *Expansion, trade and industry: Britain 1750–1900*
CS5 *The era of the Second World War*

In the National Curriculum for art it is required in Key Stage 3 that children should have an understanding of art taken from the following periods:

Classical
Medieval
Renaissance
Post-Renaissance
Nineteenth and twentieth centuries.

It is also required that children should be able to analyse the work of influential artists who exemplify these periods and assess the contribution they have made.

In the Programmes of Study for History in Key Stage 3, there is the additional requirement for the teaching of three supplementary study units to complement the above. These are to include the study of one non-European society, and require that the cultural and aesthetic aspects of that society's work should be addressed.

There is clearly room for some common resourcing and possibly some sharing of teaching in the study of the work of artists, craftsworkers, designers and architects who have helped to shape those periods and cultures that are described in the programmes of study for both art and history.

There are similar opportunities for common resourcing between art and the humanities in those schools where there is an emphasis upon using contemporary evidence in the teaching of religious education. All religions have been documented and celebrated by artists and most have been housed and furnished by builders and craftsworkers. We can trace the development of Christianity through the changing way in which the holy family have been represented by artists

249

over two thousand years. We depend upon the work of artists our knowledge and understanding of other faiths in other cultures.

There can be useful overlap between art and design and the humanities where common resource material is being used in the study of a period in time or of a particular culture or place. There can also be occasions when environmental or documentary evidence being used in the humanities by a particular year group can be matched to appropriate practical work in art and design to the benefit of both subjects.

Figures 9.3 to 9.6 are of work undertaken by children in Year 9 in which they used illustrations from *The Book of Kells*, which they were using as reference material for a humanities project, as the starting point for imaginative work in illuminated and decorative lettering in the art and design department.

Figs 9.3 to 9.6
Decorative devices and lettering; felt pens. 14-year-olds, Honiton School.

Personal motifs and initials based upon the study of the use of images and lettering in The Book of Kells.

250

Art and design and the performing arts

The introduction of the National Curriculum into schools has brought with it considerable debate about the place and status of certain subjects within the curriculum. The initial naming of English, mathematics and science as core subjects and all others as foundation subjects established an immediate and traditional hierarchy of values, which was later supplemented by the requirement that both technology and modern languages had to have a place in the core in Key Stages 3 and 4.

The status of art as a foundation subject was brought into question through an intensive lobbying by some arts educators for the 'Expressive Arts' to be identified as art, music, drama and dance and to be regarded as one subject area for the purpose of National Curriculum planning. This movement was largely initiated in an attempt to 'rescue' drama and dance from being subsumed within the programmes of study for English and physical education respectively, and to take their place within what was claimed to be the homogeneous grouping of 'expressive' subjects.

Growing pressures on time were inevitable in defining a National Curriculum with nine subjects, some of which had to have more time than others. Many schools responded to this initial debate by establishing 'Expressive Arts' faculties or departments, and in some schools an attempt was made to define common aims and objectives for the different arts subjects. Additionally, some examining boards began to offer GCSE courses in integrated, combined or expressive arts, where candidates were expected to work in a variety of ways across the arts disciplines.

These developments raise important questions about the place and nature of the separate arts disciplines in schools:

To what extent do the arts share a common purpose in the education of children?

Are there significant areas of overlap through their processes and content?

251

Do they share common methodologies and structures?

Are there transferable skills across the arts?

The arts do, quite clearly, share common purposes both politically and culturally in schools as well as the community. It makes sense for schools to adopt policies for the arts in areas of funding and entitlement. Many schools have for years required that all students should study one of the arts disciplines through to GCSE level. The arts are an important arena within which schools share and celebrate their work with their communities, through exhibitions, performances and events. Collectively, the arts may play a crucial role in educating children to be conscious of their own work as artists and performers and of the relationship between their own work in school and the cultural context within which they live.

Within the vast majority of schools and most Expressive Arts departments, the arts operate independently, and are taught separately for the good reason that the arts disciplines are very different and have to be taught as discrete subjects in order to provide children with the basic skills needed in the separate art forms. In some schools, and particularly in Years 7 and 8, there is some linking of the arts disciplines through working to common themes, where the children pursue these themes in the separate disciplines and share their work across the arts at the conclusion of the project. It is clear that the sharing of such achievement across the arts has considerable value to children in helping them to appraise and reflect upon their work and to identify how the arts may be used differently to interpret or respond to common themes.

Establishing common themes within which the arts can work is more problematic. The arts may be used to explore such familiar concepts as 'polarities', 'tension', 'distortion' etc., or to enable children to respond to a shared experience or event. When a group of arts teachers are working with children on a common theme, they may use common starting points and reference materials in a lead session, but they will still need to work separately in the discrete arts disciplines because

of their very different characteristics. Very few skills are transferable across the arts: being skilled in drawing, for example, does not support performance in music or dance.

The arts can also be said to have in common the following aims which enable children to:

observe and interpret personal responses to experience.

select, use and compose the formal elements of the arts in the systematic, intuitive or expressive ordering of ideas, feelings and intentions.

select, control and use the media, techniques and processes of the arts.

make critical judgements about their own work in the arts and that of other artists, writers, musicians and performers.

These processes of investigation, realisation and reflection are differently realised through the different arts disciplines because of their contrasting working methods and characteristics. The making of art and design is predominantly an individual activity, and is characterised by reflection upon visual experience. Drama is essentially a group activity and is characterised by human interaction. Music-making is a combination of individual and group activities and is characterised by the reconstruction of existing musical forms.

Despite these difficulties, there are some schools where good use is made of opportunities for the arts to work in collaboration, and where in working together they achieve a stronger curriculum and political presence in the school than they would through remaining separate 'minority' subjects.

Example 3 'Expressive Arts policies' contains extracts from the handbooks of two Expressive Arts departments, and outlines some of their policies and approaches to thematic work across the arts.

Faculty groupings

The development of faculty structures within schools accompanied the emergence of compre-

hensive schools in the early 1960s, with the need to provide administrative structures to cope with the task of managing the new larger schools. In principle, a faculty structure allows previously autonomous subjects to be grouped together, and for the Heads of Faculties to form a 'middle management' group within the school with responsibility for co-ordinating with the Head teacher oversight of the schools curriculum. It was logical, for example, to group the separate sciences together within a Science faculty and to place history, geography and religious education within a Faculty of Humanities.

Some Local Education Authorities adopted faculty policies that bore upon the work of art and design departments. In Leicestershire, for example, the introduction of 'Creative Design Faculties' was pioneered in the 1960s and was to some extent determined by the decision to house the 'practical' subjects of art and design, home economics and CDT in one teaching block since they all required similar services. In the 1980s, many schools set up 'Expressive Arts' faculties embracing art and design, music and drama in response to the publication of the Gulbenkian Report *The Arts in Schools* which emphasised the need for schools to have coherent policies for the arts.

As has already been discussed in this and the previous chapter, the National Curriculum has focused attention upon the working relationship between art and design and other subjects, and in many schools there has been serious discussion about whether art should work in relationship with other subjects associated with technology or be placed in a grouping of arts subjects.

The decision to place art within a design and technology or expressive arts-based grouping of subjects seems to indicate a particular view of the function of art within the school curriculum – that art is either more to do with designing and making things, or with expressing personal ideas and feelings. Since art is quite clearly to do with both, either grouping has limitations in that either arrangement may well prevent art teachers from working with colleagues they wish to work with. In this sense, the larger faculty grouping of tech-

nological and aesthetic subjects together under the umbrella of 'Creative Studies', or the practice of block-timetabling the arts and technologies back to back, can allow for a more flexible working between art and those subjects with which there has traditionally been useful contact.

Faculty groupings do have political and organisational advantages. A group of subject teachers, whether from the arts or the technologies, can have a more powerful political presence in a school than individual heads of subject departments. Collectively and through their Head of Faculty, they are in a better position to negotiate better financial and time-tabling arrangements for their subjects with senior management teams. In many schools, the establishment of faculties has brought with it subject entitlement whereby all students are required to study one of the technologies and one of the arts subjects in Key Stage 4.

It is common practice to block-timetable faculty groupings of subjects so that a team of arts or technology teachers will be timetabled together to work with a year group or a half-year group of children at one time. This is essential for any team teaching or collaborative work within the subjects concerned, and where used imaginatively can lead to a more flexible use of time than in the conventional weekly session for each subject.

Faculty groupings have been successful in those schools where they have been established for the right reasons, and where the group of teachers concerned have found common cause in their work to the benefit of their individual subject interests. There have of course been difficulties in those schools where faculties have been cobbled together for administrative reasons, where teachers have been forced reluctantly into working relationships or where the Head of Faculty has used the arrangement only to the benefit of his or her own subject. Faculties of subjects have been most successful in those schools where they have been formed from strong and committed individual subject departments, led by teachers who have sufficient confidence and expertise in their own subject discipline to understand how they can

contribute to and benefit from working alongside other subjects.

Whether you work in a single subject department, or in one of the variously titled multi-disciplinary faculties, you will need to look for ways to make sense of your subject in relation to others – not only to ensure that there is no unnecessary overlap of content in an already overcrowded curriculum, but also to seek that common ground that can help children to make better sense of their learning as they shuttle from one subject to another.

EXAMPLE 1

A cross-curricular project on the theme of the local woollen industry, Stoke Hill Middle School, Exeter

Marjorie Howard *Head Teacher*

An outline of the work undertaken with a class of twelve-year-olds in a term's cross-curricular study of the local woollen industry. The outline shows the sequence of activities undertaken during the term and how they linked with each other.

1 Initial perceptions

LANGUAGE ART DRAMA

↓

2 History of woollen industry

ENVIRONMENTAL STUDIES
DRAMA

↓

3 Related farming

ENVIRONMENTAL STUDIES
LANGUAGE

↓

4 Visit to cattle market

LANGUAGE DRAMA

↓

5 People and tourism

ENVIRONMENTAL STUDIES
LANGUAGE

6 Visit to woollen mill

LANGUAGE DANCE MUSIC
TECHNOLOGY

↓

7 Wool processing

ART SCIENCE TECHNOLOGY

↓

8 Textiles

ART TECHNOLOGY SCIENCE

↓

9 Imagery associated with wool

ART LANGUAGE
RELIGIOUS EDUCATION

↓

10 Final perceptions

ART LANGUAGE DRAMA
RELIGIOUS EDUCATION

EXAMPLE 2

EXAMPLE 2

Project sheet – Illustrating a poem, John Kitto School

Michael Clarke *Head of Art and Design Department*

Project sheet used with children in Year 7 in support of an illustration project based upon the poem *A Thought* by W. H. Davies.

JOHN KITTO COMMUNITY COLLEGE	ART TEAM	SCHEMES OF WORK	GRAPHICS	'A Thought' Illustration	Number	10
LINKS	PAINTING	**3D STUDIES**	**GRAPHICS**	**DRAWING** / **PHOTOGRAPHY**	**THEMES** / **TECHNIQUES**	

AIMS

a/ To encourage the sensitive use of a pencil or biro through the exploration of different types of mark and their function.

b/ To see how imagery and words can be used to add another dimension to both forms of expression.

RESOURCES/REFERENCE

See examples by Paul Klee, Escher and M.Clark.

UNIT OUTLINE

1/ Give the students the poem by W.H.DAVIES "A Thought"

"When I look into a glass,
 Myself my only care;
 But I look into a pool,
 For all the wonders there.

 When I look into a glass,
 I see a fool;
 But I see a wise man,
 When I look into a pool."

a/ Explain to the students that the work they do during this unit will result in the production of an illustration for this poem.

b/ Explain that the work they will do will involve the use of either a pencil or a biro and the reasons for this selection.

c/ Explain that the illustration will concentrate on producing an image that reflects the lines "But I look into a pool, for all the wonders there," and "But I see a wise man, when I look into a pool."

2/ STUDIES FOR "But I look into a pool, for all the wonders there."

a/ Refer to Paul Klee's "The Goldfish" 1925. If possible show students the colour version as well as photocopies. Discuss the nature of the image. Is it realistic? Is it detailed? Why is the drawing so simple? What kind of marks does Paul Klee make?

b/ Students will produce studies for their own pool.

i/ Produce a series of fish templates and create designs for a,b,c,d, and e.

ii/ Produce a series of plant forms.

NB. Time allocation for task 2 should be a minimum of 2hrs, approx ½hr task a/ and 1½ task b/.

Simple Templates

Each fish to be A6 in size. ± 15cm x 10cm

e. Create a mixture a, b, c, r d.

a. Line

b. Dots/ Circles

c. Cross Hatching

d. Shading

Create a variety of plant forms using similar techniques as in task 1.

PROGRAMMES OF STUDY	A1→10	B1,2,5,6,8,9,10,11,12,13	C1→5	D 5,6,7,9,10	STAFF INITIALS	MCl

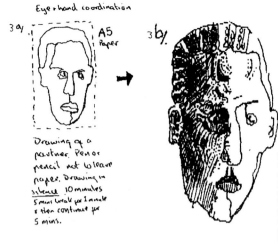

Eye + hand coordination

3a/ A5 Paper

3b/

Drawing of a partner. Pen or pencil not to leave paper. Drawing in silence 10 minutes. 5 mins break for 1 minute & then continue for 5 mins.

Work back into image to add detail. Consider the marks used in previous tasks. (Think about how the marks can show the form and add tone)

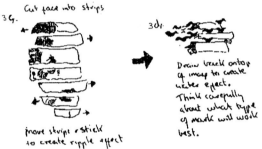

Cut face into strips

3c/

3d/

move strips & stick to create ripple effect

Draw back onto of image to create water effect. Think carefully about what type of mark will work best.

3/ STUDIES FOR "But I see a wise man, when I look into a pool."
a/ using A5 paper students to produce a line drawing of another student in the group. See illustration. Before students start discuss why they are not allowed to remove their pencil from the paper. Eyes must look at the same point on the students face as the point the pencil is on the picture. This encourages good eye and hand coordination. (Demonstrate if possible.)

b/ Complete task as illustrated.

Refer to Escher's "Rippled Surface" linocut, 1950. Discuss how water can break up or alter the quality of a reflection. How has Escher achieved this?

3c as illustrated.
3d as illustrated.

4/ Refer to Escher's "Three Worlds" lithograph 1955. Discuss why it is has this title. (1 the reflection of the trees, 2 the surface of the water shown by the floating leaves and 3 the underneath of the pool shown by the fish.)

a/ The students final illustration will take a similar format. They will use A4 paper in portrait. Very lightly draw a faint line across the paper at the mid point. In the top half the reflection of the face will be placed and in the bottom half the images to create the wonders of the pool will be placed.
b/ Drawing very lightly and referring to the studies made in tasks 2 & 3 students to draw in the basic shapes. "Do not allow the students to move on to the next task until this stage has been checked."
c/ Refer to all the illustrations provided: Paul Klee, Escher and MCL. Students work back into their design to produce final illustration. Emphasis should be made about the quality of marks made. Refer in particular to Paul Klee and MCL to see how the image can be made interesting through the selection of marks. Students might wish to add to their pictures with leaves or insects.
NB Time for task 4 approx 3 hrs.

EXAMPLE 2

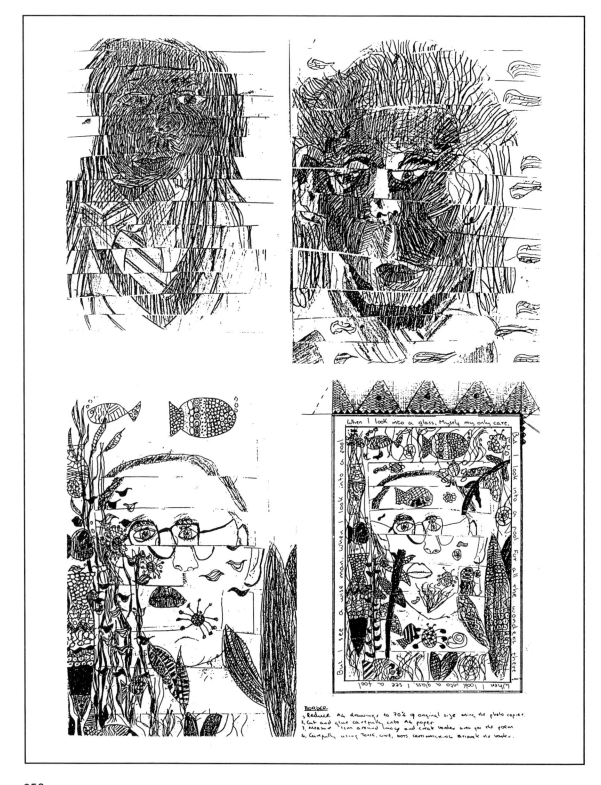

EXAMPLE 3

Expressive Arts policies

Jackie Ross *Head of Expressive Arts Faculty, Queen Elizabeth School, Crediton*

Nicholas Dormand *Head of Expressive Arts Faculty, Honiton School*

Extracts from the handbooks of two Expressive Arts Faculties: outlines to some of their policies and approach to thematic work.

Queen Elizabeth School, Crediton

Expressive arts

To see education only as a preparation for something that happens later, risks overlooking the needs and opportunities of the moment. Children do not hatch into adults after a secluded incubation at school. They are living their lives now. Helping them to an independent and worthwhile life in the adult world pre-supposes helping them to make sense of and deal with the experiences which they suffer or enjoy at present.

The Arts in Schools (Gulbenkian)

The arts are disciplined forms of inquiry and expression through which to organise feelings and ideas about experience. They are fundamental ways of organising our understanding and insight and are central to the encouragement of creative thought and action. Work in the arts develops physical and perceptual skills and puts pupils in touch with characteristic expressions of our culture. None of these are exclusive to artists, playwrights or musicians. All are 'skills' or 'areas of experience' necessary to the development of lively, enquiring, confident and independent individuals.

Every pupil, who comes into an art, drama, textiles or music studio has the right to expect an experience which will help them toward greater understanding and confidence in their own uniqueness. To find a working atmosphere where they are confident that their views will be respected; where they meet the expectation that they will act responsibly; where pupils have respect for one another and the practical demands of working together; where they acquire skills, surprise themselves with their own achievement and learn

EXAMPLE 3

how to deal effectively with disappointments and turn what might have been failure into increased technical and aesthetic understanding. Above all, where they enjoy being involved in creative activity.

The courses 11–14 years The Expressive Arts department aims to develop in young people a sensitive awareness of the world. Through their involvement in creative activity we set out to encourage and provide opportunities for –

Commitment
Confidence in their own ideas
Conjecture and imagination
Sensitive observation
Developing an understanding of the elements of
 communication
Inventiveness
Reflective translation of experience
Awareness of our cultural heritage
Respect in and for members of the group through sharing
Creative leaps: probing, tangential paths, serendipity ideas

We cannot provide a set of instructions to teach 'reflective translation of experience', but we can, by providing certain experiences and using a variety of strategies to gain involvement, create the right environment for learning. This is not an environment of vague hope, but one deliberately structured to enable particular learning to take place.

The variety of experiences and strategies we use are designed to achieve maximum levels of commitment, since we believe that without this none of the above aims can be realised.

Each of the courses outlined under individual subject headings describes the curriculum for pupils between the age of 11 and 14 years. They have been written with the awareness that some pupils will continue with courses leading to GCSE while others will have no further formal arts education.

As a department we believe that an Expressive Arts element should continue to the end of education (16 or 18).

Honiton School

Themes: General principles

1 *Content* – themes used within the Creative Arts programme should be sufficiently demanding and broadly based to enable each subject area to see them as relevant and to develop them to the full.

2 *Planning* – the sequence of themes should be dependent upon carefully co-ordinated group planning and forethought, so as to enable there to be some considered relationship between elements (themes), so that skills, concepts and understanding can be developed throughout the course of study.

3 *Relationships* – this relationship between themes should form a linear pattern, thus producing a logical programme, rather than discrete areas of experience or periods to acquire a particular skill or skills without an opportunity to apply them.

4 *Time* – sufficient time should be available to complete work, and to allow the teaching group to explore the theme in depth, as a too fragmented approach can destroy concentration and continuity.

5 *Depth* – depth of study should not be sacrificed for variety and greater specialisation, for some will be necessary at an earlier time (3rd year).

6 *Content* – the common programme of work developed to cover Years 1 and 2 should cater for the specialist subject interests and teacher strengths.

7 *Content* – any chosen theme should *not* be prescriptive, limiting or unrelated to the knowledge/experience of the target age group or teacher.

8 *Co-ordination* – the selection of themes should be co-ordinated so that it takes into account all the significant aims of the syllabus.

Themes: Aims

General aims
To heighten the pupils' awareness of their own creative potential and to develop their awareness and powers of critical judgement by experiencing, organising and participating in a full range of practical, creative and expressive activities.

EXAMPLE 3

Specific aims

The aims of the course are to stimulate, encourage and develop the following:

(a) *Emotional responses* – the ability to express emotions in an individual and creative manner through a variety of active and passive activities.

(b) *Myself and others* – an awareness of the pupils' self, others and other groups in their own culture.

(c) *Other times and places* – an understanding of other cultures and traditions and their relationship to the pupils' own culture and time.

(d) *Environment* – an understanding and appreciation of the natural and built environment.

(e) *Change* – an awareness of the elements of life which are changeable, irrational or fantastic and of the existence of the extraordinary in the everyday.

(f) *Group organisation* – the ability to work creatively, as part of a co-operative group, towards a common end.

(g) *Instruments, equipment and materials* – the necessary skills to use the instruments, equipment and materials with control, understanding and expression.

To realise these specific aims, themes will be selected to relate to individual aims or groups of aims. A selection of suitable themes can be summarised as:

(a) *Emotional responses*
 (i) Moods/Emotions, e.g. love, hate, likes, dislikes, favourite things.
 (ii) Emotional responses to places, things, people.
 (iii) Expressive use of the formal elements of the subject areas, e.g. colour, improvisation and mime, composition.

(b) *Myself and others*
 (i) A day in my life, e.g. first day at school.
 (ii) Appearance, e.g. disguise, make-up, fashion and dress.
 (iii) Media, e.g. television and advertising, the popular press, contemporary arts.

(c) *Other times and places*
 (i) Cultural contrast, e.g. tribal ritual and custom, city and rural life, home and abroad.

 (ii) Historical development, e.g. human conflict (war and peace).

 (iii) Ceremony, e.g. masks for disguises, protection or ceremony.

(d) *Environment*

 (i) A.B.E. (Art and the Built Environment)

 (ii) Man and machine, e.g. transport, industry, etc.

 (iii) Interior and exterior space, e.g. space, scale, form.

 (iv) The elements (earth, air, fire, water).

(e) *Change*

 (i) Erosion, decay, demolition.

 (ii) Time.

 (iii) Dreams and nightmares, e.g. Surrealism.

 (iv) Movement, speed, travel.

 (v) Contrast, e.g. big and small, new and old.

 (vi) Metamorphosis, e.g. melting, freezing, ageing.

 (vii) The grotesque, e.g. monsters, demons.

(viii) Fantasy.

10 REFLECTION AND APPRAISAL

The pattern of record-keeping and assessment

All schools have traditionally required that teachers regularly assess the work of individual children in all subjects. In all schools there is a set pattern which determines at what point in each year children have to be examined and assessed and the results of these assessments reported to parents.

The introduction of the National Curriculum with its pattern of Attainment Targets, End of Key Stage Statements and Levels of Attainment has given the assessment of children's learning a much higher profile throughout their schooling. Indeed, there are those who claim that the National Curriculum is essentially assessment-driven – to monitor and assess the work of children and thereby to report publicly upon the performance of teachers and their schools.

Each subject now has its own End of Key Stage Statements which describe what children should have achieved in each of the Attainment Targets for that subject, and it is now required that children should be assessed on their Level of Achievement in each of the National Curriculum subjects at the end of each Key Stage (at ages 7, 11, 14 and 16).

Although there has always been an important element of assessment in schools at sixteen plus through the long-standing examination structures and procedures, this emphasis upon appraising and monitoring children's progress throughout their schooling is a major development that will bring with it significant changes to the traditional pattern of assessment in schools.

Until very recent years, the assessment of children's work in Key Stages 2 and 3 has been at a very general level and often limited to awarding simple numbers or grades for effort and achievement. The limitations of this kind of assessment in art have been immortalised in Charles Schulz's famous cartoon where Lucy considers the implications of her being awarded a 'C' for her 'coat-hanger sculpture' (Figure 10.1) and asks questions as:

Was I judged on the piece of sculpture itself? If so, is it not true that time alone can judge a work of art?

Was I judged on my talent? If so, is it right that I be judged on a part of my life over which I have no control?

If I was judged on my effort, then I was judged unfairly for I tried as hard as I could!

Was I judged on what I had learned about this project? If so, then were not you as my teacher also being judged on your ability to transmit your knowledge to me? Are you willing to share my 'C'?

What Lucy is amusingly and rightly demanding is that her coat-hanger sculpture should be judged by criteria that are rather more descriptive than the symbol 'C', and that her own views on the circumstances and quality of her achievement should also be taken into account!

It is worth recording that over the past decade there have been developments in assessment, through the introduction of GCSE in the 1980s and the move, nationally, towards establishing a pattern of 'Records of Achievement' in all schools, that would allow Lucy's work in art to be more appropriately appraised and recorded.

Many art teachers have argued in the past that it is virtually impossible to appraise children's work in art in the same terms as other subjects. They might use the standard excuse that in art 'the process is more important than the product' and

by implication assume that you cannot assess the process.

There are major differences between art and many other subjects. Art does not rely so much upon the acquisition of a certain body of knowledge as is so evident in such subjects as history and physics. There are fewer certainties in art – in such subjects as mathematics and science, many things can be said to be right or wrong – in art we are more concerned with appropriate responses than with right answers. Nevertheless, even those art teachers who deny the possibility of assessment do continuously assess their pupils' work through their talk with the children, through their responses to the children's work, through choosing to display certain children's work and not others' etc. There is certainly much more evidence of continuous negotiated assessment in the work of a good art department than may be seen in many other departments. The very nature of the subject requires a consistent and progressive interplay

between teacher and pupil, as the child moves through the school and, with the acquisition of skills and confidence, begins to want to use his or her skills in an increasingly personal way.

It may be difficult to 'mark' art as other subjects are sometimes marked, and certainly it cannot be done within the same narrow criteria. The nature and range of the tasks we set children within art and design do require us to adopt a more flexible system of assessment than other subjects may require – it must be obvious that you cannot assess by the same criteria tasks as various as making a colour chart, modelling a figure in clay, illustrating a poem or painting a dream.

The importance of reflection and appraisal

The National Curriculum in Art recognises the importance of this good practice of negotiated assessment between teacher and child, and the valuable contribution it makes to the quality of their making.

'Where there is good practice in art education, assessment is an essential element in the creative process itself. Pupils involved in art, craft and design are constantly assessing, evaluating and making judgements about their work, as a result of which they may decide to make modifications and refinements.'

Art for Ages 5–14

The requirements that children should be actively involved in the development and appraisal of their own work are built into the Programmes of Study for AT1 on the following page.

In Attainment Target 2 'Knowledge and understanding', the requirement that children should be able to make connections between their own work and that of other artists, and that they should understand the reasons and purposes for the making of different kinds of work in different times and cultures, will necessarily involve them in appraising the purpose and development of their own work.

AT1 *Investigating and making*

Key Stage 2	Key Stage 3
Pupils should:	
Use a sketch book to record observations and ideas.	Keep a sketch book to collect and record information and ideas for independent work.
Experiment with ideas suggested by different source materials and explain how they have used them to develop their work.	Select and organise a range of source material to stimulate and develop ideas or themes.
	Discuss the impact of source material on the development of their work.
Adapt or modify their work in order to realise their ideas and explain and justify the changes they have made.	Modify and refine their work as the result of continuing and informed discussion.
Use a developing and specialist vocabulary to describe their work and what it means.	Discuss their work using a specialist vocabulary.
	Plan and make further developments in response to their own and other's evaluations.

Monitoring and record-keeping

The essential base for fair and accurate assessment of the children's work is in developing within your department an efficient system for monitoring the children's work as they progress through the first two or three years. This requires a more detailed system of record-keeping than the standard series of grades or marks in a register – especially when, as in many schools, the children may be taught by several art teachers during their time in the lower school.

The obvious and most useful support for monitoring children's work is for them to keep and maintain an individual folder of their own work, dating all work within the folder, so that at any time of the year it is possible to review with individual children what work they have done and in what order. It is also important to keep some work from year to year so that progress can be seen and commented upon. Obviously children

will want to discard work they find unsatisfactory as they progress through the school, and will want to take home work of which they are particularly proud. Despite these constraints, it is possible to retain at least enough work to mirror what has been achieved and what progress has been made. This retention of work is especially crucial as children pass from art teacher to art teacher at termly or yearly intervals.

The keeping of a sketch book is now a requirement for work in Key Stages 2 and 3 and should be used by all children to 'collect ideas and information for independent work'. In many art departments the sketch book is used simply as a convenient way to store drawings made for homework! It can, however, be used much more positively than this, and in some departments it has become one of the principal means by which the progress and development of children's work is monitored. A good sketch book or 'work' book could include the following:

drawings

photocopies of drawings and paintings made by the children

natural and made resources they have collected

photographs

reproductions of works of art and design used in association with their own work

comments and notes about things they have seen

sketches and working drawings for things they want to make

notes on technical processes

descriptions of things they have made

personal comments about things they have made.

In addition to keeping the work itself there is a variety of supporting strategies that all contribute to a better understanding by the children of what they have achieved as well as helping teachers to evaluate more precisely what the children have learnt through the process of making. Example 1 provides some useful descriptions of these. Assessment is supported by:

time for reflection

sharing ideas and experience within the group

discussions about further possibilities of the work

personal records or diaries

reinforcement of experiences through repetition

etc.

Implicit here is the notion that children's self-evaluation of their own work is as important as the teacher's assessment. The ability of children to appraise their own work can only develop when you allow time and provide the structure for this to happen. Some of the strategies for generating appraisal through talk and interaction have already been discussed in Chapter 3.

If you allow children to record some of their observations and comments about their own work as part of the departmental system of record-keeping, they become fully aware of the importance of their own decisions and conclusions in the forming of their work.

There are a number of ways in which you can involve children in the continuous process of monitoring and commenting about their work, and where record-keeping and appraisal can work in harness. Example 2 'Art coursework units' illustrates how, in one department, the working briefs presented to children at the beginning of each project are linked to reflection upon the work through the questionnaire on the reverse side which they have to complete at the end of each unit of work. Example 3 is the record and self-assessment card used in a large department, through which children describe the work they have made, comment upon what they have learnt and what they perceive as their achievements in the work.

Careful monitoring of the children's work becomes even more important if you are working in a large department or faculty and the children are being taught art and design by several teachers within the same academic year.

The notes in Example 1 make specific reference to the close link between evaluation and project planning:

> Assessment is dependent upon having clearly defined aims and strategies established before the outset of a project. Only by having reference points can we hope to match achievement with objectives. Evaluation therefore becomes an integral part of project planning: what we have done, how they respond, what they think they have achieved, what the standard of work was like and how do you know they want to carry on, form the discussion points for the development of projects.

Negotiating assessment

Since the nature of art teaching and of learning through art allows for a much more natural and personal means of assessment to operate than in many other subjects, it does seem reasonable to take this into account when planning projects and courses. A characteristic of good art teaching is the way the art teacher sets up a continuous dialogue with individual children about their work

as it progresses. This dialogue will consist of a mixture of exchanges between teacher and child: some searching, some encouraging, some prodding and some straightforward exchange of information. All this adds up to a form of continuous negotiated assessment in which the child responds through his or her own making to the problems and possibilities presented. It is also clear that the content of this exchange varies significantly from task to task and changes in its emphasis as children pass through the school.

When younger children are drawing from observation, the exchange is a fairly simple one and will be concerned with ways of making different kinds of marks, ways of measuring, ways of looking carefully:

Try using the chalk over the charcoal.
Where will you need to use the pencil lightly?
Does it really curve as much as that?
Can you see all of that ear?

The dialogue will change in emphasis depending upon the task and so will the balance of assessment that is implicit in this kind of exchange. Dialogue about drawing is mainly about looking – technical matters are supportive to the looking. Dialogue about making a pinch-pot in clay is mainly about technical matters. Dialogue about making a drawing of a dream is mainly about notions.

If and when the children's work has to be formally assessed, and real marks entered into a mark book, it will make much more sense to the children if they know how the grade or mark was arrived at – which aspects of the work were most successful. If a pupil has spent the best part of three hours making a drawing of a still-life group, more response than C+ or six out of ten is deserved! Assessment of such a task will flow more naturally if both the introduction to the task and group appraisal at the end focus upon those different elements within such a drawing:

How well is space described within the drawing?
Do the objects appear to be solid?
Are the materials used sensitively to explain the surfaces?

Has a variety of weights of pencil been used?
Has an interesting aspect of the group been chosen?
How well is it arranged within the page?
Is this a better drawing than the last one you made?

Formal assessment of the children's work need not become unduly artificial as some teachers fear, as long as within the structure of the work and through the discussion and appraisal about it the children are fully informed about what is being assessed and why. As they progress through the school, it becomes more and more important to involve the children in their own assessment of their work. This can be encouraged by the way in which projects are set and courses are introduced to them.

The quality of the dialogue between teacher and child, which is such an important part of negotiated assessment, is dependent upon your skills as an initiator of reflection through asking the right kinds of questions and making the right demands of children. It is also dependent upon what kind of vocabulary the children have, to deal with describing, comparing and analysing their own achievements within art and design. Within the National Curriculum there are specific Programmes of Study concerned with the development of an art vocabulary. Some of the strategies you might use to help children talk and write about art and use specialist vocabulary have already been discussed in Chapter 7 'Understanding and using works of art' (pages 162–205).

Assessment profiles

Assessment profiles are now in use in the majority of art and design departments both as a means of recording children's progress over a period of time and for the assessment of work at specific points in the school year. The use and development of assessment profiles was accelerated through the introduction of the GCSE Examinations in 1986 and with it the principle that children should be assessed upon the basis of what they can achieve

– on what they *can* do rather than upon what they have failed to do!

The GCSE examinations brought with them a new emphasis upon the use of what have been called 'grade criteria', which are simply descriptions of what the candidate has to do in order to achieve a particular assessment grade within a subject discipline. In art and design, the introduction and use of grade criteria for assessment has generated a much more pragmatic view of assessment, which takes account of all those different processes and qualities that describe a child's achievement in the making of a complex artefact, instead of trying to sum up that achievement in a single grade or number. In designing profiles for assessment – in seeking to 'describe' children's achievements in art and design – teachers have had to give attention to identifying those personal, technical and aesthetic skills that contribute to the making of an image or artefact. This has led to a much more careful consideration of those key elements or 'domains' in art that might both describe and determine an appropriate pattern of work for use in schools and which have been discussed in detail in Chapter 1 'A framework for the syllabus'.

Example 4 'Assessment profiles' provides examples of profiles used in two different departments, where the teachers concerned have agreed upon what are for them the key elements or processes necessary to the making of art and which they need to consider when assessing students' work.

They refer to the following skills and processes in different kinds of combinations:

Observing and recording visual experience

Use of tools and materials

Understanding concepts

Decision making, ideas development

Expressing and developing ideas

Critical skills

Design skills

Communication of visual ideas

Interest and motivation.

Different departments will necessarily arrive at different frameworks of descriptions for their work. What is more important is that such descriptions will help a group of teachers to identify the purpose and scope of their work and thus provide a framework for its assessment.

Many departments will also include in such profiles descriptions of what is meant by each level of achievement within each key element or process included within the framework, as for example in the following descriptions of different levels of achievement in drawing:

Ability to observe and record visual experience:

- demonstrates a high level of visual sensitivity and observes with great accuracy.
- records accurately and shows evidence of careful observation.
- shows some effort at careful observation and records with reasonable accuracy.
- observation can be rather superficial resulting in some problems when recording.
- has great difficulty in effectively recording what is seen.

However difficult and time consuming may be the semantic exercise of agreeing upon such descriptions, they are a great deal more informative and helpful to teachers, children and parents about what has actually been achieved in some aspect of art and design than the traditional and abstract number or letter, where a 'C' for drawing would mean only 'somewhere in the middle'!

Another virtue of appraising children's work in this way is that it can be a great deal more encouraging to children to assess their work to a number of different criteria rather than to have to give them a single mark or grade for a piece of work that has taken place over several weeks. In using different criteria you are able to be more flexible in negotiating with them what they have achieved in different aspects of their work. You can praise certain aspects and be critical of others and you can use the assessment positively to show them where their strengths and weaknesses may lie.

Self-assessment and review

Many art and design departments use similar methods and profiles to encourage the practice of

self-assessment, frequently using the reverse side of the profile for the children to complete as part of the negotiation about assessment, as illustrated in Example 5 'Self-assessment profiles'.

The practice of self-assessment or 'reflection' back upon the work is an important part of Attainment Target 1 in the National Curriculum in Art because it is recognised that the practice of such reflection has important bearing upon the development of children's work.

Children have to be given time to practise self-assessment in order to develop the necessary skills to review their work and to use such review positively to generate further work and ideas. Although you may find such time hard to find, especially in Key Stage 3 where most children only have one module of 60–70 minutes of work in your department in each week, it is time well spent. The habit of reflection can begin in Year 7, largely through the familiar group review and discussion at the end of each session, where you will be able to draw from the children descriptions of and comments about what has been attempted and achieved in a particular lesson. Discussion about and review of work is common practice in many primary schools across a whole range of subjects, and if you ask children to comment upon, talk about and write about their work in art right from the beginning of their secondary schooling such review will become an accepted part of practice in the art and design studios. Through your work in critical studies you will necessarily be asking children to talk and write about the work of other artists and it is a natural extension of such practice for them to be asked to describe or write a review or criticism of a work they have made themselves.

In order to establish the practice of review effectively, you will need to set aside time at the end of each half-term or term project for this to take place, to review with the children what they have achieved and for them to find some modest means to record their achievements, whether within the framework of an assessment profile or more informally through making notes and comments in their work books/sketch books.

Assessment within the National Curriculum for Art

The future pattern of assessment in art and design will be determined by the structure of the Attainment Targets and Programmes of Study for Art within the National Curriculum as it evolves and changes over the next decade. These have been discussed and described in some detail in Chapter 2 'The National Curriculum in Art'.

As in all National Curriculum subjects, children's work in art and design will have to be assessed to show how their work matches the expectations of the Attainment Targets for art and how they satisfy the requirements of the Programmes of Study. The two ATs together with their three key strands of experience and seven key components (which are listed below), will form the basis for future assessment in art and for the shape of the subject's assessment profiles.

The National Curriculum in Art: The Key Strands

AT1 Investigating
Observe and record, make connections and form ideas by working from direct experience, memory and imagination to develop visual perception.

Visualise ideas by collecting and using a wide range of reference materials.

Making
Develop skills and express ideas, feelings and meanings by working with materials, tools and techniques and the visual language of art, craft and design.

Review and modify own work in relation to intentions.

AT2 Understanding
Know about different kinds of art, how they are made and their different purposes.

Explore art, craft and design in a wide historical, social and cultural context.

Use other artists' methods and systems practically and imaginatively in their own work.

These key strands and their components form the basis for the formulation of the End of Key Stage Statements which are detailed for Key Stages 2 and 3 on pages 29–32 of Chapter 2. These End of Key Stage Statements will, in turn, be the future basis for designing the grade descriptions that will identify children's progress in art and design throughout their schooling.

A postscript

In its present form, the National Curriculum in Art will serve well enough to provide a start upon that long process of putting in place a coherent programme of work in art and design for children in our primary and secondary schools. Whatever its faults and pitfalls – and these will not emerge until it has some basis in practice – it has at least some logic to it. It is rooted in good and perceived practice in schools. It does, to some extent, resolve long-standing arguments about the place and purpose of art education for children. Its overriding virtue is that it is in place in the core curriculum for all children from the ages of 5 to 14, and that from September 1992 it is a statutory and legal requirement that it should be taught to all children in all our schools.

EXAMPLE 1

EXAMPLE 1

Introductory notes to the expressive arts syllabus, Queen Elizabeth School, Crediton

Jackie Ross *Head of Expressive Arts Department*

General guidelines for assessment within an expressive arts department that includes art, drama, music and textiles. These notes refer to the variety of ways that children's work is assessed, in addition to the formal grading of their work (see pages 66–9).

The experience When planning projects and schemes of work, we aim deliberately to provide time or space during a session or number of sessions for some of the following:

Opportunities for:

time/space for their assessment of their work;
pride and a sense of achievement in their work;
quiet individual reflective work;
use of expressive arts sketchbook/diaries;
sharing of ideas/experiences within the group;
relevant reference to culture and civilisation/place in history;
discussion/awareness of further possibilities of the work;
reading and gleaning from non-verbal material;
wondering, conjecture and imagining;
detailed observational drawings and notation;
development of manipulative skills;
opportunity of independent work;
sharing of work within the group and/or school.

Every project, session or part of session should have:

a deliberate focus area;
a conscious balance of activities.

After a number of projects pupils should have:

a personal record of what they have done (diaries);
a number of experiences;
a folder of work;
a reinforcement of experiences by repetition;
the ability and interest to develop projects further.

The strategies Strategies need to be carefully matched to activities. The use of role play as an all-involving beginning, designed to achieve group identification with a new situation, is very different from quiet individual problem setting which looks for individual absorption and concentration.

The theme of the project, the focal points, the provision of opportunities and the strategies we use are all inter-dependent. The breakdown into compartments is a useful way of examining our teaching and their learning.

Assessment Assessment is dependent upon having clearly defined aims and strategies established before the outset of a project. Only by having reference points can we hope to match achievement with objectives. Evaluation, therefore, becomes an integral part of project planning. What we have done, how they respond, what they think they have achieved, what the standard of work was like and how you know they want to carry on, form the discussion points for the development of projects.

The children's assessment of their own achievement is an element that should not be overlooked. Finding the right moment and the appropriate form for the expression of thoughts and feelings should be established from the first year. Reflecting on experiences and learning to value their own work is important and contributes to the longer term aim of developing more discriminating young people.

A record of the pupils' work will be found in their folders and expressive arts books. We need to ensure that we keep records of things not found in their books – for example, contribution to, and ability to work in groups, and whether they have a particular feel for visual, practical or mechanical areas of work. These are, in fact, all those things we need to know when compiling profile reports.

Among the things we are looking for are:

high standards of work;
a continuous working process;
an independent and responsible attitude;
self-assessment and evaluation.

These should be encouraged through the careful use of personal sketchbooks, diaries and folders, as well as through group sharing and individual discussion with staff.

Folders provide the opportunity to look back, to take pride in a year's work, to develop work at a later stage in the overall scheme and to 'get out and continue with work through

EXAMPLE 1

breaks and lunchtimes'. Work from as many areas as is practicable can be kept in folders. They can stay with pupils from one half-year's subject to the next, offering opportunities for cross-referencing and reminders.

Sketchbooks/diaries, which this year will be introduced at the start of the year by art, expressive arts, textile or design staff, should become an important part of the creative arts as well as the expressive arts course. They should show evidence of the working/exploring/thinking process and can be used for notes which reflect 'what we have done today' as well as the normal drawing, notation and homework.

EXAMPLE 2

Coursework unit with self-assessment questionnaire,
Coombe Dean School, Plymstock

Peter Hall *Head of Art and Design Department*

A Year 10 project brief for a coursework unit on analytical
drawing, which includes a questionnaire to encourage
children to reflect back upon the activity.

EXAMPLE 2

COOMBE DEAN ART COURSEWORK UNIT YEAR

NAME	Tutor

Date Set	Deadline

"Analytical Studies" (Expressive Process) - choose to work from the fruit and vegetables provided. Look at the worksheet on shading techniques and use it to help reveal texture, form, light and shade. Cut open the fruit and veg and make further studies on colour, tone, and structure. Experiment with different materials to achieve realistic effects i.e. pen and ink, shading pencils, pastels, chalk and charcoal, paint, fibre pens, coloured paper, rubbings and collage.

Having completed your studies make a number of small symmetrical viewfinders e.g. squares, equilateral triangles, octagons, hexagons etc. Place these on top of your studies and trace off any interesting design that you come across. Start to repeat these designs to form tessellations. Experiment with different colour and tone combinations and work out a large design suitable for printing. Write down and include with your presentation sheet the reasons why you selected your design.

Homework 10) - "Egg Shells" place two broken egg shells on coloured paper or silver foil. One half to face up and the other down. Now make a larger than life study using shading pencils and/or colour. Note carefully the effects of light and shade, and the subtle reflections of the coloured paper or foil.

Homework 11) - "Plants" using colour and shading make either one large study or a series of studies of an indoor or outdoor plant. Do not draw the pot.

Homework 12) -

ORGANISATION

MATERIALS

UPPER SCHOOL SELF-ASSESSMENT

Please write in sentences your response to the following questions based on the coursework unit you have just completed:

1) Did you understand the coursework unit, and was it clear what you had to do?

2) Do you think you could have been more thorough with your preparation?

3) Did you have more than one idea to use?

4) What were your sources for investigation and information, e.g. the library, art and art history books, magazines, observational drawing?

5) Did you experiment before finally selecting your chosen idea and choice of materials?

6) Underline any of the following that are evident in this coursework unit?
 a) Visual Elements - line, tone, colour, pattern, texture, shape, form, space;
 b) Conceptual Elements - proportion and scale, plane, volume, the use of light;
 c) Practical Elements - representation, meaning and function.

7) What did you learn from this coursework unit?

8) How do you think you have improved upon this coursework unit?

9) Did you enjoy this coursework unit or not? Please explain why.

EXAMPLE 3

EXAMPLE 3

Record card, Queen Elizabeth's Community College, Crediton

Jackie Ross *Head of Expressive Arts Department*

A record card in use in an Expressive Arts department, through which children record the progress of work on a particular project and comment upon their achievement.

EXPRESSIVE ARTS DEPARTMENT
PUPIL/TEACHER ASSESSMENT
SUBJECT : COMBINED ARTS

QUEEN ELIZABETH'S
COMMUNITY COLLEGE
Crediton

PUPIL ...

PERIOD COVERED : TERM

YEAR

TEACHERTUTOR GROUP..

Name of Project(s)

Write a short description of the Project(s)

What activities were involved?

What did you learn?

EXAMPLE 3

Investigation and research

Did you try out different ways of doing things in lessons/in between lessons?
How did you do your research?

Skill, techniques and materials

How well did you use the tools and materials?
What would help you to improve?

Evaluation

Are you pleased with your work?
What would you change or do differently?

Staff comment:

Parent comment:

EXAMPLE 4

Assessment profiles

Rob Chapman *Head of Art and Design Department,* Audley Park School, Torquay

Tony Preston *Head of Art and Design Department,* Estover School, Plymouth

John Broomhead *Head of Art and Design Department,* Great Torrington School

Assessment profiles for three departments in which key processes in art and design are identified for assessment and are used as the basis for negotiating assessment with children. Two of the profiles include grade descriptions for each element in the profile to identify what has been achieved.

EXAMPLE 4

GCSE Art & Design

Assessment Sheet

AUDLEY PARK SCHOOL

FORTITER ET FORTITER

NAME

	4TH YEAR	5TH

ABILITY TO OBSERVE AND RECORD VISUAL EXPERIENCE

A Observes with accuracy and skill, revealing a high level of visual sensitivity.

B Records with reasonable accuracy, showing some ability to respond sensitively and selectively.

C Observation tends to be superficial, resulting in problems when recording.

USE OF TOOLS AND MATERIALS

A Uses media with confidence and skill to create subtle and expressive work.

B Handles tools and materials well, showing some skill and sensitivity.

C Has difficulty in controlling materials effectively.

COMMUNICATION OF VISUAL IDEAS

A Able to express complex ideas with fluency and imagination. Produces strong personal statements.

B Achieves a recognisable personal response and shows evidence of an imaginative approach.

C Unable to respond with other than obvious and second hand solutions.

MOTIVATION AND INTEREST

A Always shows interest and involvement. Is lively and curious and capable of self-motivation.

B Makes personal decisions and works consistently.

C Fails to show sufficient interest.

EXAMPLE 4

Module	Art Department Profile
1	Name
2	
3	Form
4	

Teacher Assessment Pupil Assessment

Observation Skills

			1	Can analyse as well as record; uses media selectively				
			2	Can record accurately and with some sensitivity				
			3	Attempts to record but has practical difficulty				

Technical Skills

			1	Good co-ordination; capable of independent work				
			2	Competent but needs time to develop new skills				
			3	Poor co-ordination and slow to learn from mistakes				

Critical Skills

			1	Understands subtle qualities; makes informed judgements				
			2	Makes judgements which show some thought and awareness				
			3	Rarely shows preferences; passive rather than inquisitive				

Design Skills

			1	Solves problems in an intelligent, well-organised manner				
			2	Inventive but lacks organisation and determination				
			3	Needs close supervision in order to make progress				

Skills in Communicating Ideas and Emotions

			1	Produces varied personal images and sees potential of materials				
			2	Can organise images but needs help to develop ideas				
			3	Finds it difficult to produce visual images; lacks confidence				

Social Skills

			1	Always shows a great deal of interest and involvement				
			2	Works consistently in class both individually and in a group				
			3	Fails to understand the needs of others; not always co-operative				

EXAMPLE 5

Self-assessment profiles

Richard Dunn *Head of Art and Design Department,*
Ivybridge School and Community College

Jean Coombe *Head of Expressive Arts Department,*
Dawlish School

Self-assessment profiles in use in two departments, which
are designed in different ways to encourage children to
consider and reflect back upon a recently completed project.

EXAMPLE 5

PUPIL PROFILE / ASSESSMENT CARD

Project No.

PUPIL / STUDENT NAME: .. TUTOR GROUP:

USE THE AREAS BELOW TO COMMENT ON THE QUALITIES FOUND IN YOUR WORK.
PLEASE READ THE QUESTIONS CAREFULLY & RING THE ANSWER THOUGHT TO BE APPROPRIATE.

OBSERVATION
- HOW MUCH HAVE YOU NOTICED IN YOUR SUBJECT? A LOT / MORE THAN EXPECTED / NOT MUCH
- HOW MUCH HAVE YOU SUCCEEDED IN SHOWING? A LOT / I HAVE TRIED / BASICS / NOT MUCH
- HOW EFFECTIVELY HAVE YOU SHOWN YOUR OBS? WELL / ADEQUATELY / JUST / NOT AT ALL
- WAS YOUR WORK JUST BEEN CONCERNED WITH THE APPEARANCE? YES / NO

INTERPRETATION RESPONSE
- HAVE YOU SUCCESSFULLY CONVEYED YOUR IDEAS? YES / ALMOST / NO / ?
- HAVE YOUR IDEAS DEVELOPED BEYOND THE ORIGINAL BRIEF? GREATLY / JUST / NEARLY / NO.
- HAVE YOUR IDEAS CAUSED YOU TO LOOK AT OTHER SOURCES? EXTENSIVELY / YES / NO.
- ARE YOUR IDEAS YOUR OWN? MOST / ALL / YES / NO

PRACTICAL HANDLING of MATERIALS.
- DID YOU CHOOSE THE RIGHT MATERIALS FOR YOUR SCHEME? YES / NO
- WHAT ALTERNATIVES DID YOU CONSIDER? ANSWER OVERPAGE
- HAVE YOU CONTROLLED YOUR MATERIALS? WELL / YES / BASICALLY / NO

DECISION MAKING IDEA DEVELOPMENT
- HAVE YOU TRIED TO COMMUNICATE AN IDEA / THOUGHT? YES / NO
- HAS IT BEEN SUCCESSFUL? VERY / YES / JUST / NO.
- HAVE YOU MADE LINKS WITH OTHER IDEAS? YES / NO / NEARER OVERPAGE
- WHAT WORK? / SET / WORKS? ANSWER OVERPAGE

BASIC ELEMENTS
- WHICH OF THE FOLLOWING ELEMENTS IS/ARE MOST IMPORTANT IN YOUR WORK.
 — LINE / TONE / SHAPE / PATTERN / TEXTURE / FORM / COLOUR. —
- HAVE YOU DEVELOPED YOUR WORK WITH THIS IN MIND? YES / NO
- HOW MUCH HAS IT DOMINATED YOUR INTERPRETATION? GREATLY / NOT AT ALL

INGREDIENT "X"
- HOW MUCH HAVE YOU ENJOYED YOUR WORK? GREATLY / BITS / MOSTLY / NOT AT ALL
- HOW WELL HAVE YOU ORGANIZED YOURSELF? V. WELL / WELL / JUST / NOT AT ALL
- HOW INVOLVED HAVE YOU BECOME IN YOUR WORK? MORE THAN EXPECTED / VERY / AV. / NORMAL
- HAVE YOU GAINED IDEAS FOR FURTHER WORK? MANY / SEVERAL / NONE / YES / NO.
- HAVE YOU PROGRESSED? GREATLY / YES / A LITTLE / NO.

PUPIL / STUDENT COMMENTS

STAFF COMMENTS.

SIG.

IVYBRIDGE COMMUNITY COLLEGE

ART · DESIGN DEPARTMENT

PROJECT TITLE:

BRIEF:

COMPLETION DATE:

MATERIALS NEEDED / USED. PROCESSES INVOLVED.

RESOURCES USED / LINKED LOOKING / RESEARCH

PROBLEMS / PROBLEM AREAS.

Final End Of Course assessment and Review

Self-Assessment Sheet
(CRITICAL FACULTY...)

Date	Term			Teacher
MAY 1991	5 ✓	2	3	MRS COOMBE

Teaching Group	Name	Specialist Area
5H	ROSALYN CAMP	PAINTING + DRAWING G.CSE

Project Title	Overall Grades					
	Conduct	A	Effort	B	Attainment	E/D

List and Description of Work

The intire two year course work folder including the exam.

1 How much of my work did I complete satisfactorily?

(a) All of it	✓	Reasons: Some of my work which I didnt quite finish I took home to do. But I have finished all of my work satisfactorly.
(b) Most of it		
(c) Some of it		
(d) None of it		

2 How did I work during the lessons?

(a) Very hard	✓	Reasons: I worked very hard during my lessons because I enjoyed the work which I was doing. and concentrated hard on what I was doing.
(b) Quite hard		
(c) Not very hard		
(d) Not at all		

3 How do I feel when I look at my work?

(a) Very pleased		Reasons: I am pleased with most of my work but I could have done better at some peices like pencil drawings which I didnt really like doing. I also think I could have tried better at my sketch book work.
(b) Quite pleased	✓	
(c) Not very pleased		
(d) Disappointed		
(e) I do not care		

4 Did I produce my best possible standard?

(a) Yes, I did		Reasons: All the work which I liked doing, Paintings, chalk drawings I produced my best. But I could have done better at my pencil drawings, I didnt really enjoy doing them but I did do my best at everything else.
(b) No, I could have done better	✓	
(c) No, I could have done much better		

5 What have I learnt from this project, and how could I have improved it?
COURSE

I have learnt how to apply my different materials which I used and learnt about proportions. Positions of drawings.

BIBLIOGRAPHY

Adams, E. and Ward, C. *Art and the Built Environment*, Longman.
Allison, B. 'Identifying the Core in Art and Design, *Journal of Art and Design Education*, Vol. 1 No. 1, 1982.
Arnheim, R. *Art and Visual Perception*, Faber.
Association of Art Advisers *Learning Through Drawing*, AAIAD.
Barrett, M. *Art Education: A Strategy for Course Design*, Heinemann.
Baynes, K. *Attitudes in Design Education*, Lund Humphries.
Berger, J. *Ways of Seeing*, BBC/Penguin.
Best, D. *Feeling and Reason in the Arts*, Allen and Unwin.
Calouste Gulbenkian Foundation, *The Arts in Schools: Practice and Provision*, Gulbenkian.
Clement, R. and Page, S. *Primary Art*, Oliver and Boyd.
Clement, R. and Tarr, E. *A Year in the Art of a Primary School*, NSEAD.
DES *Art in Secondary Schools, 11–16*, HMSO.
DES *Art in Junior Education*, HMSO.
DES *The Curriculum from 5–16*, HMSO.
DES *Art for Ages 5–14*, HMSO.
Dubrey, F and Willats, J. *Drawing Systems*, Studio Vista.
Eisner, E. *Educating Artistic Vision*, Macmillan.
Field, R. *Change in Art Education*, RKP.
Gentle, K. *Children and Art Teaching*, Croom Helm.
Gregory, R. *Eye and Brain*, New English Library.
Lowenfeld, V. and Brittain, W. L. *Creative and Mental Growth*, Collier Macmillan.
Morgan, M. *Art 4–11*, Blackwell.
Read, H. *Education Through Art*, Faber and Faber.
Robertson, S. *Rose Garden and Labyrinth*.
Robertson, S. *Creative Crafts in Education*, RKP.
Robinson, K. (ed.) *The Arts 5–16: A Curriculum Framework*, Oliver and Boyd.
Ross, M. *The Creative Arts*, Heinemann.
Schools Council (Ed. Clement, R. T.) *Art 7–11*, Schools Council.
Schools Council (Ed. Westall, D.) *Visual Resources for Art Education 7–13*, Schools Council.
Taylor, R. *Educating for Art*, Longman.
Thistlewood, D. (ed.) *Issues in Design Education*, Longman/NSEAD.
Thistlewood, D. *Critical Studies in Art and Design Education*, Longman/NSEAD.
Vernon, M. D. *The Psychology of Perception*, Penguin.
Witkin, R. *The Intelligence of Feeling*, Heinemann.

INDEX